ALL

about techniques:

ANATOMY FOR THE ARTIST

ALL

about techniques:

ANATOMY FOR THE ARTIST

BARRON'S

Contents

Anatomy for artists is a discipline partway between medical science and the art that was introduced to the art curriculum during the Renaissance, an age in which artists and scientists had some of the same preoccupations (recall that perspective was introduced during this time). Since that time, anatomy has become one of the essential skills in the training of every illustrator and painter. Technical, stylistic, and aesthetic changes that have taken place in the art world have often modified the criteria for criticism and the audience, but they have never displaced anatomy from its central position in training for the artist.

This book offers the reader a complete, practical guide for learning anatomical drawing. This is a well-balanced guide. It combines purely descriptive content on bones, muscles, and joints with their application to artistic practice without overdoing the descriptive portions at the expense of their practical application or vice versa. In other words, it does not unduly favor the number of figure drawings without justification by the anatomical explanations.

The work is divided into chapters dedicated to the trunk, the hands, the legs, the feet, and the head. Each of the chapters explains and illustrates in detail all the bone and muscle features of interest to the artist, emphasizing the ones that have the greatest impact on the body's

external appearance. This means that all the muscles that influence this relief in any way are described and illustrated. However, the muscles that are hidden in deeper layers and that do not influence the drawing in any position or movement of the figure are omitted.

The intention has been that all the illustrations of bones and muscles be accompanied by illustrations that show their visible and palpable manifestations under the skin in different views and in various movements. In some cases (in the relief of the torso, for example), the readers will be able to identify every muscle immediately. In others (as with the shape of the forearm), it will be necessary to study closely the anatomical illustrations and explanations to determine the muscles and bones to which every superficial prominence corresponds. In such cases, it is a good idea for the readers to copy the drawings to gain familiarity with the shape, spatial orientation, and name of every anatomical feature and fix them in their memory.

At the end of these chapters is a section in which detailed practical sketches are offered to familiarize the readers with drawing every body part, with useful information on proportions. Also, we propose a simple way to construct figures on the basis of these sketches. The sketches facilitate drawing by providing a basic structure for the figure, a structure that can be completed only once the main points of the preceding sections have been assimilated.

The last chapter is devoted to examples of anatomical drawing, illustrated and explained step-by-step. There are eight drawings of male and female figures done in techniques that range from charcoal to colored pencils, which show the practical application of the points explained throughout the book. In nearly all cases, the drawing process includes, in the early phases, a representation of the skeleton deduced from the pose of each figure.

This work has required lots of editing in both the graphic and textual parts. The exclusive purpose has been to create a truly practical tool for all readers who are seriously interested in artistic anatomy.

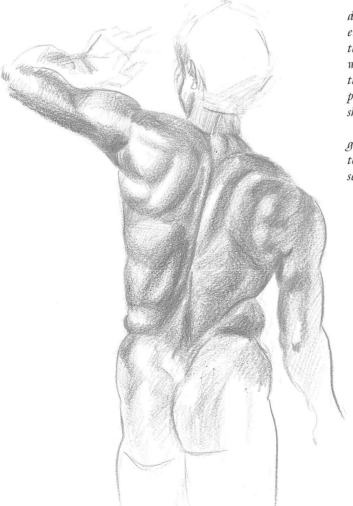

Anatomy in Art

The intense dedication of the great artists of all ages has made the nude into a type of formal model for all kinds of sculpture and architecture. The study of anatomy has been and continues to be the basis on which that model is constructed. The successive styles and eras have favored specific aspects of the prototype created in classical Greece, but they have never abandoned the solid foundation, common to all of them, that anatomy presents.

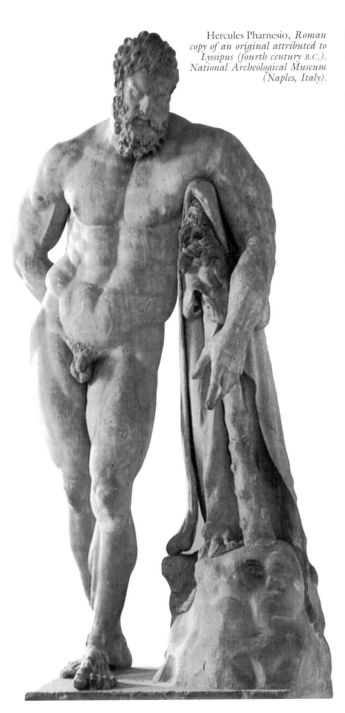

Hercules Pharnesio, *Roman copy of an original attributed to Lyssipus (fourth century B.C.). National Archeological Museum (Naples, Italy).*

THE ORIGIN OF ANATOMICAL STUDIES

The origin of anatomy as a science was in ancient Greece, but just when it first appeared is much more difficult to specify. It is possible that Hippocrates (the most famous doctor of antiquity) dissected some cadavers, but there is nothing that suggests a systematic knowledge of anatomy. What's more, in ancient Rome, medicine was more practical in nature. Surgeons were considered to be mere manual laborers, so dissections were never considered as a basis for knowledge of anatomy.

Regardless of whether the Greeks knew the configuration of the internal organs of the human body, they not only achieved perfect anatomical correctness but also established the anatomical ideal for European art. Most authors agree that it was possible to accomplish this independently of any scientific anatomical knowledge and that it was the product of a stylistic evolution that stretched from the archaic to the classical period and was combined with the observation of nature. Whatever the case, no artist trained in

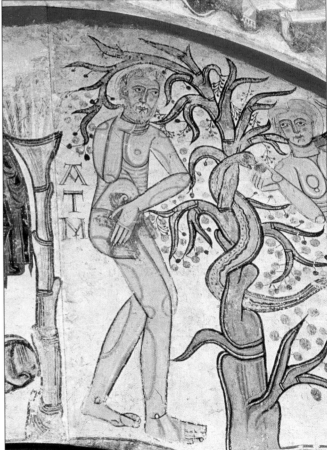

The Master of Maderuelo (twelfth century), The Creation of Adam and Original Sin. *The Prado (Madrid, Spain). In medieval art, representations of the human body are reduced to an interplay of ornamental shapes that suggest the musculature.*

anatomy during the centuries that followed has created a more faithful version of human anatomy than what we see in classical statuary.

THE MIDDLE AGES

After the second century of the Christian era, anatomy in art suffered a total lack of appreciation for almost twelve centuries. The church forbade the dissection of cadavers, and the rare depictions of nudes treated muscular relief as an interplay of ornamental shapes.

The human body was known by the nomenclature of its parts and its organs, generally without illustrations or according to a simplified and very approximate struc-tural scheme. In universities, lessons were limited to the dissection of pigs and monkeys, relying on the similarities between these animals and humans. Depictions of human figures were based on copies of other painted figures and on certain working formulas for proportions.

THE RENAISSANCE

The extraordinary emphasis placed on anatomy in Italy (specifically in Florence) during the fifteenth century was the product of passionate curiosity applied to the study of all kinds of things from classical antiquity. Florentine illustrators took an interest in

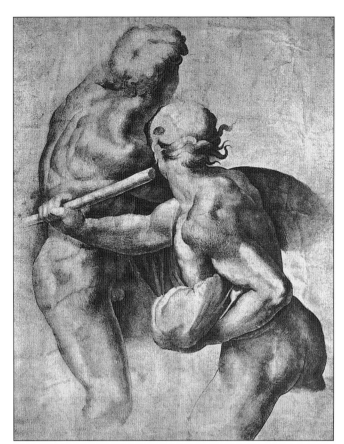

Michelangelo, Two Male Torsos Seen from the Rear. *Academy Gallery (Venice, Italy). Michelangelo turned muscular relief into a means of expression of the greatest magnitude by placing anatomy in the center of aesthetic interest for several generations of artists.*

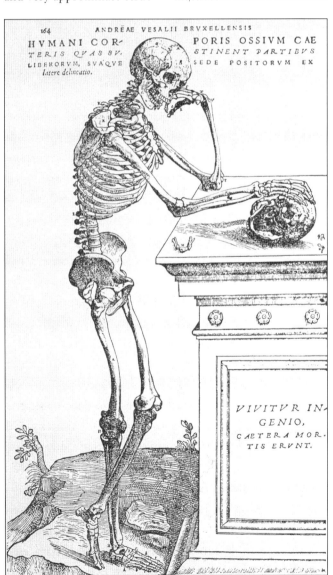

Andrea Vesalius, Engraving from the work Humani corporis fabrica. *The illustrations from the great anatomical treatise by Vesalius, in a wonderful Renaissance style, are the best demonstration of the intimate link that existed between art and anatomical science.*

the proportions of the human body, the precise topography of the muscles, and the means of creating expression and movement. They studied nudes, and eventually—first Pollaiuolo (1433–1495), then Leonardo (1452–1519), and finally Michelangelo (1475–1564)—used dissection to arrive at definitive preciseness. Consequently, at the end of the fifteenth century, many painters found satisfaction in displaying their recently acquired knowledge by illustrating figures with their bodies flayed ("sacks of nuts," as Leonardo called them). This practice was incorporated into the courses at art academies.

THE ANATOMY OF VESALIUS

The sixteenth century marks the beginning of a wide dissemination of methodical anatomical engravings with pretensions to accuracy. In 1543, the book *De humani corporis fabrica* by Andrea Vesalius (1514–1564), the most celebrated anatomist of the Renaissance, was published. This work openly criticized the ancient artists and proposed a systematic anatomy based on careful dissections. The engravings that illustrate Vesalius's book are artistically of the highest order, and they began a long tradition of anatomical illustrations.

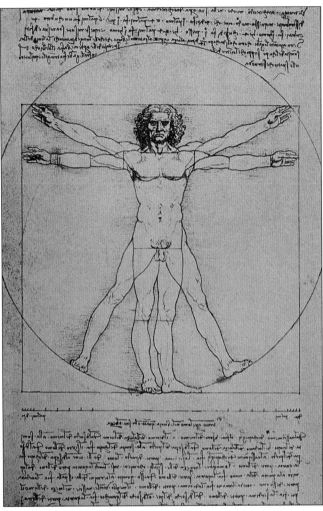

Leonardo da Vinci, Vitruvian Man. *Gallery of the Academy (Venice, Italy). The title of this famous illustration refers to Vitruvius, the great Roman writer of treatises on classical architecture. Leonardo, among many other artists of the Renaissance, tried to reconcile human proportions with the principles of harmony put forth by Vitruvius.*

development of medical science rendered obsolete the idealized anatomical images of the old treatises that were always accompanied by the accustomed frontispieces, inscriptions, and moralizing scenes. Ultimately, anatomical illustration was relegated to a purely didactic function, and it renounced its application as a model for artists. Medical and artistic anatomy took different directions. At that time, the first anatomy manuals for exclusive use by painters and sculptors appeared. They were limited to images of skeletons and flayed figures in "artistic" poses inspired by the statuary of antiquity. There were statues of flayed bodies in all the workshops and academies of the eighteenth century. The most famous statue was by Houdon; it was copied thousands of times by students in the nineteenth century.

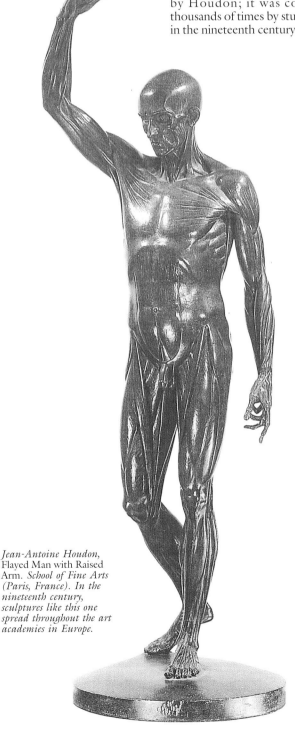

Jean-Antoine Houdon, Flayed Man with Raised Arm. *School of Fine Arts (Paris, France). In the nineteenth century, sculptures like this one spread throughout the art academies in Europe.*

ANATOMY AND PROPORTIONS

In parallel with anatomical investigation, Renaissance humanists and artists carried out a broad spectrum of inquiries focused on systems of proportions for the human body. An analysis of the relationships between length, width, and thickness among the different parts of the body produced all kinds of templates and precepts of construction that were difficult to apply but that gave an illusion of presenting the secrets of ideal beauty. One of the consequences that came from an effort to unite anatomical knowledge with an ideal of human proportions was mannequins constructed in various sections or blocks, which have been used in art academies ever since. The indisputable usefulness of these models shows that knowledge of anatomy is of no use to artists unless they also have a clear understanding of human proportions.

ART ACADEMIES

In the eighteenth century, academies for the fine arts were established throughout all of Europe. Most of them had a distinctly national character and were directed by the absolute monarchies of the corresponding countries. This was also the era of illustration and of rationalism. The rapid

ANATOMY IN OUR TIME

The crisis in academic art instruction, brought on by impressionism, removed anatomy from the privileged place it had occupied in art instruction ever since the Renaissance. Nowadays, the human figure is no longer the symbolic nucleus of artistic creation. The art of our time—ever changing and unpredictable—seems to leave little room for anatomy. Anatomy is truly an essential and indisputable discipline, as many people who are not familiar with modern art suppose. However, it is not something archaic and useless, as some artists believe. When we contemplate modern and contemporary works where the human figure is still central, we can see how anatomy is present implicitly or explicitly, how it is interpreted objectively or rearranged according to the artist's personal vision. To ignore that fact would be tantamount to denying the evidence that anatomy is inseparable from any type of representation of the human shape.

AN AESTHETIC WAGER

Today we can clearly see that anatomy, in the modern sense of the word, is more than a test of artistic correctness: it is an aesthetic wager based on the classical concept of beauty. This is the formula of anatomy in art: anatomical science vivified by the ideal of classical beauty. It is a wager that remains in force. Even today, the nude is still a way of affirming faith in ultimate perfection and in the beauty of the human form.

Mariano Amare, Academy Drawing. *University of Madrid (Spain). In the great art academies, the study of anatomy has traditionally been linked to representing the human figure according to classical proportions.*

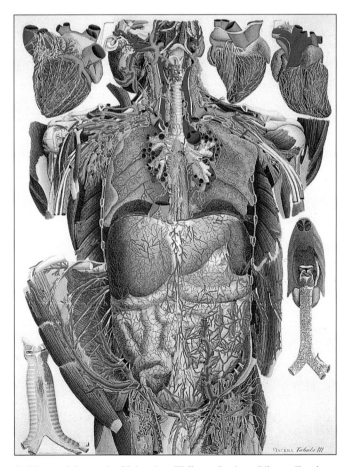

P. Mascagni, Anatomiae Universiae. *Wellcome Institute Library (London, England). Starting at the end of the eighteenth century, anatomical illustration clearly separated the artistic element from the medical aspect, and medical works like this one show great quality and graphic effect.*

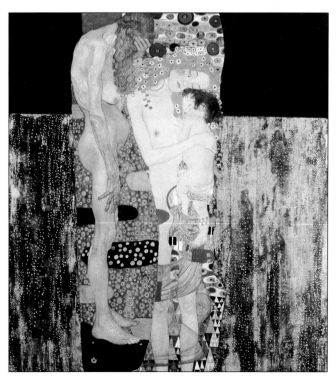

Gustave Klimt. The Three Ages of Woman. *National Gallery of Modern Art (Rome, Italy). A perfect knowledge of anatomy is concealed behind apparently arbitrary exaggerations in the representation of these bodies. In the hands of modern artists, anatomy is a tool for expression in the service of individual sensitivity.*

Fundamentals for the Artist

A knowledge of artistic anatomy deals with everything concerning the skeleton, the muscles, the proportions, and the movement of the human body. Every one of these considerations is a specialty in itself and could be studied separately in great detail. The purpose of this chapter, though, is to provide a global, integrated view encompassing all the relevant factors and an effective aid in producing artwork.

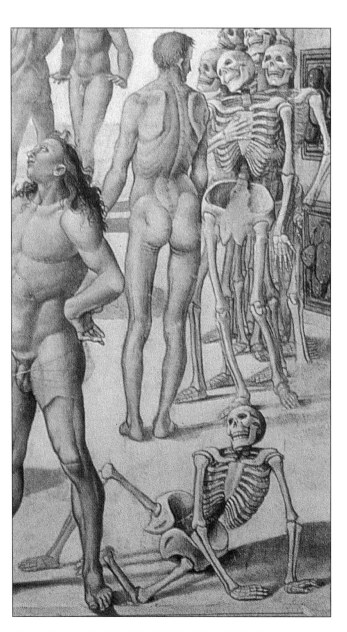

Luca Signorelli, detail from The Resurrection. *Cathedral of Orvieto (Italy). In this work, the artist interprets the shape of the skeleton according to his creative ideals and interests, based on a thorough knowledge of anatomy.*

THE SKELETON AND THE BONES

The skeleton is the jointed, bony structure that holds up the human body and supports and protects the internal organs. Nearly all of the 233 bones that comprise the human skeleton are jointed and act as levers that are moved by the muscles. Most of the bones are present in pairs arranged to the left and right of the body's line of symmetry. The bones that form an exception to this rule, such as the cranium and the vertebrae, are made up of two similar halves.

THE DISTRIBUTION OF THE BONES

The bones of the skeleton are distributed around the spinal column and are connected to it directly or indirectly. In its upper part, the spinal column supports the weight of the skull and the scapular belt (consisting of the two clavicles and the two shoulder blades), where the bones insert into the upper limbs. In the middle, the spinal column holds up the bony arches of the ribs (the thoracic cage). In the lower part, it rests on the pelvis and the lower limbs.

THE HARDNESS AND ELASTICITY OF THE BONES

First of all, the bones have to withstand the pressure exerted by the weight of the body. Second, they also have to resist the flexions caused by the muscles. Third, they have to be strong enough to resist the stress caused by such things as lifting heavy objects. The strength of the bones comes from both their rigidity and their elasticity (which is much greater in infancy than in adulthood). If they were only rigid, they would be fragile; and if they were too flexible, they would become distorted.

THE SHAPE OF THE BONES

Depending on their shape, the bones are divided into long ones, such as the humerus and the tibia, and flat, broad ones, such as the scapula and the pelvis. There are also short and irregular bones such as the vertebrae and the bones of the wrist and the ankle. Long bones usually serve as the axis of the limbs. They consist of a semicylindrical or prismatic part, known as the body or diaphysis, and of two enlarged extremities with surfaces that are adapted to articulation, each known as an epiphysis. Despite the names, some can be very short, such as the phalanges of the fingers.

The flat bones are plate shaped, with faces, edges, and angles. The shoulder blade is the most representative of this type of bone, which is also found in the head and the pelvis. These bones have protuberances and hollows. The prominent parts have such names as apophysis, protuberances, tuberosities, crests, spines, and so forth. The hollows are known as cavities, fossae, furrows, and other terms.

The short bones are more or less cube shaped, and they too have faces and edges. They are located in the midpart of the skeleton (vertebrae) and at the extremities of the limbs (bones of the tarsus and carpus). They are small in size and are found in clusters.

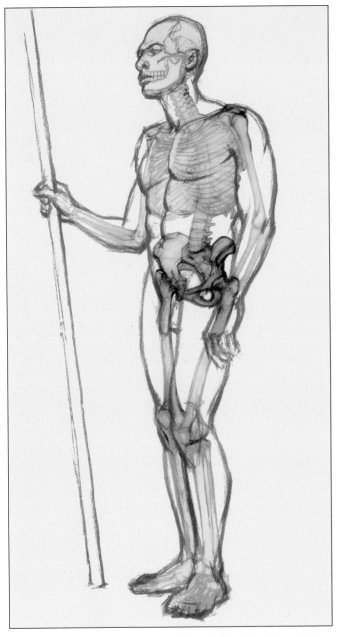

Frontal view of the skeleton. The skeleton is the solid framework that holds up the body. It is made up of a total of 233 bones arranged around the spinal column. Illustration by Carlant.

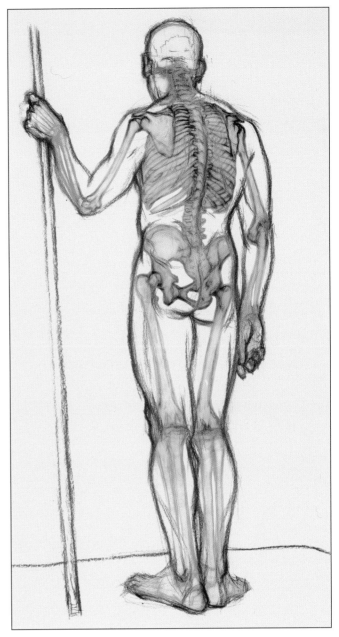

Dorsal view of the skeleton. Above all, a familiarity with the bones has a functional value for the artist since that is what makes it possible to understand the internal causes that determine the proportions and the movement of the figure. Illustration by Carlant.

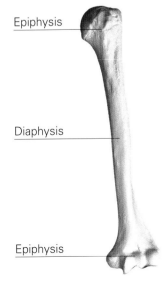

Epiphysis

Diaphysis

Epiphysis

To the left, the humerus bone with labels for the parts that correspond to every long bone: two epiphyses or ends (which abut other bones in the joints) and a diaphysis or central body. To the right, an illustration showing the base of the skull, the bony area that has the greatest number of processes. These include the epiphyses, spines, tuberosities, crests, and others and also hollow areas such as fossae, processes, canals, orifices, and so forth.

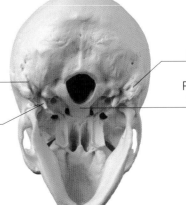

Mastoid process

Styloid apophysis

Mastoid apophysis

Pharyngeal tuberosity

A NATOMICAL TERMS FOR THE BONES

Here are some of the terms that pertain to the skeleton and that will reappear throughout this book.

ACROMION. The hook-shaped crest on the upper part of the shoulder blade, which is connected to the outer end of the clavicle.

APOPHYSIS. The protruding part of a bone used for muscle insertion or forming a joint with another bone.

CERVICAL. Pertaining to the cervix or the nape of the neck. The cervical vertebrae are located at the upper end of the spinal column.

CONDYLE. A barrel-shaped eminence at the end of a bone that fits into the recess of another bone to form a joint. The condyle of the humerus forms a joint with the ulna.

CORACOID. From the Latin *coracoideus*, meaning shaped like a crow's beak. The coracoid apophysis is part of the shoulder blade and is located near the joint of this bone with the humerus.

COSTAL. Pertaining to the ribs. The costal cartilage joins the ribs to the sternum.

CREST. An apophysis in the shape of a prominent edge. The iliac crest forms the upper and outer edge of the ilium (pelvis).

CUBOID. Bone in the shape of a cube. The cuboid is one of the bones of the carpus.

CUNEIFORM. A wedge-shaped bone. The cuneiform bones of the tarsus are also called cuneate bones.

DIAPHYSIS. The central part or body of a long bone.

DORSAL. Pertaining to the back. The dorsal vertebrae are located between the cervical and the lumbar vetebrae.

EDGE. The ridge of a long bone.

EPICONDYLE. An apophysis that projects over a condyle. The humerus has two epicondyles on its inner and outer faces.

EPIPHYSIS. The end of a long bone.

FACE. The flat surface of a bone.

FOSSA. A channel or cavity in a bone.

HOLLOW. A channel or shallow incision in a bone.

ILIAC. Pertaining to the ilium in the pelvis.

LUMBAR. Pertaining to the area where the kidneys are located. The lumbar vertebrae are at the lower end of the spine between the dorsal vertebrae and the sacrum.

MALLEOLUS. Literally, hammer shaped. The malleoli are processes located on the inner and outer faces of the ankle; they correspond to the lower epiphyses of the tibia and fibula.

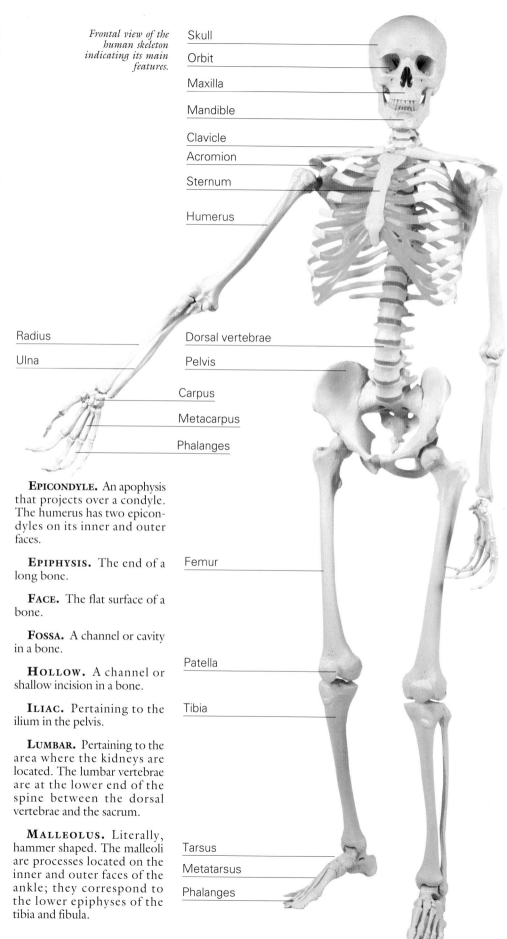

Frontal view of the human skeleton indicating its main features.

Skull, Orbit, Maxilla, Mandible, Clavicle, Acromion, Sternum, Humerus, Radius, Ulna, Dorsal vertebrae, Pelvis, Carpus, Metacarpus, Phalanges, Femur, Patella, Tibia, Tarsus, Metatarsus, Phalanges

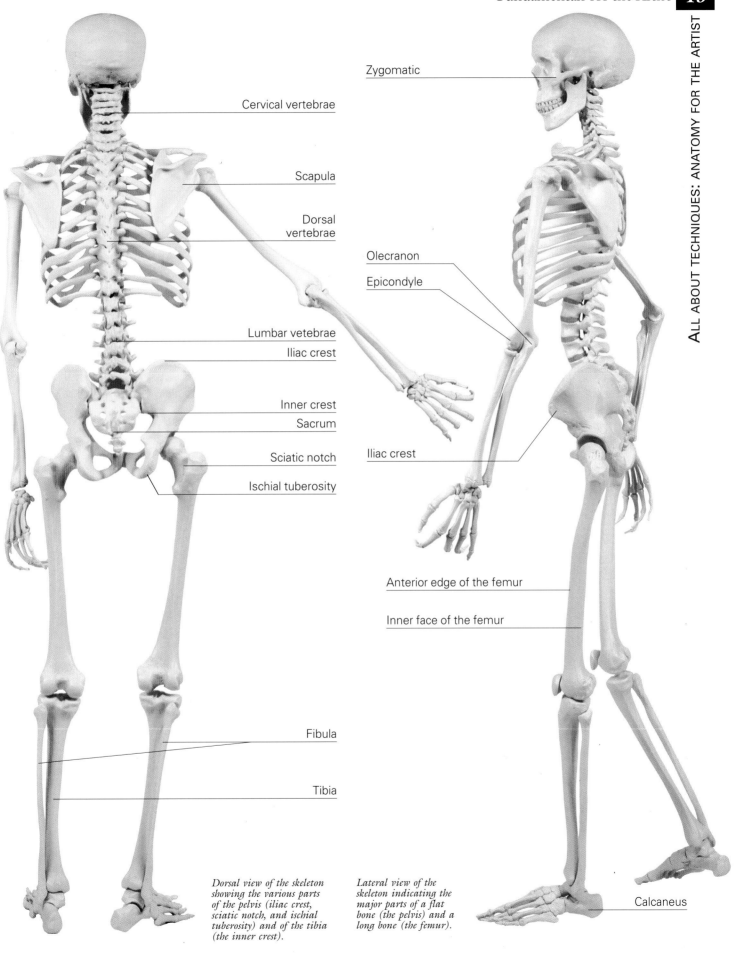

Zygomatic

Cervical vertebrae

Scapula

Dorsal
vertebrae

Olecranon

Epicondyle

Lumbar vetebrae

Iliac crest

Inner crest

Sacrum

Iliac crest

Sciatic notch

Ischial tuberosity

Anterior edge of the femur

Inner face of the femur

Fibula

Tibia

Calcaneus

*Dorsal view of the skeleton
showing the various parts
of the pelvis (iliac crest,
sciatic notch, and ischial
tuberosity) and of the tibia
(the inner crest).*

*Lateral view of the
skeleton indicating the
major parts of a flat
bone (the pelvis) and a
long bone (the femur).*

OLECRANON. Literally, a prolongation of the elbow. A process located at the rear face of the upper epiphysis of the ulna.

PISIFORM. Shaped like a pea (such as the pisiform bone of the tarsus).

RADIAL. Pertaining to the radius.

SCAPHOID. From the Latin *scaphoideus*, boat shaped (like the scaphoid bone of the tarsus).

SCAPULA. The shoulder blade.

SPINE. An apophysis in the shape of an angular edge (the iliac spine, the spine of the scapula).

TROCHLEA. The surface of a joint in the shape of a pulley. The trochlea of the humerus is located next to the condyle, and both surfaces form a joint with the ulna.

TUBEROSITY. A thick, bulky, bony eminence.

ZYGOMATIC. Pertaining to the cheek. The shape of the cheeks corresponds to the zygomatic bone.

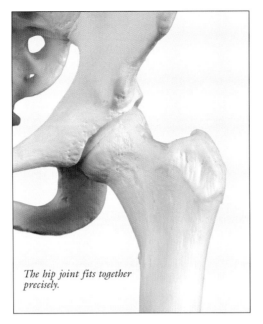

The hip joint fits together precisely.

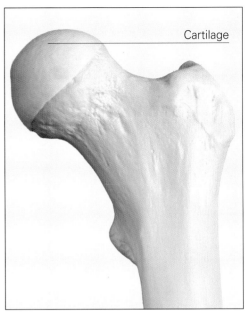

Cartilage

The joint surfaces are covered with a layer of tissue known as cartilage that reduces friction to a minimum.

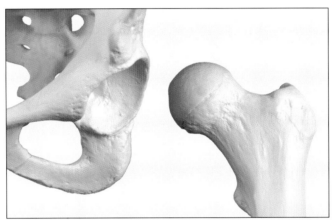

The pelvis has a deep hollow where the head of the femur inserts.

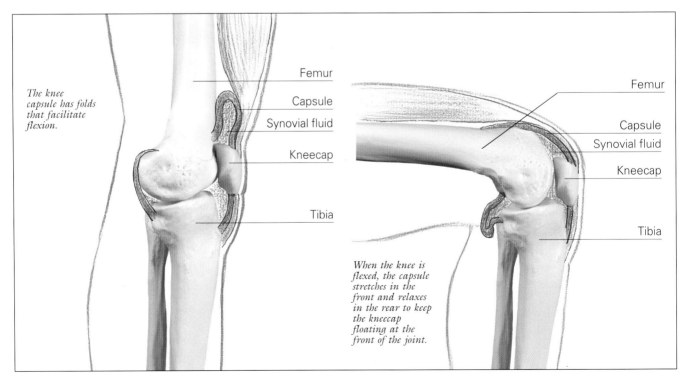

The knee capsule has folds that facilitate flexion.

Femur

Capsule

Synovial fluid

Kneecap

Tibia

Femur

Capsule

Synovial fluid

Kneecap

Tibia

When the knee is flexed, the capsule stretches in the front and relaxes in the rear to keep the kneecap floating at the front of the joint.

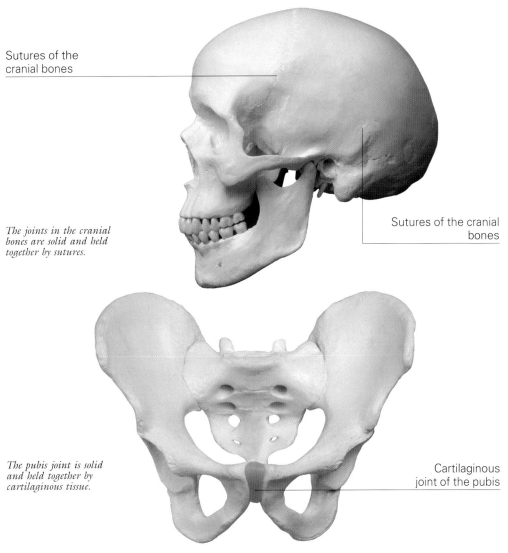

Sutures of the
cranial bones

*The joints in the cranial
bones are solid and held
together by sutures.*

Sutures of the cranial
bones

THE JOINTS

Bones join one another at joints that may be either fixed or movable. Fixed joints may be held together by sutures, as in the bones of the cranium, or by cartilaginous tissues, as in the pubis. In the movable joints, the bones meet at their extremities, and their union is reinforced by ligaments. The contact surfaces fit together with a concave shape on one bone and a convex shape on the other. With this type of joint, the mating between the surfaces can be quite complete and precise. Thus, the fit of the femur in the pelvis is much more precise than that of the humerus in the scapula.

CARTILAGE AND LIGAMENTS

Cartilage is made up of layers of flexible and elastic tissue that cover the joint surfaces, that is, the areas where the bones contact one another. Ligaments are bands of fibrous tissue that connect neighboring bones. They are not extendable, and their function is solely to hold the joints together.

The joint surfaces are surrounded by a capsule that completely encloses the joint and makes it a waterproof chamber. On the inside, this chamber is lined with synovial membranes that secrete synovial fluid for lubricating the bony surfaces and make sliding against one another easier.

*The pubis joint is solid
and held together by
cartilaginous tissue.*

Cartilaginous
joint of the pubis

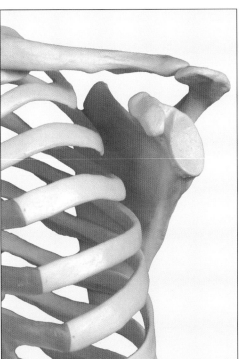

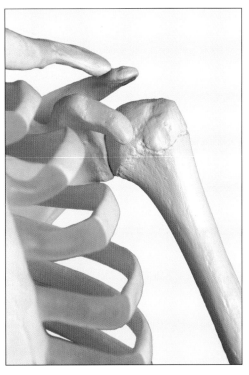

*The concave shape of the scapula's
joint area is designed to
accommodate the head of the
humerus.*

*The fit between the humerus and
the scapula is not very precise.*

THE MUSCLES

The muscles are fleshy masses made up of bundles of fibers that produce the movements of the body when they contract in response to a nervous stimulus. The number of muscles varies from between 460 to 501, depending on how they are counted by different anatomists; many muscles can be considered to form a single unit or an aggregate. They overlap one another and are arranged in layers or planes. The muscles of the internal organs and the motor muscles located in deep layers are not visible in relief on the outside of the body, which is the view of interest to artists. With the exception of the cutaneous muscles and the sphincters, a muscle is always joined to at least two separate bones.

ANATOMICAL TERMS FOR THE MUSCLES

Here are some of the terms that pertain to muscles and that are used in this book.

ABDUCTOR. A muscle that separates or moves a limb away from the axis of the body.

ADDUCTOR. A muscle that moves a limb closer to the body.

APONEUROSIS. A membrane in the shape of a band or belt, also known as a fascia. It consists of a membranous covering on the muscles.

BICEPS. This term refers to muscles that are made up of two parts or heads. The biceps brachii is the most robust muscle in the arm.

Frontal and dorsal views showing the locations of the muscles in a male figure. These illustrations are very detailed anatomical studies done in the Department of Fine Arts at the University of Barcelona. The illustrations contain many handwritten notes. Illustrations by Carlant.

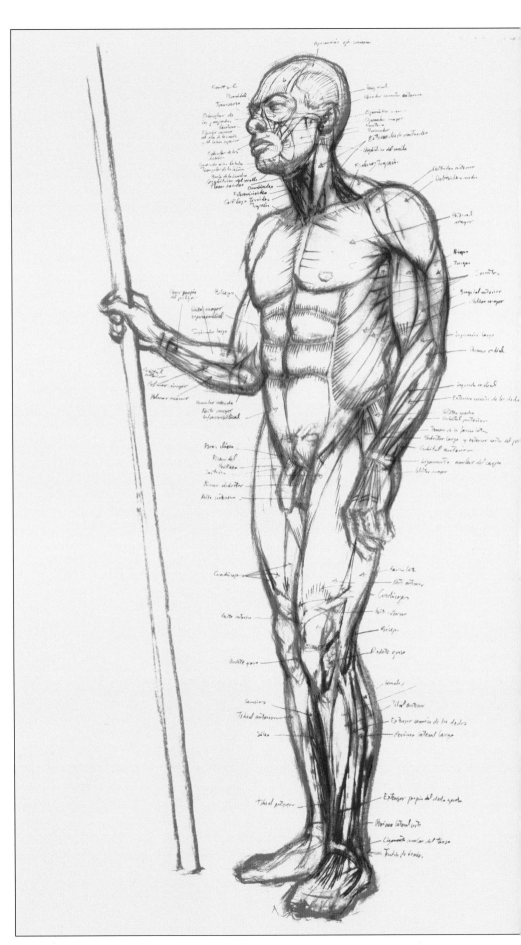

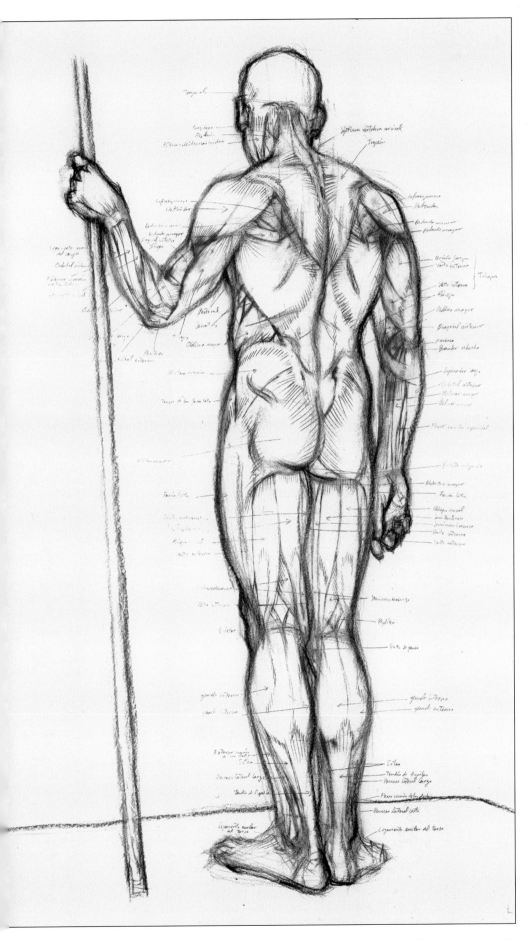

BRACHIAL. Pertaining to the upper arm. The brachial muscle originates at the anterior face of the humerus and inserts in the tuberosity of the ulna.

CORACOBRACHIAL. Pertaining to the arm and the coracoid apophysis. The coracobrachial muscle originates at the coracoid apophysis.

CUTANEOUS. Pertaining to the skin; a superficial muscle that inserts below the skin.

DELTOID. Shaped like a delta (triangular). The deltoid muscle surrounds the shoulder joint.

ELEVATOR. A muscle that lifts or elevates a limb or other anatomical part.

EMINENCE. A fleshy part that sticks out from the external relief of the body.

EXTENSOR. A muscle that extends a limb; the extensor muscle for the fingers is located in the outer face of the forearm.

FASCICLE. The diminutive of fascia. The small tendinous extremity of a muscle.

FEMORIS. Pertaining to the thigh. The biceps femoris is located on the posterior face of the thigh.

FLEXOR. A muscle that flexes or bends a limb. The flexor muscles of the fingers are located in the hand.

ILIOPSOAS. Pertaining to the lumbar region. The iliopsoas muscle is part of the muscles on the inner face of the thigh and originates at the inner face of the iliac bone, that is, in the lumbar area.

INSERTION. The place where a muscle is anchored, normally on a bony area.

LIGAMENT. A membranous tissue that joins two bones and that generally does not bend.

ORIGIN. The highest of a muscle's insertions.

POPLITEAL. Pertaining to the back of the knee. The popliteal hollow appears in the rear of the knee when the leg is bent.

PRONATOR. A muscle that moves the palm of the hand downward. The rounded pronator crosses the upper part of the anterior face of the forearm.

QUADRICEPS. The quadriceps femoris is located on the anterior face of the thigh and has four heads: rectus femoris, vastus lateralis, vastus intermedius, and vastus medialis.

SUPINATOR. A muscle that makes the palm of the hand turn upward. The supinator is located in a deep layer of the forearm muscles.

THENAR. From the Latin *thenar*, the palm of the hand. The thenar and hypothenar eminences are swellings on the palm of the hand (at the base of the thumb and the little finger, respectively).

TENSOR. A muscle that tenses or stretches. The tensor fasciae latae is located in the upper part of the outer face of the thigh.

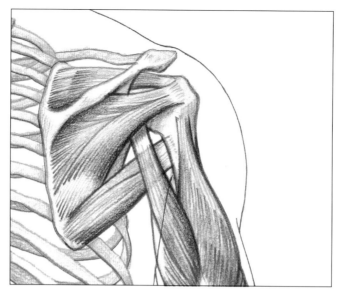

Short muscles are the ones that develop the greatest strength. The muscles of the shoulder blade have to support almost all the effort exerted by the arm.

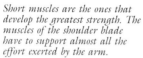

An example of a broad muscle: the transversus, which is located in a deep layer of the muscular sheath that surrounds the abdomen. It is shaped like a sheet and makes contracting the waist possible.

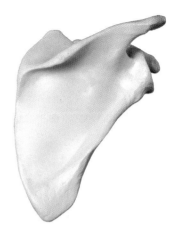

The irregular shape of some bones allows for the insertion of many muscles. The shoulder blade or scapula is a bone that has many areas for the attachment of the short muscles that cover it on its anterior and posterior faces.

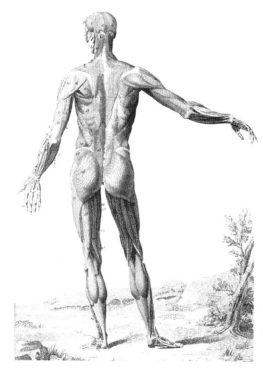

Rear view of a flayed figure; illustration from the Encyclopédie *by Diderot and d'Alembert.*

MUSCLE MECHANICS

The mechanics of muscle movement are governed by laws identical to those that control the movement of a lever. The muscle exerts a force to overcome resistance (the weight to be moved), and the joint serves as a fulcrum for the system.

Except for the cutaneous muscles, every muscle movement is usually complemented by the action of another muscle group referred to as antagonists.

MUSCLE SHAPE

Muscles are divided into long muscles (in the extremities), broad muscles (which impart movement to the trunk), short muscles (capable of developing greater strength), and annular muscles (which surround the body's orifices). The names they are given may allude to their shape (trapezius, rectus, serratus), to the number of their parts or heads (quadriceps, biceps), to the area where they are located (pectorals, abdominals, gluteals), or to their makeup (semitendinosus, semimembranosus).

In general, the names of the muscles are related to their shape, their location, and their function. For example, the muscles called oblique, pyramidal, and rectus owe their names to their characteristic shape. The labels pectoral, dorsal, and sacrospinal come from the muscles' location. The muscles such as the pronators, supinators, and flexors get their names from their function.

When they are called into play, the muscles contract and bunch up. They also become more prominent and move closer to their insertion points in the joints.

TENDONS AND APONEUROSES

At their ends, muscles become elongated with cords known as tendons, which insert into the bones and are visible beneath the skin during muscle contractions. In addition, the same muscles are covered by fibrous membranes known as an aponeurosis or fascia, which keeps the muscle fibers together. Often these aponeuroses form broad, whitish partitions that cover muscle groups and give shape to the outside of the body.

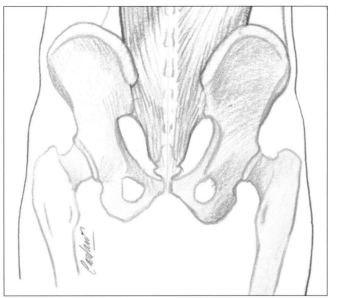

The aponeuroses are tendinous areas that can form large partitions into which many muscles may insert. The illustration shows the lumbar aponeurosis.

Tendons

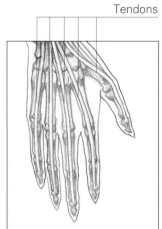

Many forearm muscles are lengthened by tendons that insert into the hand bones. During muscle contractions, these tendons are clearly visible beneath the skin on the back of the hand.

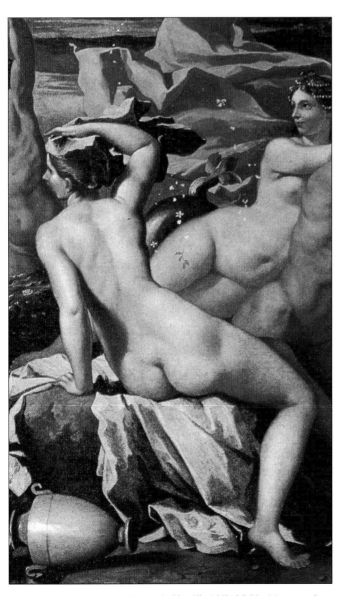

Nicolas Poussin, Neptune's Triumph *(detail). Philadelphia Museum of Art (Philadelphia, PA).*

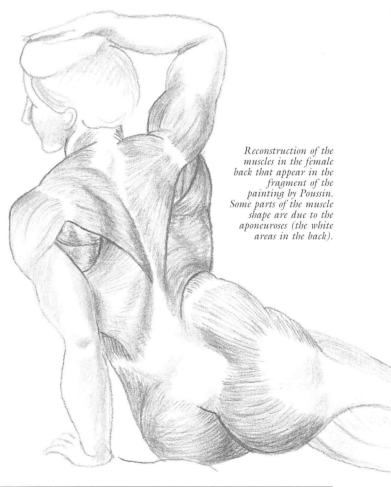

Reconstruction of the muscles in the female back that appear in the fragment of the painting by Poussin. Some parts of the muscle shape are due to the aponeuroses (the white areas in the back).

HUMAN PROPORTIONS

For any shape in nature, it is possible to come up with various systems of proportions depending on the basic features of the shape (height, width, or the dimensions of one of its parts). This also applies to the human figure. The proportions of the figures in Oriental art or the sculptures of the African tribes are clearly different from those of a Greek sculpture. Western culture's roots are in classical antiquity, and that is the source of its sense of proportion. According to this concept, the relationship of the head to the body determines the pattern by which all the other proportions are judged. A system or canon of proportions establishes a relationship between the height and the width of the body and the dimensions of the head. The idealized classical canon dictates a height of eight heads. However, the following canon is a bit closer to reality: seven and a half heads for adult figures and between four and six for children and adolescents.

Among the many possible patterns, this is one of the most useful ones in creating well-proportioned drawings of figures without exaggerated stylizing. In this book, artistic anatomy is adapted to this system or general framework of relationships among the parts of the human body.

RELATIONSHIPS AMONG THE DIMENSIONS OF THE BODY

The proportional harmony of a figure of seven and a half heads affects all the dimensions of the body. Ideally, the total height of a figure can be precisely determined using a circle centered on the pubis, and the two resulting halves are inscribed in other circles centered on the sternum and at the level of the kneecap, respectively. The total height is equal to the total width of the figure with the arms held straight out to the sides. The center of this width is likewise located at the sternum, and the quarters are centered at the elbow joints.

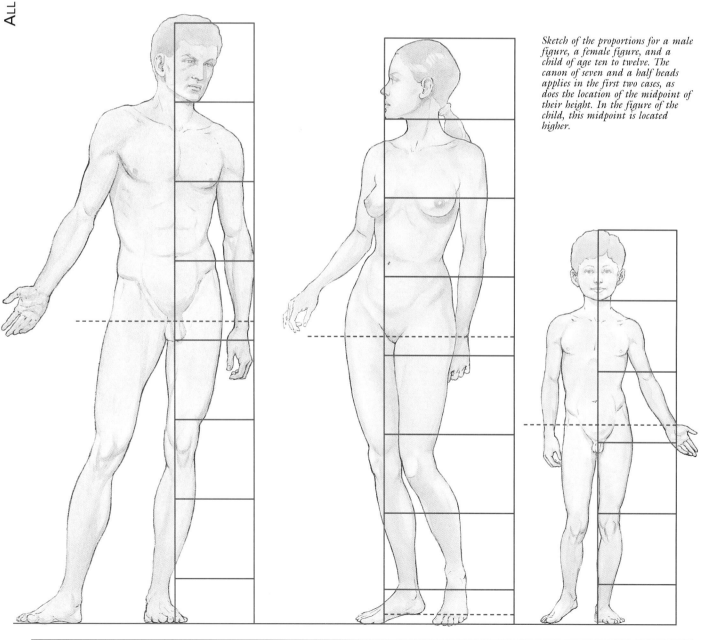

Sketch of the proportions for a male figure, a female figure, and a child of age ten to twelve. The canon of seven and a half heads applies in the first two cases, as does the location of the midpoint of their height. In the figure of the child, this midpoint is located higher.

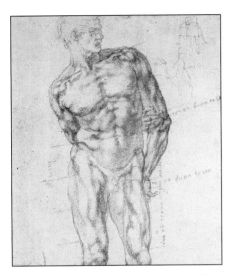

Michelangelo. Male Nude with Indications of Proportions. *Royal Library, Windsor Castle (Windsor, England). Every system of proportions is an idealization, and the idealizations of Michelangelo are famous for their emphasis on the monumental aspect of anatomy.*

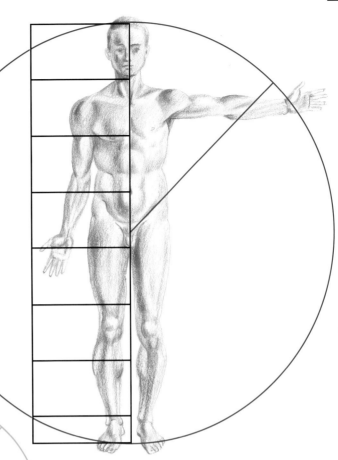

The ideal center of a figure of seven and a half heads is located at the height of the pubis, so the entire figure can be enclosed in a circle centered at that point.

The two halves of the figure—upper and lower— are centered on the sternum and between the knees, respectively. The distance that separates the fork of the sternum from the ends of the fingers when the arms are held out to the sides is equivalent to one-half the body.

OTHER SYSTEMS OF PROPORTIONS

During the Renaissance, the passion for discovering the "secrets" of the art and thought of the ancients led many artists to come up with various systems of proportions that were thought to reveal the key to beauty in the arts. Albrecht Dürer expended great effort in searching for the geometric rule of human proportions. Other investigators of the era proposed clever models of varying complexity and harmony. Some were as stylized as the canon of ten heads, as the adjacent illustration shows.

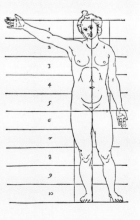

BODY MOVEMENTS

To facilitate describing all the anatomical features, explaining their location is also necessary. For that purpose, the body is divided into three imaginary planes: the frontal plane, the sagittal plane, and the transverse plane.

The frontal plane divides the body into anterior and posterior planes, making it possible to distinguish between dorsal or posterior areas (close to the back) and anterior or ventral areas (near the chest and abdomen). The sagittal plane divides the body into left and right halves and makes it possible to speak of medial areas (near the median plane) and lateral areas (further from it). Finally, the transverse plane divides the body into upper and lower halves.

MOVEMENTS WITHIN THE FRONTAL PLANE

Movements within the frontal plane are always from left to right or vice versa. Most of the time, though, this distinction is confusing, so different nomenclature is used. When the movement of one limb moves toward the body's median line, we speak of adduction; and if the limb moves further from the median line, the movement is called abduction. With respect to the trunk and the neck, movements in the frontal plane are called lateral inclinations. Adduction and abduction of the fingers are established with reference to the median line of the hand (along the middle finger), not the body.

Movement planes of a figure: in red, the frontal plane; in blue, the sagittal plane; and in green, the transverse plane.

MOVEMENTS WITHIN THE SAGITTAL PLANE

Movements within the sagittal plane are visible from the side, and they move the limbs forward and back. When a movement within the sagittal plane moves a limb forward, it involves flexion. When the movement is toward the rear, this involves extension. Special terms are used only with the shoulders (antepulsion and retropulsion).

MOVEMENTS WITHIN THE TRANSVERSE PLANE

Movements within the transverse plane are rotations. In the case of the hips and the shoulders, these rotations are referred to as external if the limb rotates toward the outside of the body's medial line; they are called internal if the movement is toward the inside. Rotations of the trunk can be toward the right or the left. Rotation in the forearm is called pronation (downward) and supination (upward).

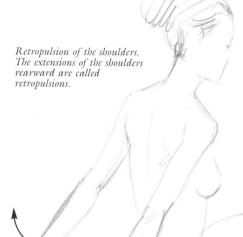

Retropulsion of the shoulders. The extensions of the shoulders rearward are called retropulsions.

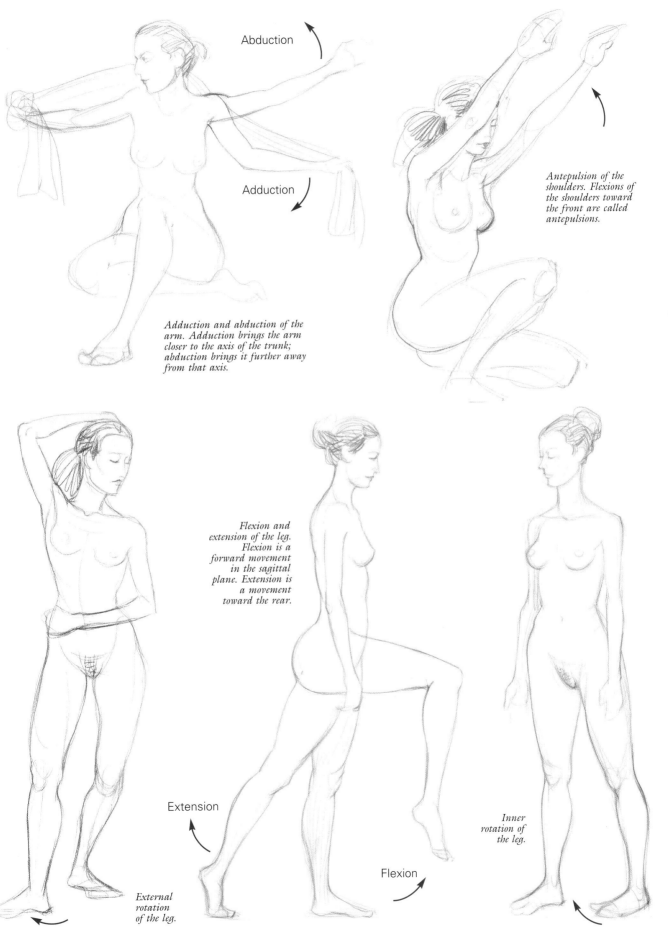

Abduction

Adduction

Adduction and abduction of the arm. Adduction brings the arm closer to the axis of the trunk; abduction brings it further away from that axis.

Antepulsion of the shoulders. Flexions of the shoulders toward the front are called antepulsions.

Flexion and extension of the leg. Flexion is a forward movement in the sagittal plane. Extension is a movement toward the rear.

Extension

Flexion

External rotation of the leg.

Inner rotation of the leg.

The Torso

The torso or trunk is the central part of the body. It can bend in the shape of a curve but cannot make angular movements. Almost all movement in the torso originates in the spinal column. The bones of the torso are the ones that make up the thoracic cage, the clavicles, the shoulder blades or scapulae, the spinal column, and the pelvis. The shape of some of these bones (the thoracic cage and pelvis) serve to support and protect vital organs, such as the lungs, the heart, the liver, and others. The muscles of the torso go through various joints (that is, they are polyarticular), and they are commonly arranged in large, superimposed layers. Most of the muscles of the torso are located in the back. They are normally large and powerful since their function is to maintain the erect position of the body and impart movement to the joints in the limbs.

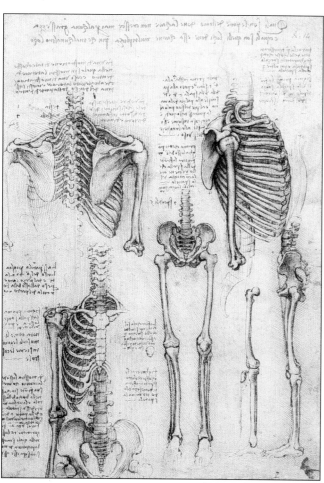

Leonardo da Vinci,
Study of the Torso.
*Royal Library,
Windsor Castle
(Windsor,
England).*

THE THORACIC CAGE

The thoracic cage is made up of pairs of ribs aligned on both sides of the sternum. Each of these pairs is connected to one or two vertebrae. The upper ten pairs are jointed to the front part of the sternum by flexible cartilage.

Side view showing the bones of the torso. The curvature of the spinal column and the angle of the ribs, which form a shape like a barrel, are visible. The joint surface of the shoulder blade (the area in which it joins the humerus) looks like a flattened protuberance at the upper end of this bone. The joint surface of the pelvis (the area where it joins the femur) looks like a hollow excavated in the lower part of this bone.

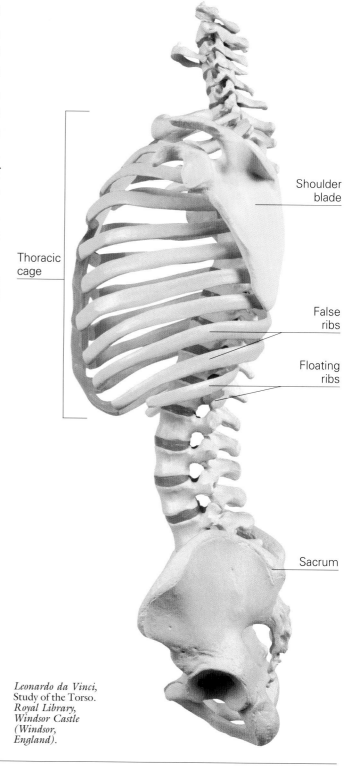

Shoulder blade

Thoracic cage

False ribs

Floating ribs

Sacrum

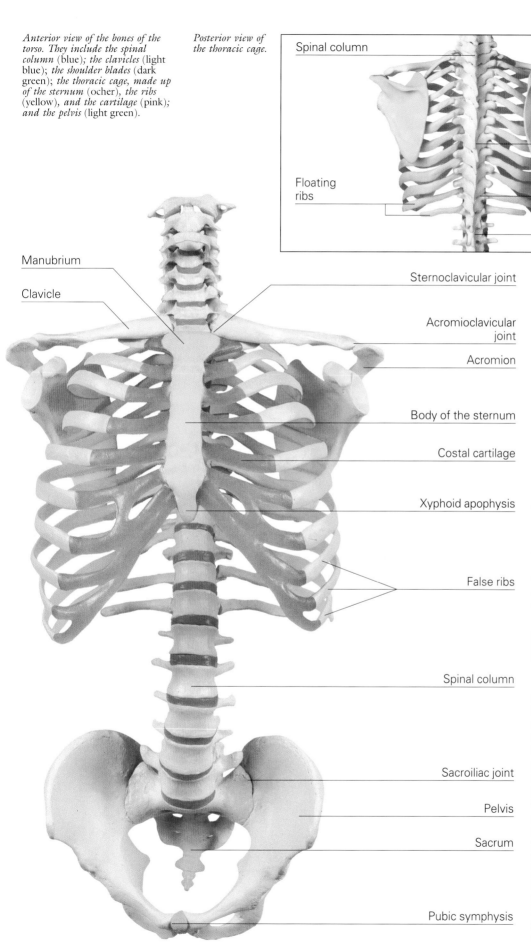

Anterior view of the bones of the torso. They include the spinal column (blue); *the clavicles* (light blue); *the shoulder blades* (dark green); *the thoracic cage, made up of the sternum* (ocher), *the ribs* (yellow), *and the cartilage* (pink); *and the pelvis* (light green).

Posterior view of the thoracic cage.

Spinal column

Acromioclavicular joint

Spinal column

Floating ribs

Rib joint on spinal column

Lumbar vertebrae

Manubrium

Clavicle

Sternoclavicular joint

Acromioclavicular joint

Acromion

Body of the sternum

Costal cartilage

Xyphoid apophysis

False ribs

Spinal column

Sacroiliac joint

Pelvis

Sacrum

Pubic symphysis

THE STERNUM

The sternum is divided into three parts: the manubrium, the body, and the xyphoid apophysis. The manubrium is located in the top part of the sternum, which is the sturdiest part. That is where the clavicles join it and create the characteristic hollow visible on the surface: the fork of the sternum. The joint between the manubrium and the body of the sternum facilitates the movement in the sternum when we breathe. The xyphoid apophysis is a bony appendage that is not present in everyone's body.

The upper ten pairs of ribs and the pectoralis major muscles insert into the sternum.

THE RIBS

The twelve pairs of ribs that make up the thoracic cage form joints with the spinal column in the rear. At their forward extremities, the upper ten pairs have a cartilaginous part that links them to the sternum. The upper seven pairs of ribs, which are known as the true ribs, join the sternum directly with their own cartilage. The next three pairs join the sternum by means of the seventh cartilage. These are the false ribs, and they constitute the most mobile part of the rib cage. Finally, the last two ribs have no cartilage, and they are called the floating ribs.

PARTS OF THE TORSO

The outer shape of the torso offers may reference points to both bones and muscles, which facilitate envisioning the location of the muscles and bones. In people with a normal build, the shapes of the clavicles and the scapulae stand out, along with certain vertebrae, the sternum, the abdominal muscles, the iliac crests, and other anatomical features.

The shape of the torso as seen from the front is determined by the cartilage of the ribs and the epigastric hollow that are defined below the sternum. Other important reference points are the shape of the clavicles and the fork of the sternum.

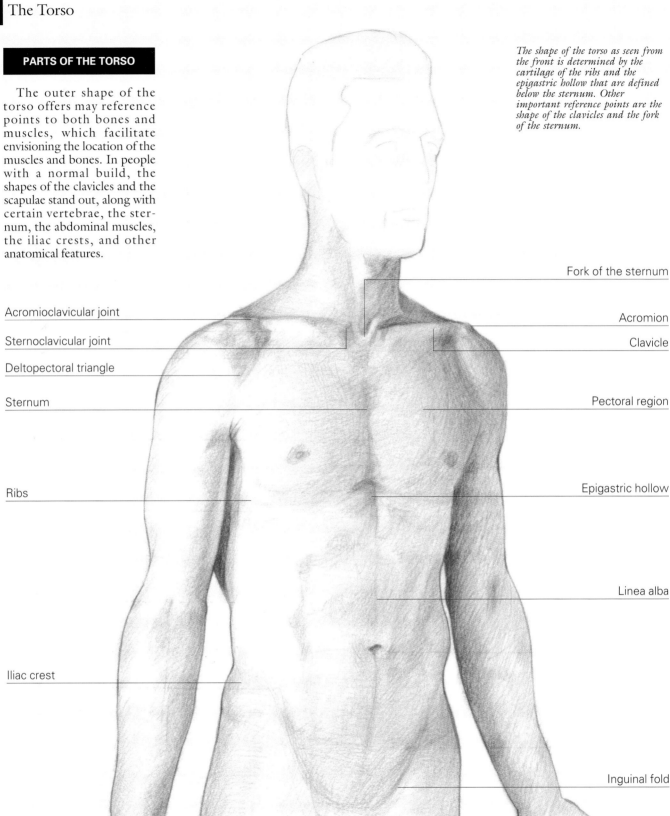

Acromioclavicular joint

Sternoclavicular joint

Deltopectoral triangle

Sternum

Ribs

Iliac crest

Fork of the sternum

Acromion

Clavicle

Pectoral region

Epigastric hollow

Linea alba

Inguinal fold

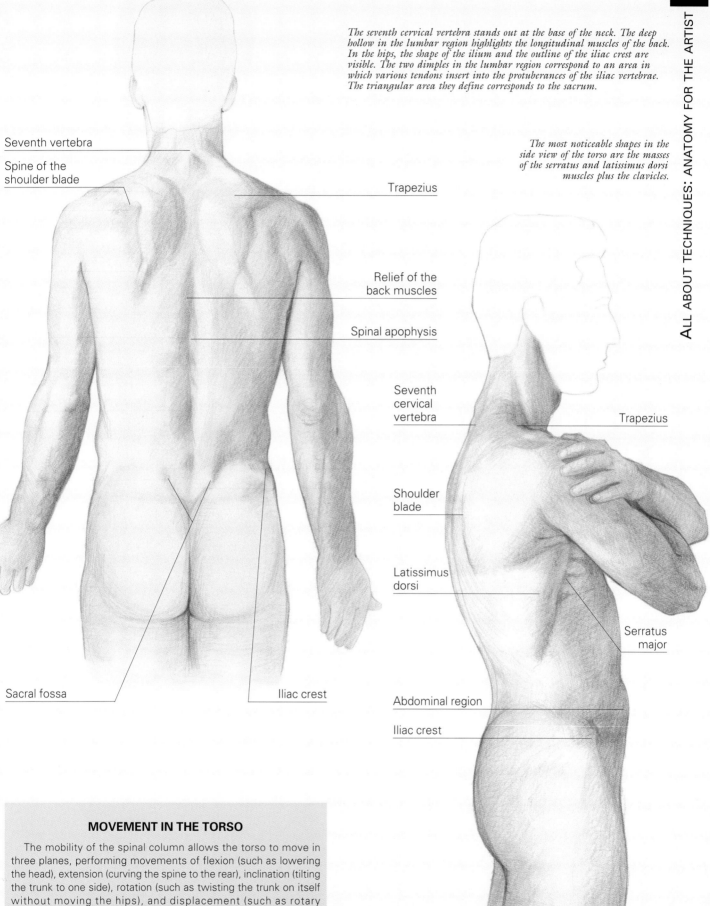

The seventh cervical vertebra stands out at the base of the neck. The deep hollow in the lumbar region highlights the longitudinal muscles of the back. In the hips, the shape of the ilium and the outline of the iliac crest are visible. The two dimples in the lumbar region correspond to an area in which various tendons insert into the protuberances of the iliac vertebrae. The triangular area they define corresponds to the sacrum.

The most noticeable shapes in the side view of the torso are the masses of the serratus and latissimus dorsi muscles plus the clavicles.

Seventh vertebra

Spine of the shoulder blade

Trapezius

Relief of the back muscles

Spinal apophysis

Seventh cervical vertebra

Trapezius

Shoulder blade

Latissimus dorsi

Serratus major

Abdominal region

Iliac crest

Sacral fossa

Iliac crest

MOVEMENT IN THE TORSO

The mobility of the spinal column allows the torso to move in three planes, performing movements of flexion (such as lowering the head), extension (curving the spine to the rear), inclination (tilting the trunk to one side), rotation (such as twisting the trunk on itself without moving the hips), and displacement (such as rotary movements in the neck or waist).

THE SPINAL COLUMN

The spinal column is a movable, bony structure made up of twenty-four separate vertebrae distributed in three regions: seven cervical vertebrae, twelve dorsal vertebrae, and five lumbar vertebrae, as well as the sacral bone and the coccyx. Altogether, the verte-brae make up a series of curves that give the back its charac-teristic undulation (known as lordosis when it is concave and kyphosis when it is convex). This undulation may appear more or less pronounced depending on the shape of the soft parts of the back and hips since the arch of the spinal column is nearly always the same in different individuals.

THE VERTEBRAE

All the vertebrae are weight bearing, so their size increases toward the fifth lumbar vertebra. The arrangement of the vertebrae facilitates rota-tion and rocking movements, which are greater in the cervical and lumbar areas than in the dorsal.

The vertebrae are bony parts of very irregular shape. The inner part, which carries the weight, is cylindrical. In the rear, though, they look like a bony arch that encloses the spinal cord. There are three horizontal and four vertical apophyses that project around this arch; they permit multiple muscle insertions.

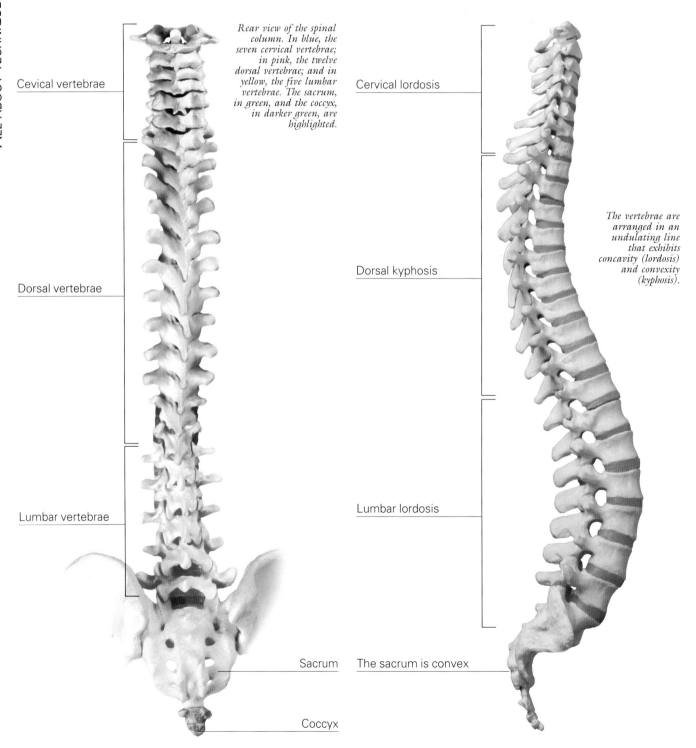

Cevical vertebrae

Rear view of the spinal column. In blue, the seven cervical vertebrae; in pink, the twelve dorsal vertebrae; and in yellow, the five lumbar vertebrae. The sacrum, in green, and the coccyx, in darker green, are highlighted.

Dorsal vertebrae

Lumbar vertebrae

Sacrum

Coccyx

Cervical lordosis

Dorsal kyphosis

Lumbar lordosis

The vertebrae are arranged in an undulating line that exhibits concavity (lordosis) and convexity (kyphosis).

The sacrum is convex

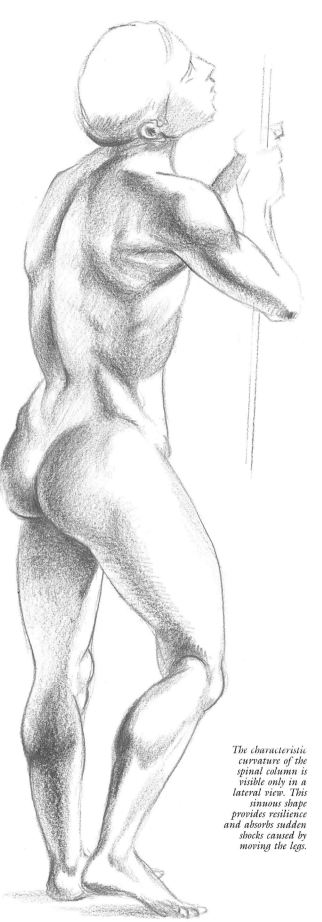

The characteristic curvature of the spinal column is visible only in a lateral view. This sinuous shape provides resilience and absorbs sudden shocks caused by moving the legs.

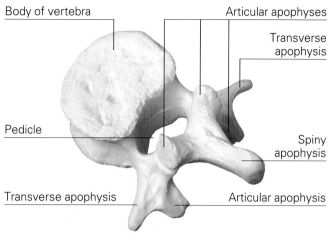

Body of vertebra

Articular apophyses

Transverse apophysis

Pedicle

Spiny apophysis

Transverse apophysis

Articular apophysis

View of a dorsal vertebra from underneath.

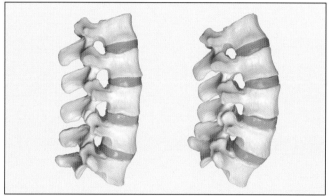

The vertebrae are separated by fibrous, flexible, and elastic disks known as vertebral disks; they allow inclination movements in the spinal column. The vertebrae have joints among them through the articular apophyses.
The spiny apophyses of the vertebrae contact one another and prohibit flexion of the spinal column rearward beyond a certain point. The illustration on the right shows the maximum flexion of a set of lumbar vertebrae.

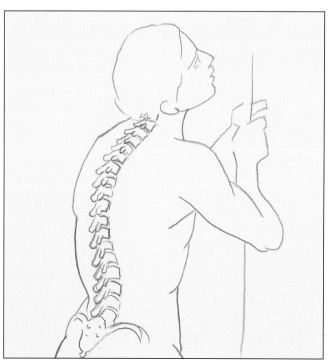

DRAWING THE SPINAL COLUMN

The spinal column is one of the basic references used in drawing the human figure. Its undulation determines the movement of the entire torso and determines the movements in the extremities. The artist must consider the curves that result with every posture and completely avoid straight lines, even in the most static poses. This chapter will show various examples of positions and movements in the spinal column that correspond to other postures in the figure.

When the shoulders are lowered and the figure is totally relaxed, the curve of the spine is barely visible.

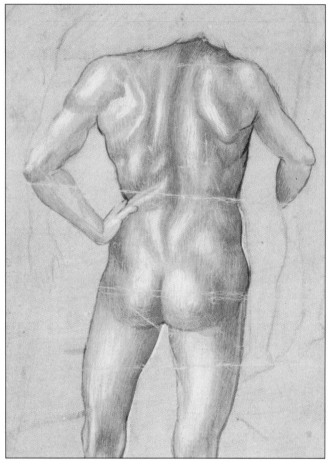

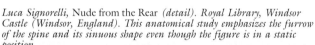

Luca Signorelli, Nude from the Rear *(detail). Royal Library, Windsor Castle (Windsor, England). This anatomical study emphasizes the furrow of the spine and its sinuous shape even though the figure is in a static position.*

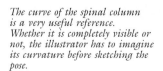

The curve of the spinal column is a very useful reference. Whether it is completely visible or not, the illustrator has to imagine its curvature before sketching the pose.

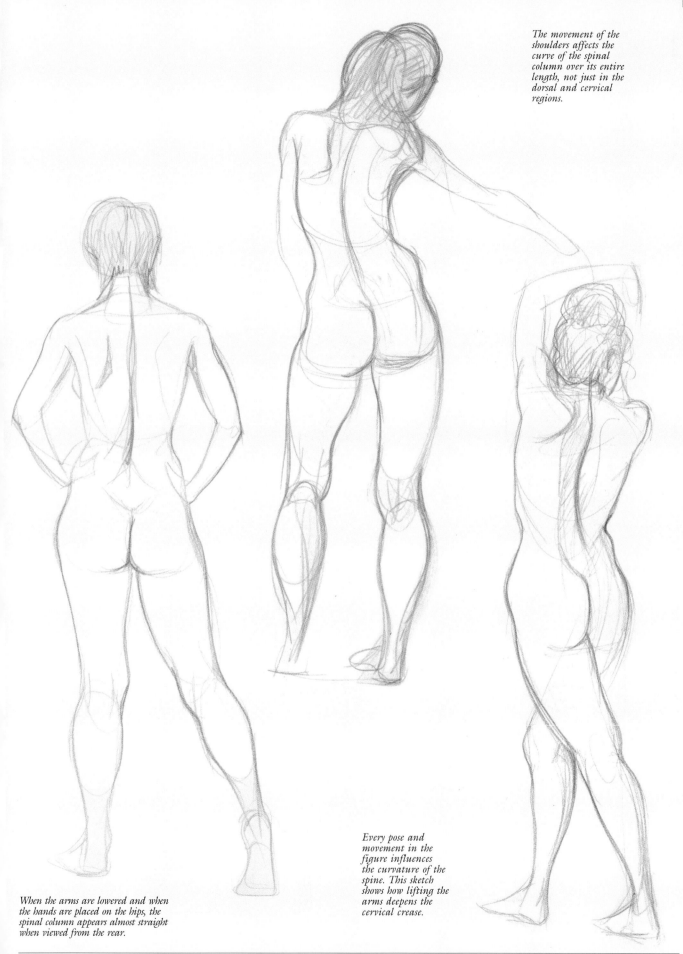

The movement of the shoulders affects the curve of the spinal column over its entire length, not just in the dorsal and cervical regions.

When the arms are lowered and when the hands are placed on the hips, the spinal column appears almost straight when viewed from the rear.

Every pose and movement in the figure influences the curvature of the spine. This sketch shows how lifting the arms deepens the cervical crease.

THE MUSCLES OF THE THORAX

The muscles of the anterior thoracic region are called the pectoral muscles. We will now take a look at the two most important ones: the pectoralis major and the serratus. Both are muscle pairs (they are located symmetrically on both sides of the body's centerline),

and the former partially cover the latter. Therefore, the illustration shows just one pectoral and one serratus.

PECTORALIS MAJOR

The pectoralis major is a broad, fan-shaped muscle that originates at the clavicle and

the head of the humerus. It inserts along the sternum, into the cartilage of the first six ribs. The muscle inserts into the humerus by means of a broad, flattened tendon that curves back on itself. The pectoralis major is used for adduction of the arm (when the arm is held out to the side, the muscle brings it in toward the midline of the body) and for rotating

the arm inward. When the arm is raised, the pectoralis major forms the inner wall of the axial hollow.

SERRATUS ANTERIOR

The serratus is a broad band of muscle that runs along the side of the thoracic cage. It originates on the inner face of the shoulder blade, and it divides into bundles or fingers that insert around the first ten ribs. The muscle moves the shoulder blade forward and keeps it in place on the thorax. This muscle is responsible for pushing and striking movements with the fist. The ends of its last four or five fingers are clearly visible under the skin of a well-muscled figure.

The illustration shows the location and the insertions of the pectoralis major (right) *and the serratus anterior* (left).

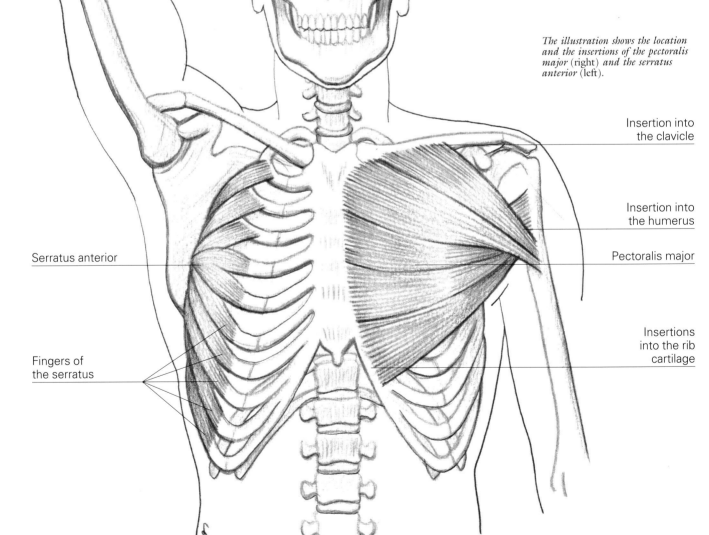

Serratus anterior

Fingers of the serratus

Insertion into the clavicle

Insertion into the humerus

Pectoralis major

Insertions into the rib cartilage

THE ABDOMINAL MUSCLES

The abdominal muscles are not located only in the front of the abdomen; they go up to the ribs and as far as the vertebrae in back. The most important ones are the rectus abdominis, the external oblique, the internal oblique, and the transverse. Of all of them, only the external oblique and rectus abdominis are situated in surface layers. In other words, only these two have a direct effect on how the shape of the abdomen is drawn. Except for the pyramidalis muscle and the rectus abdominis, all the other muscles of the abdomen insert into the back at the level of the kidneys, either in the lumbar vertebrae or in the lumbar aponeurosis (which will be studied in the pages devoted to the back muscles).

EXTERNAL OBLIQUE

This muscle is a sheet of muscle that wraps around the sides of the abdomen and produces the characteristic bulges seen over the hips in figures from classical art. The external oblique inserts in the last seven ribs and the iliac crest, and its fibers angle directly toward the lumbar aponeurosis. The external oblique is responsible for twisting the torso and compensating on one side of the trunk for the force exerted by the arm on the opposite side (for example, by lifting a weight).

PYRAMIDALIS

This is a small muscle located in the pubic area and is covered by the fatty tissue. It is of no consequence to the external shape of the abdomen.

This illustration shows the most superficial muscles of the abdomen, the rectus abdominis and the external oblique.

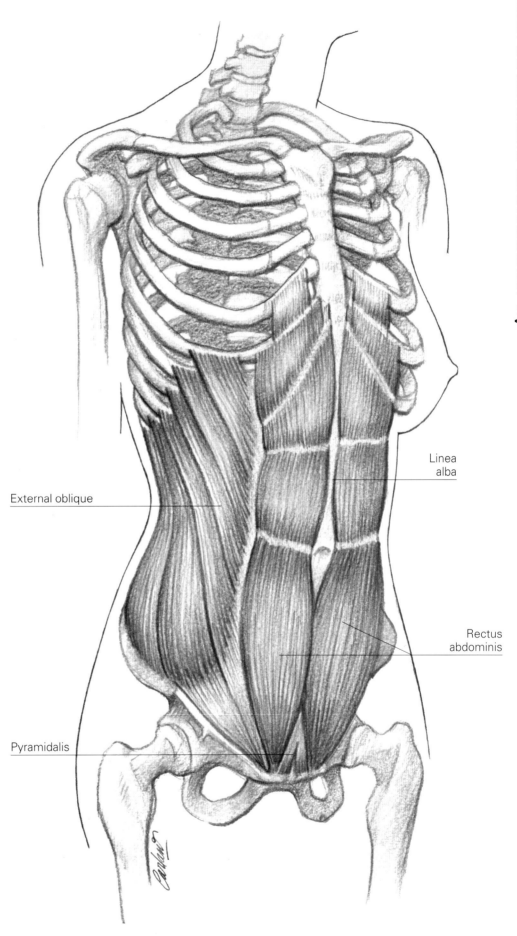

Linea alba

External oblique

Rectus abdominis

Pyramidalis

INTERNAL OBLIQUE

The internal oblique originates in the pelvis and the lumbar aponeurosis, and its fibers insert in the last four ribs and the abdominal aponeurosis. It is almost completely hidden by the external oblique. If it is activated on just one side of the body, it inclines and rotates the torso. If it is activated on both sides, it bends the trunk forward.

TRANSVERSE

The transverse is the deepest of the abdominal muscles and is completely covered by other muscles. It is a muscular belt that wraps around the waist from the lumbar vertebrae to the sides of the stomach.

When it contracts, the transverse reduces the diameter of the waist and pulls in the abdomen.

RECTUS ABDOMINIS

This is the abdominal muscle closest to the surface and gives people with an athletic physique a special appearance. At the top, it originates at the fifth, sixth, and seventh ribs, and at the lower part of the sternum, it inserts into the pubis. It serves to flex the torso.

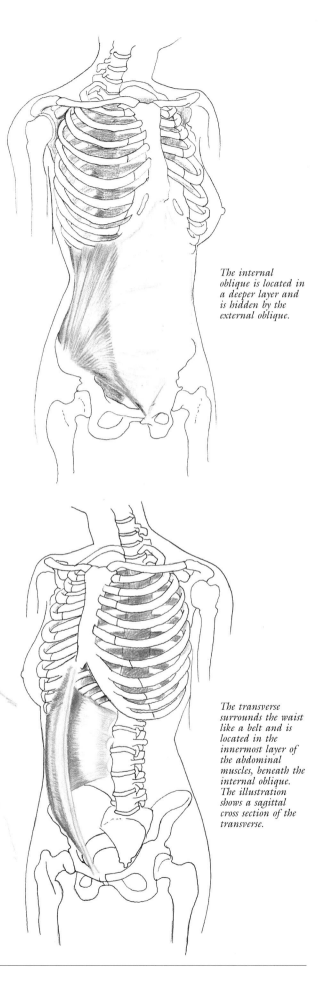

The internal oblique is located in a deeper layer and is hidden by the external oblique.

The transverse surrounds the waist like a belt and is located in the innermost layer of the abdominal muscles, beneath the internal oblique. The illustration shows a sagittal cross section of the transverse.

The abdominal muscles are very elastic muscular walls that enclose the internal organs and create the characteristic contours in the lower part of the torso.

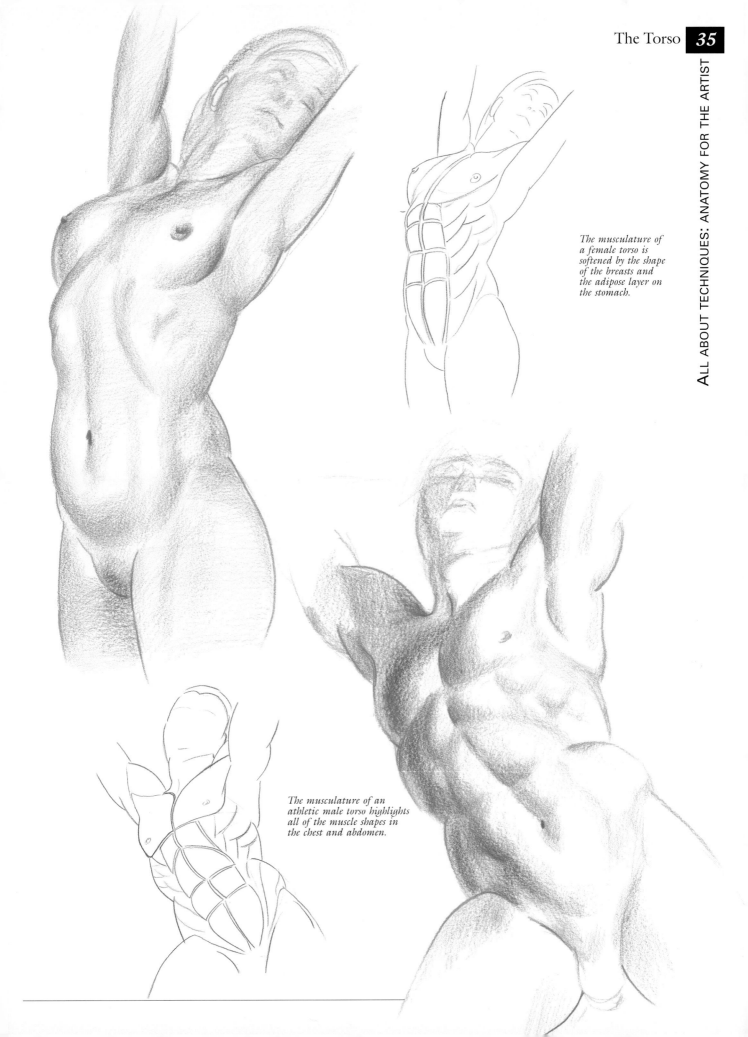

The musculature of a female torso is softened by the shape of the breasts and the adipose layer on the stomach.

The musculature of an athletic male torso highlights all of the muscle shapes in the chest and abdomen.

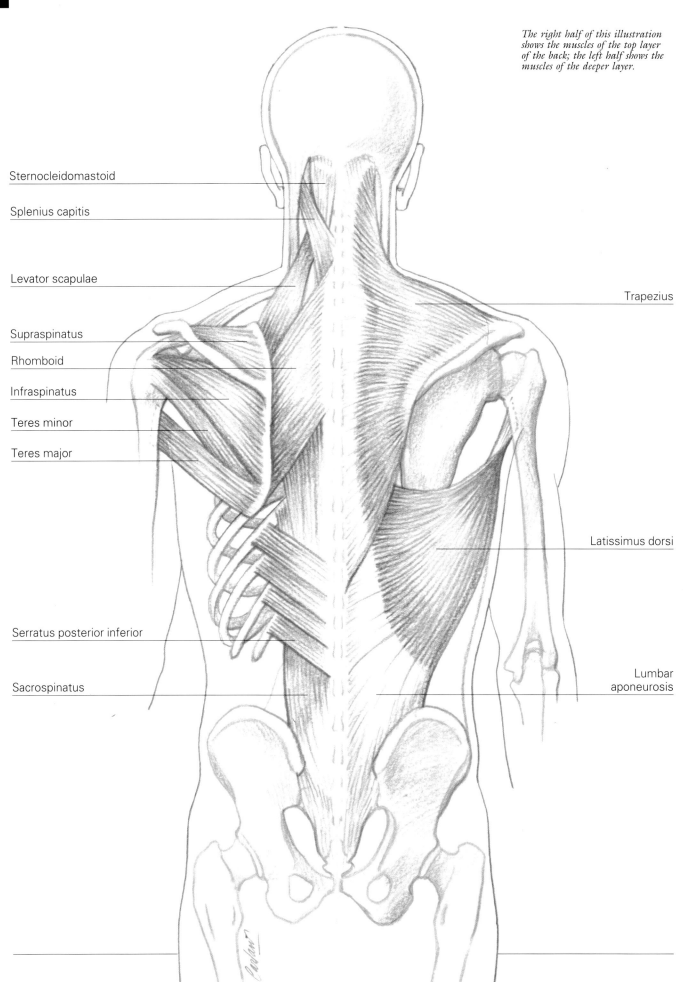

The right half of this illustration shows the muscles of the top layer of the back; the left half shows the muscles of the deeper layer.

Sternocleidomastoid

Splenius capitis

Levator scapulae

Supraspinatus

Rhomboid

Infraspinatus

Teres minor

Teres major

Serratus posterior inferior

Sacrospinatus

Trapezius

Latissimus dorsi

Lumbar aponeurosis

THE MUSCLES OF THE BACK

This section describes the muscles of the back and the lower part of the neck.

The back contains many very powerful muscles that are hidden beneath the broad expanses of the trapezius and the latissimus dorsi. We will focus only on the most important ones that are particularly relevant to drawing.

SACROSPINATUS

The spinal column is covered vertically by the robust surfaces of the sacrospinatus muscle, which is responsible for the inclination of the back. The shape of the sacrospinatus is visible on both sides of the spinal column in the lumbar region. At the height of the vertebrae, the sacrospinatus breaks into three muscle bundles, thereby losing most of the shape visible on the outside.

SERRATUS POSTERIOR INFERIOR

The serratus posterior inferior muscles originate in the last two thoracic vertebrae and the first two or three lumbar vertebrae. They insert into the inferior border of the last four ribs. The serratus posterior superior muscles (in the illustration, hidden beneath the rhomboids) originate in the last two cervical and first two or three thoracic vertebrae. They insert into the rear part of the second, third, fourth, and fifth ribs.

RHOMBOIDS

These muscles descend on an angle from the sixth and seventh cervical vertebrae and insert beneath the spine of the scapula. Their function is to lift up the shoulder blade and keep it close to the median line of the back.

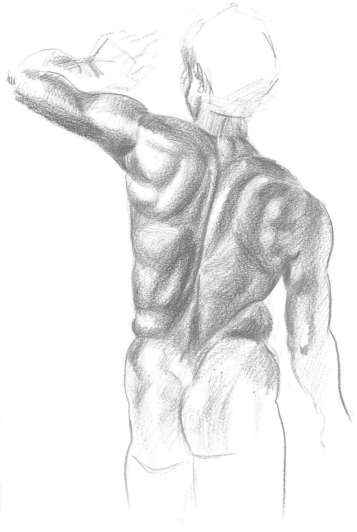

The heavy and intricate muscle mass of the back offers artists one of the best opportunities to demonstrate their knowledge of anatomy.

the rear of the neck. It stretches down to the twelfth dorsal vertebra, where it inserts. The trapezius pulls upward from the shoulder blade and sustains the weight of the arms.

LATISSIMUS DORSI

This muscle originates in the head of the humerus near the shoulder blade, and it inserts along the large lumbar aponeurosis. It participates in all the movements in which the arm is drawn to the rear or toward the torso (adduction).

STERNOCLEIDOMASTOID

This muscle is made up of an intricate arrangement of fibers; it originates in the base of the skull and has multiple insertions in the cervical vertebrae. It lets the head extend to the rear and lets the head turn when it is extended.

SUPRASPINATUS

This is an auxiliary muscle to the deltoids, which contributes to raising the arm and keeping the head of the humerus inside its socket. It inserts into the head of the humerus and in the inside, upper angle of the shoulder blade.

INFRASPINATUS

The function of this muscle is analogous to that of the supraspinatus. However, it specifically makes possible the outward rotation of the arm by pulling forward on the head of the humerus toward the outside of its socket. This muscle originates at the spinal edge of the shoulder blade and inserts into the head of the humerus.

TERES MINOR

This muscle is contiguous to the infraspinatus and follows the same direction. It also has the same function.

TERES MAJOR

This muscle originates at the lower edge of the shoulder blade and inserts in the upper body of the humerus. Its function is to keep the humerus near the shoulder blade.

TRAPEZIUS

The trapezius is a triangular sheet of muscle that covers the upper part of the shoulder and

SPLENIUS CAPITIS

The splenius capitis is located immediately beneath the trapezius. Its function is analogous to that of the sternocleidomastoid: extending the head.

LEVATOR SCAPULAE

This muscle extends from the upper cervical vertebrae to the upper inside angle of the shoulder blade. It is used in raising the shoulder blade.

THE PELVIS

The pelvis, or the pelvic belt, is a bony ring made up of four main elements: the sacrum and the three pairs of iliac bones. The pelvis, which is like a double bowl, supports the weight of the upper body. In addition, the pelvis transmits the shocks and impulses from the trunk and the ground to the lower extremities.

BONES OF THE PELVIS

The pelvis is made up of three pairs of bones that are solidly joined together: the ilium, the ischium, and the pubis. The ilium is the largest of the three, and it gives the pelvis its characteristic shape. Its upper edge forms the iliac crest, which is visible on the exterior. The ischium is located further down and appears like an extension of the ilium. The pubic bone forms a belt with the ischium, and it meets the leg joint on its outer face. The sacrum is located at the rear of the pelvis; this is where the spinal column ends.

The male pelvis is narrower and inclined more to the rear than the female pelvis, which has larger iliac crests and tips more toward the front.

POSITION OF THE PELVIS

With respect to the vertical axis of the body, the pelvis is tipped forward. To draw it correctly in a figure seen from the side, you have to keep in mind that the imaginary line that joins the extreme front and the back of the iliac crest is a horizontal line and the imaginary line that joins the front of the iliac crest and the pubic joint is a vertical one.

The pelvis clearly defines the external shape of the abdomen. In a male figure, it produces the characteristic shield shape at the lower end of sides of the abdomen.

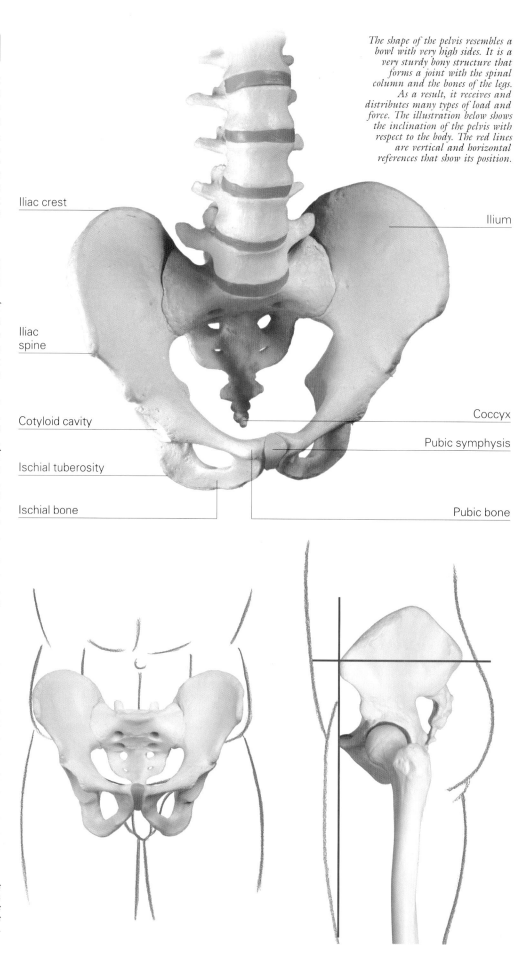

The shape of the pelvis resembles a bowl with very high sides. It is a very sturdy bony structure that forms a joint with the spinal column and the bones of the legs. As a result, it receives and distributes many types of load and force. The illustration below shows the inclination of the pelvis with respect to the body. The red lines are vertical and horizontal references that show its position.

Iliac crest — Ilium

Iliac spine

Cotyloid cavity — Coccyx

Ischial tuberosity — Pubic symphysis

Ischial bone — Pubic bone

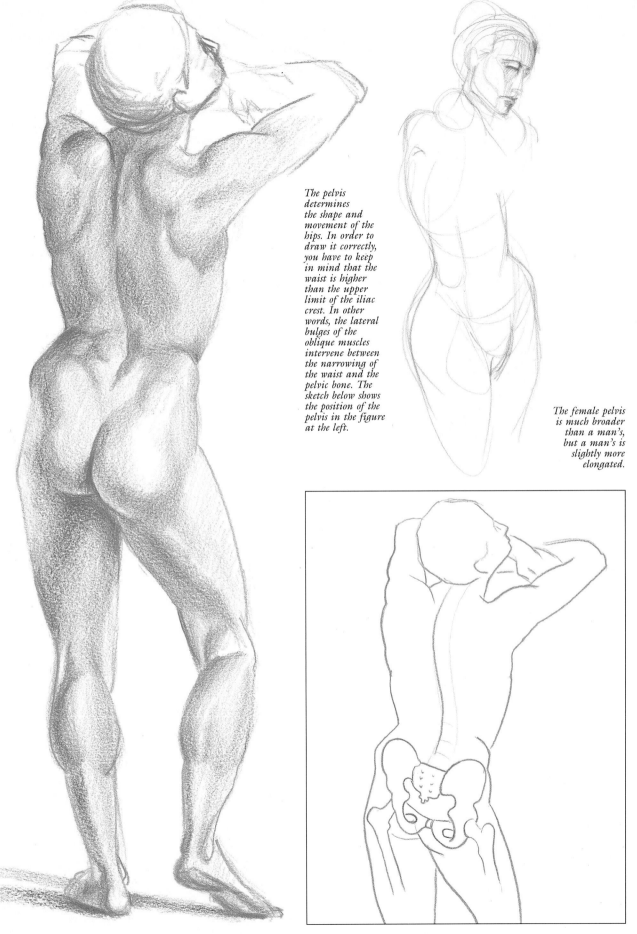

The pelvis determines the shape and movement of the hips. In order to draw it correctly, you have to keep in mind that the waist is higher than the upper limit of the iliac crest. In other words, the lateral bulges of the oblique muscles intervene between the narrowing of the waist and the pelvic bone. The sketch below shows the position of the pelvis in the figure at the left.

The female pelvis is much broader than a man's, but a man's is slightly more elongated.

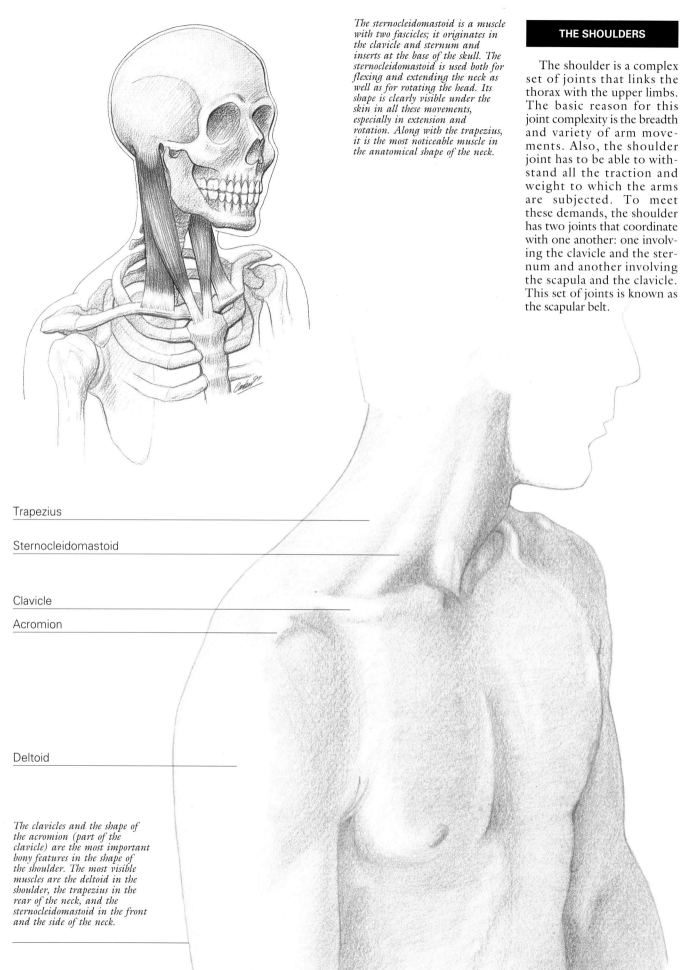

The sternocleidomastoid is a muscle with two fascicles; it originates in the clavicle and sternum and inserts at the base of the skull. The sternocleidomastoid is used both for flexing and extending the neck as well as for rotating the head. Its shape is clearly visible under the skin in all these movements, especially in extension and rotation. Along with the trapezius, it is the most noticeable muscle in the anatomical shape of the neck.

THE SHOULDERS

The shoulder is a complex set of joints that links the thorax with the upper limbs. The basic reason for this joint complexity is the breadth and variety of arm movements. Also, the shoulder joint has to be able to withstand all the traction and weight to which the arms are subjected. To meet these demands, the shoulder has two joints that coordinate with one another: one involving the clavicle and the sternum and another involving the scapula and the clavicle. This set of joints is known as the scapular belt.

Trapezius

Sternocleidomastoid

Clavicle

Acromion

Deltoid

The clavicles and the shape of the acromion (part of the clavicle) are the most important bony features in the shape of the shoulder. The most visible muscles are the deltoid in the shoulder, the trapezius in the rear of the neck, and the sternocleidomastoid in the front and the side of the neck.

THE CLAVICLES

The clavicles are short, S-shaped, cylindrical bones that connect the sternum to the shoulder blades. Their joint with the manubrium of the sternum makes possible three types of movements in the clavicle: forward and backward, raising and lowering, and rotation on its own axis. All these movements are done automatically when the shoulder blade is moved.

In men, the outer end of the clavicle is commonly a bit higher than in women.

The clavicle keeps the shoulder blade to the rear and outside. It allows for the insertion of several muscles of the neck, arm, and thorax. The shape of the clavicle is almost entirely visible under the skin, and it is a help to illustrators in calculating proportions.

The acromion and the coracoid apophysis are extremities of the shoulder blade that surround and protect the humerus joint. Both are insertion sites for several muscles, and the shape of the acromion is visible beneath the skin.

THE SHOULDER BLADES OR SCAPULAE

The shoulder blades are flat, triangular bones that are slightly arched on their inner face to fit the curvature of the thoracic cage. The shoulder blade has two faces, three angles, and three edges. The upper edge reaches as far as the second rib. The lower angle commonly reaches the level of the seventh rib. This lower angle (or peak) is an important reference point for artists since its shape, which is covered by muscle insertions, is clearly visible on the surface of the back. In addition, the inner edge near the spinal column is also visible in certain movements. The outer face of the scapula has two apophyses or projections. The first, the spine, which culminates in the voluminous acromion, forms a joint with the clavicle. The second, the coracoid process, projects toward the front of the scapula. Both the spine and the acromion can be felt beneath the skin and are clearly visible in certain movements.

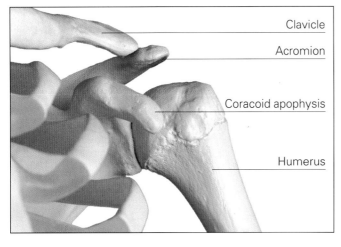

Clavicle
Acromion
Coracoid apophysis
Humerus

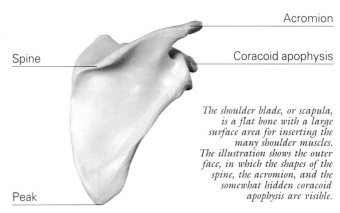

Spine
Acromion
Coracoid apophysis
Peak

The shoulder blade, or scapula, is a flat bone with a large surface area for inserting the many shoulder muscles. The illustration shows the outer face, in which the shapes of the spine, the acromion, and the somewhat hidden coracoid apophysis are visible.

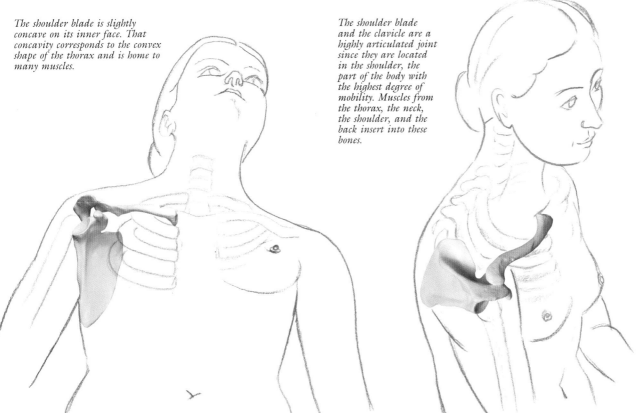

The shoulder blade is slightly concave on its inner face. That concavity corresponds to the convex shape of the thorax and is home to many muscles.

The shoulder blade and the clavicle are a highly articulated joint since they are located in the shoulder, the part of the body with the highest degree of mobility. Muscles from the thorax, the neck, the shoulder, and the back insert into these bones.

MOVEMENT IN THE SHOULDER BLADE

The scapula is an extremely mobile bone. It slides in many directions on the rear face of the thorax, and this is what facilitates such a broad variety of arm movements.

REST POSITION

With the arms held at the sides of the body, the spinal or inner edge of the scapula is parallel to the spinal column, and the space that separates the two shoulder blades is equivalent to the width of one of them. The scapulae are not located on a single plane. Rather, when they are in contact with the ribs, they form an obtuse angle.

ROCKING

When the arms are raised, the scapulae rock in such a way that their lower angle points toward the outside of the body. This rocking is limited by the contact of the humerus with the acromion; at that point, the arms can be raised no further.

When the arms are raised to their maximum height, the shoulder blades move toward the outside of the thoracic cage and rock upward. This elevation involves a twist in the forearm, which keeps the head of the humerus from butting against the acromion.

MAXIMUM ELEVATION OF THE ARMS

When achieving maximum lift in the arms, the scapulae have to rock around the thorax until they are nearly parallel to one another on both sides of the thoracic cage.

ARM ROTATION

As the arms are rotated inward, the scapulae lower and move toward the outside of the thoracic cage. During outward rotation, the scapulae also lower, but they move closer to the spinal column.

The shoulder blades or scapulae extend down as far as the level of the seventh or eighth rib and can be moved across part of the thoracic cage; they raise or lower with the movement of the arms.

When the arms are raised from a position straight out to the sides, the head of the humerus can go only so high because of the acromion, which acts as a stop. In order to continue raising the arms, the forearm has to turn; the head of the humerus can then clear the acromion.

When moving the arms to the rear and trying to touch elbows behind the back (inner rotation of the arms), the shoulder blades come quite close together and nearly touch over the spinal column. This causes a significant muscle displacement and a deep furrow in the spinal region.

The shoulder blades are planes tangent to the curve of the ribs. In other words, they are not located in a single plane but follow the curved plane that the thoracic cage describes in the back. This is very important when drawing the shoulders of figures in perspective, like the adjacent one.

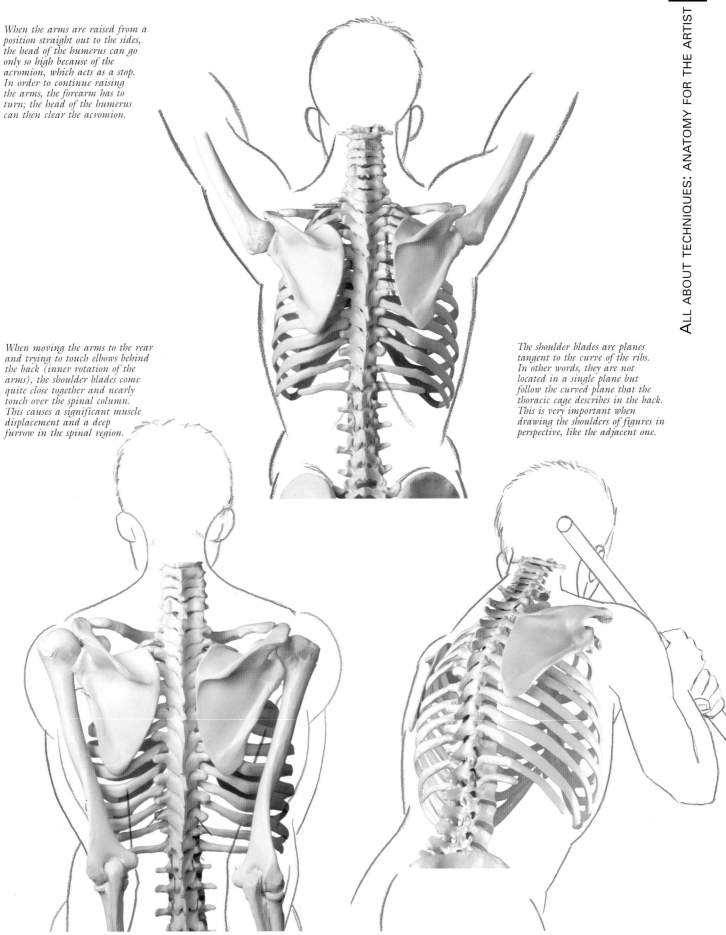

ALL ABOUT TECHNIQUES: ANATOMY FOR THE ARTIST

THE ARMPIT

For many artists, the armpit is one of the must confusing parts of anatomy. It is an area where many groups of muscles come together. Specifically, these include the muscles of the arm, the shoulder, the thorax, and the back. In addition, it is clearly visible only when the arm is raised to the maximum, in other words, when the muscles of this area are subjected to tensions that affect their shape.

Triceps
Biceps
Deltoid
Coracobrachial
Pectoral
Latissimus dorsi
Serratus

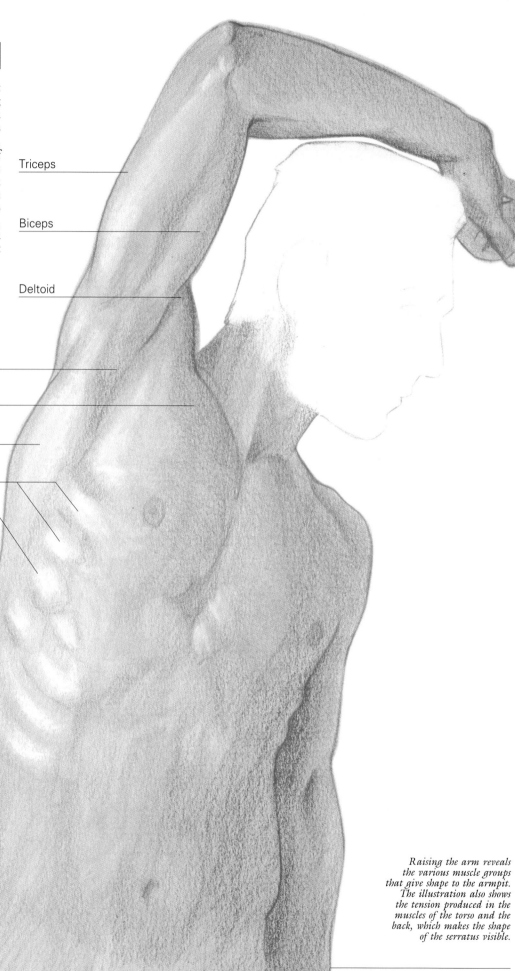

Raising the arm reveals the various muscle groups that give shape to the armpit. The illustration also shows the tension produced in the muscles of the torso and the back, which makes the shape of the serratus visible.

THE RELEVANT MUSCLES

Several muscles contribute visibly to the shape of the armpit. First is the deltoid, which provides the muscle that wraps around the shoulder and clearly delineates the hollow of the armpit. The pectoral muscle also figures prominently; it is stretched upward with the elevation in the humerus (the bone into which it inserts). The fingers of the serratus muscle are also commonly visible since they are stretched through their insertions in the inner face of the shoulder blade. A back muscle that helps shape the armpit is the latissimus dorsi, which is likewise stretched through its insertions in the humerus.

The greatest difficulty in understanding the shape of the armpit is recognizing the arm muscles that appear at an unaccustomed angle. Both the triceps and the biceps are visible (along with the muscle below the biceps, the brachialis). The pairing of these two muscles commonly creates a characteristic furrow that runs along the inner surface of the arm from the armpit to the elbow.

THE CORACOBRACHIALIS

The coracobrachialis is a small arm muscle that was not mentioned before now because of its very secondary role in determining the visible shape. However, it is mentioned at this point because it does contribute to the shape of the armpit. The coracobrachialis originates in the coracoid apophysis of the shoulder blade and inserts in the midpoint of the inner surface of the humerus. When the arm is raised, the coracobrachialis can be identified by its small, spindly shape that arises between the pectoral and the latissimus dorsi and slips beneath the biceps and disappears between that muscle and the triceps. The illustrations on these pages make it possible to identify

this muscle, plus all the rest that determine the shape of the armpit.

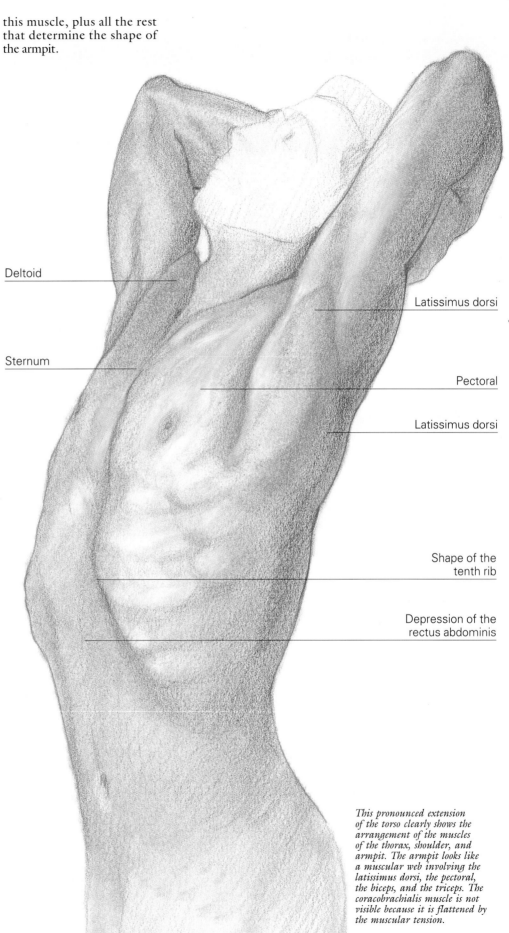

Deltoid

Sternum

Latissimus dorsi

Pectoral

Latissimus dorsi

Shape of the tenth rib

Depression of the rectus abdominis

This pronounced extension of the torso clearly shows the arrangement of the muscles of the thorax, shoulder, and armpit. The armpit looks like a muscular web involving the latissimus dorsi, the pectoral, the biceps, and the triceps. The coracobrachialis muscle is not visible because it is flattened by the muscular tension.

DRAWING THE TORSO

The trunk is the origin of body movements. As we have seen in the preceding pages, it contains a number of powerful muscle groups that determine its outward shape. Still, the trunk is quite limited in its movements when compared with the arms and legs. The most active movements in the torso involve flexion, extension, and rotation. All these movements cause various muscular tensions and pronounced furrows in the back (along the spinal column) as well as folds at the waist (in conjunction with the external oblique and the latissimus dorsi). The important factor for drawing the torso in motion is to capture these references clearly (furrows and folds) and use them in constructing the rest of the figure. These pages will show some illustrations that exemplify the most typical movements in the trunk.

FLEXION MOVEMENTS

Flexion movements in the torso involve moving it forward. This type of movement causes folds in the abdomen as a result of maximal relaxation in the rectus abdominis. Flexion also produces tension in the sacrolumbar muscles, which stretch and flatten the shape of the lower back. This stretching of the sacrolumbar muscles makes the spinal column more visible, especially the dorsal and cervical vertebrae.

EXTENSION MOVEMENTS

These are movements that incline the back to the rear. Extending the torso is much more limited than flexion because of the configuration of the spinal column (the apophyses keep the back from bending too far rearward). Extending the trunk produces tension in the pectorals, stretches the rectus

abdominis, and reveals the serratus on the thorax. If the extension is accompanied by raising the arms, significant creases form around the neck due to the tension in the deltoids.

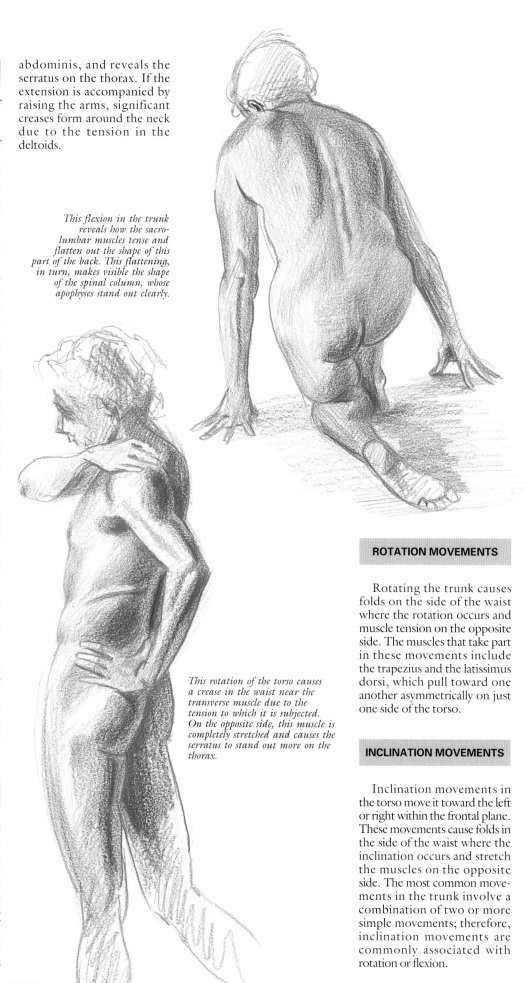

This flexion in the trunk reveals how the sacro-lumbar muscles tense and flatten out the shape of this part of the back. This flattening, in turn, makes visible the shape of the spinal column, whose apophyses stand out clearly.

This rotation of the torso causes a crease in the waist near the transverse muscle due to the tension to which it is subjected. On the opposite side, this muscle is completely stretched and causes the serratus to stand out more on the thorax.

ROTATION MOVEMENTS

Rotating the trunk causes folds on the side of the waist where the rotation occurs and muscle tension on the opposite side. The muscles that take part in these movements include the trapezius and the latissimus dorsi, which pull toward one another asymmetrically on just one side of the torso.

INCLINATION MOVEMENTS

Inclination movements in the torso move it toward the left or right within the frontal plane. These movements cause folds in the side of the waist where the inclination occurs and stretch the muscles on the opposite side. The most common movements in the trunk involve a combination of two or more simple movements; therefore, inclination movements are commonly associated with rotation or flexion.

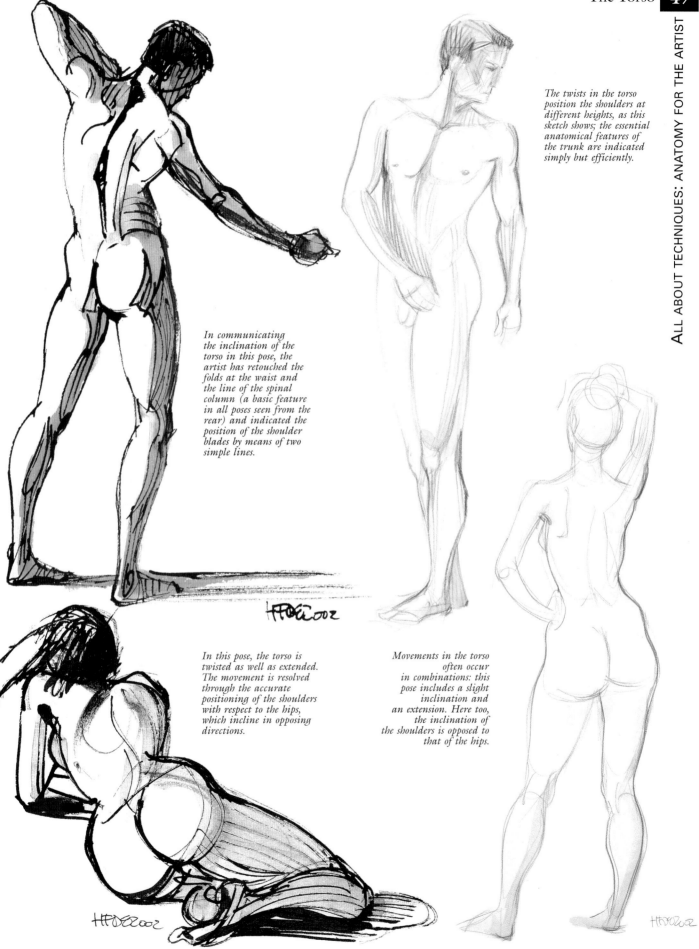

The twists in the torso position the shoulders at different heights, as this sketch shows; the essential anatomical features of the trunk are indicated simply but efficiently.

In communicating the inclination of the torso in this pose, the artist has retouched the folds at the waist and the line of the spinal column (a basic feature in all poses seen from the rear) and indicated the position of the shoulder blades by means of two simple lines.

In this pose, the torso is twisted as well as extended. The movement is resolved through the accurate positioning of the shoulders with respect to the hips, which incline in opposing directions.

Movements in the torso often occur in combinations: this pose includes a slight inclination and an extension. Here too, the inclination of the shoulders is opposed to that of the hips.

The Arms

The upper limb is composed of the upper arm and the forearm. The humerus is the bone of the upper arm, and the bones of the forearm are the radius and the ulna. The humerus is the longest of the three. At its top, it forms a joint with the shoulder, and at its lower end (the elbow), with the other two bones. The ulna and the radius in turn form a joint at their lower end with the bones of the wrist. The length of these two bones is approximately equal to three-quarters the length of the humerus.

THE HUMERUS

The humerus is the longest and most robust of the arm bones. At its epiphysis or upper end, it forms a joint with the glenoid cavity of the shoulder blade by means of a spherical joint surface covered with cartilage. The upper end of the humerus exhibits two external processes where the muscles coming from the shoulder blade insert and that act as pulleys for the large tendons of the biceps. The diaphysis or body of the humerus is cylindrical in its upper part and otherwise triangular.

Leonardo da Vinci, Arm Studies. Royal Library, Windsor Castle (Windsor, England). These drawings by Leonardo da Vinci clearly show the location of the muscles on the anterior and posterior faces of the arm.

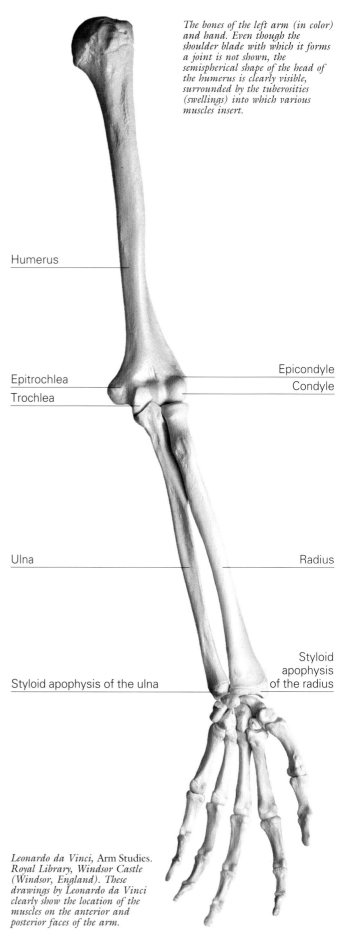

The bones of the left arm (in color) and hand. Even though the shoulder blade with which it forms a joint is not shown, the semispherical shape of the head of the humerus is clearly visible, surrounded by the tuberosities (swellings) into which various muscles insert.

Humerus

Epitrochlea

Trochlea

Epicondyle

Condyle

Ulna

Radius

Styloid apophysis of the ulna

Styloid apophysis of the radius

The lower end of the humerus is flattened, and it has two joint surfaces shaped like a pulley—an inner one for the ulna and an external one for the radius. The most important shape of this extremity is on the inside and is known as the epitrochlea.

THE FOREARM

The bones of the forearm are the ulna and radius. With the arm extended and the palm forward, both bones are parallel; the ulna is located in the inner part of the forearm and the radius in the outer. The upper end of the ulna, which is known as the olecranon, is much larger than the lower end. It is the end that forms the typical, slightly pointed shape that appears at the rear of the elbow joint. The lower end, in turn, is also significant in the outward shape of the forearm since the styloid apophysis is located on the inside. This styloid apophysis of the ulna is commonly visible as a prominent projection near the outer part of the wrist.

The radius is a slightly convex bone on the outside and shaped like a triangular prism. Its upper end is much smaller than the lower and is shaped like a ring. The lower end contains numerous channels into which some of the finger tendons fit. As with the ulna, the lower end of the radius also has an apophysis (the styloid apophysis of the radius). Even though it is not as obvious as the apophysis of the ulna, it often sticks out on the other side of the wrist.

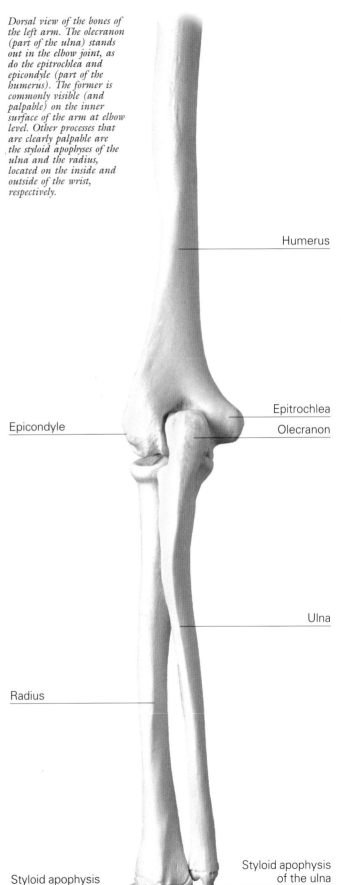

Dorsal view of the bones of the left arm. The olecranon (part of the ulna) stands out in the elbow joint, as do the epitrochlea and epicondyle (part of the humerus). The former is commonly visible (and palpable) on the inner surface of the arm at elbow level. Other processes that are clearly palpable are the styloid apophyses of the ulna and the radius, located on the inside and outside of the wrist, respectively.

Humerus

Epitrochlea

Olecranon

Epicondyle

Ulna

Radius

Styloid apophysis of the ulna

Styloid apophysis of the radius

THE ARRANGEMENT OF THE ARM BONES

When the arm is extended, the upper arm and the forearm are clearly not aligned along the same axis. Rather, the forearm follows a different axis. This is because the axis of the elbow joint (its hinge, so to speak) angles upward and outward. This anatomical feature is of great importance in drawing the human figure, especially when the artist has to work from memory.

The arm bones are not aligned along the same axis: the bones of the forearm form an obtuse angle with the axis of the humerus. That is because the angle of the elbow joint with respect to the humerus is not straight but, rather, elevated toward the outside of the arm. This is an important feature to remember when drawing a human figure.

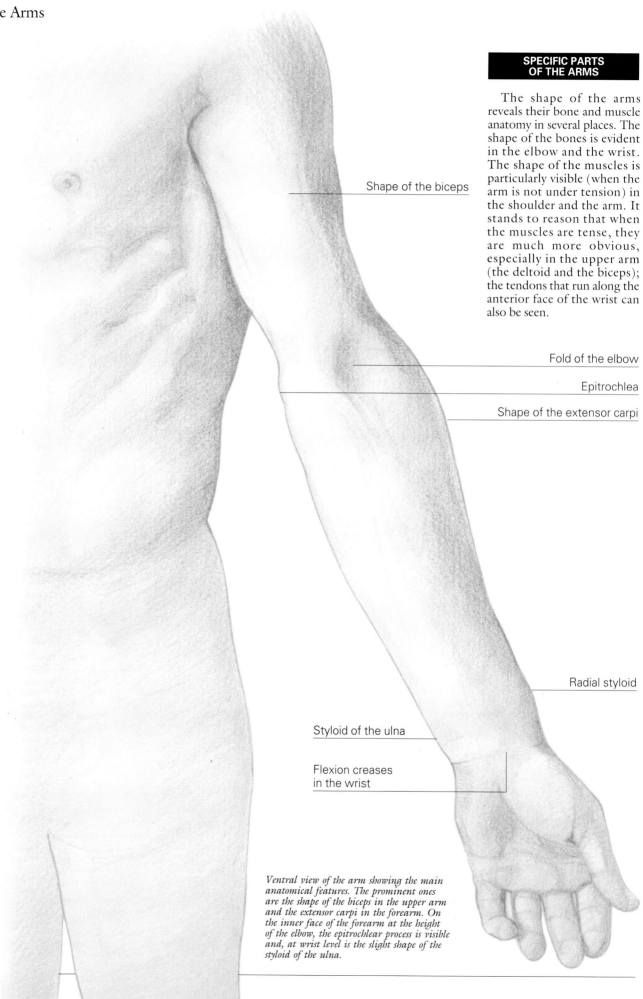

Shape of the biceps

Fold of the elbow

Epitrochlea

Shape of the extensor carpi

Radial styloid

Styloid of the ulna

Flexion creases
in the wrist

SPECIFIC PARTS OF THE ARMS

The shape of the arms reveals their bone and muscle anatomy in several places. The shape of the bones is evident in the elbow and the wrist. The shape of the muscles is particularly visible (when the arm is not under tension) in the shoulder and the arm. It stands to reason that when the muscles are tense, they are much more obvious, especially in the upper arm (the deltoid and the biceps); the tendons that run along the anterior face of the wrist can also be seen.

Ventral view of the arm showing the main anatomical features. The prominent ones are the shape of the biceps in the upper arm and the extensor carpi in the forearm. On the inner face of the forearm at the height of the elbow, the epitrochlear process is visible and, at wrist level is the slight shape of the styloid of the ulna.

ANTERIOR FACE

With the arm extended, the most important shapes are that of the biceps (which gives rise to a slight concavity at its insertion into the forearm), the shape of the extensor carpi on the outer face of the forearm, the epitrochlea on the inner face of the elbow, and the opposing processes of the radial styloid and the styloid of the ulna on the inner and outer faces, respectively, of the wrist.

POSTERIOR FACE

The most important shapes on the rear face of the arm are the deltoid (in the shoulder), the triceps (upper part of the arm), the dimple of the epicodyle (most clearly visible when the arm is completely extended and under tension), and the swelling of the olecranon and the shape of the styloid of the ulna.

Rear view of the arm. The most obvious bony shapes are the olecranon and the epicondyle in the elbow and the protuberance of the styloid of the ulna in the wrist.

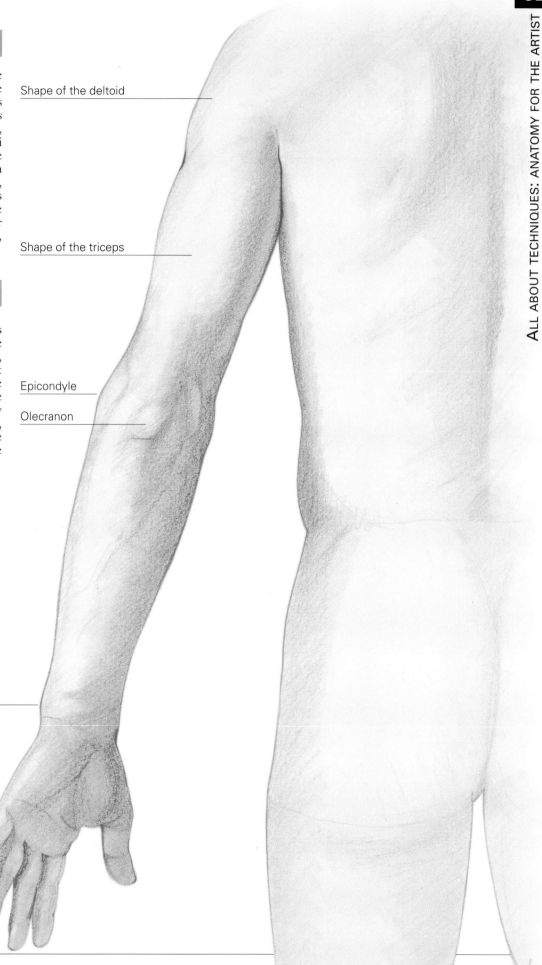

Shape of the deltoid

Shape of the triceps

Epicondyle

Olecranon

Styloid of the ulna

UPPER ARM MUSCLES

Basically, the upper arm is made up of four muscles: three in the front and one in the rear. The muscles in the front part are the biceps, the brachialis, and the coracobrachialis. The muscle in the rear is the triceps. In addition to these muscles is the deltoid, which is the large muscle that encircles the shoulder joint.

THE REAR OF THE ARM

The large muscles of the arm originate in the bones of the shoulder: the shoulder blade and the clavicle. In the rear, the upper insertions of the shoulder muscles are in the humerus and the shoulder blades. The lower insertions are located at the elbow joint and the upper ends of the radius and ulna.

THE SUPRASPINATUS

The supraspinatus muscle is located in the hollow formed at the top of the spine of the scapula. This muscle originates on the inside of this hollow and inserts into the process on the head of the humerus. Its function is to work in conjunction with the deltoid in raising the arm and keeping the humerus joint inside the glenoid cavity in the shoulder blade.

THE INFRASPINATUS

The infraspinatus is a large triangular muscle that originates in the infraspinatus cavity located under the spine of the shoulder blade; it inserts into the process on the head of the humerus. This muscle makes rotating the humerus to the outside possible. With the arm held at the side of the body, the infraspinatus causes the movement by which the palm is rotated to face the outside of the arm.

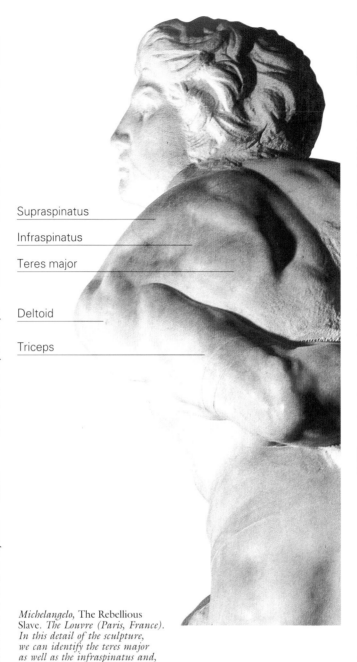

Supraspinatus

Infraspinatus

Teres major

Deltoid

Triceps

Michelangelo, The Rebellious Slave. The Louvre (Paris, France). In this detail of the sculpture, we can identify the teres major as well as the infraspinatus and, on top of those two, the spine of the shoulder blade. Also, the deltoids and the triceps are clearly visible.

THE TERES MAJOR

The teres major originates on the outer face of the lower angle of the shoulder blade and inserts into the anterior surface of the humerus. Its function is to pull the humerus toward the shoulder blade as well as to make rotating the arm toward the outside possible. With the arm extended and the palm facing the thigh, the teres major causes the palm to rotate toward the rear.

OTHER SHOULDER MUSCLES

Two shoulder muscles do not appear in the illustration: the subscapularis and the teres minor. The subscapularis is located on the front face of the shoulder blade (between the shoulder blade and the thorax), and it has no effect on the outward appearance of the body. The teres minor is a small muscle contiguous to the infraspinatus; it follows a very similar direction and partially fuses with it. Like the supraspinatus, the teres minor facilitates rotating the arm toward the outside.

THE DELTOID

The deltoid wraps around the shoulder joint. It is a large and powerful muscle that lends an athletic appearance in drawings of male subjects. It originates along the entire spine of the shoulder blade, on the acromion, and along the forward edge of the clavicle. It inserts into the upper outside area of the humerus beneath the tuberosities on the very top of this bone. The deltoid is a muscle made up of three bodies or fascicles, which in turn are made up of many smaller fascicles that are tightly intertwined. This makes the muscle very compact and powerful.

The deltoid is used in raising and lowering the arm. It also protects and stabilizes the shoulder joint.

THE TRICEPS

The triceps consists of three heads: the long head, the lateral head, and the medial head. The long head arises on the shoulder blade; the lateral head originates in the top of the rear face of the humerus; and the medial head arises in the lowest part of that same posterior face. These three heads join at a powerful flat tendon (the tendon of the triceps), which inserts into the upper part of the olecranon. The triceps is responsible for extending the forearm, and it aids in keeping the head of the humerus inside the shoulder joint.

THE ANCONEUS

Although the anconeus is part of the forearm, it is treated here so it can be seen more clearly. This is a small muscle that originates in the epitrochlea of the humerus and ends at the rear face of the ulna. Its function is to extend the elbow.

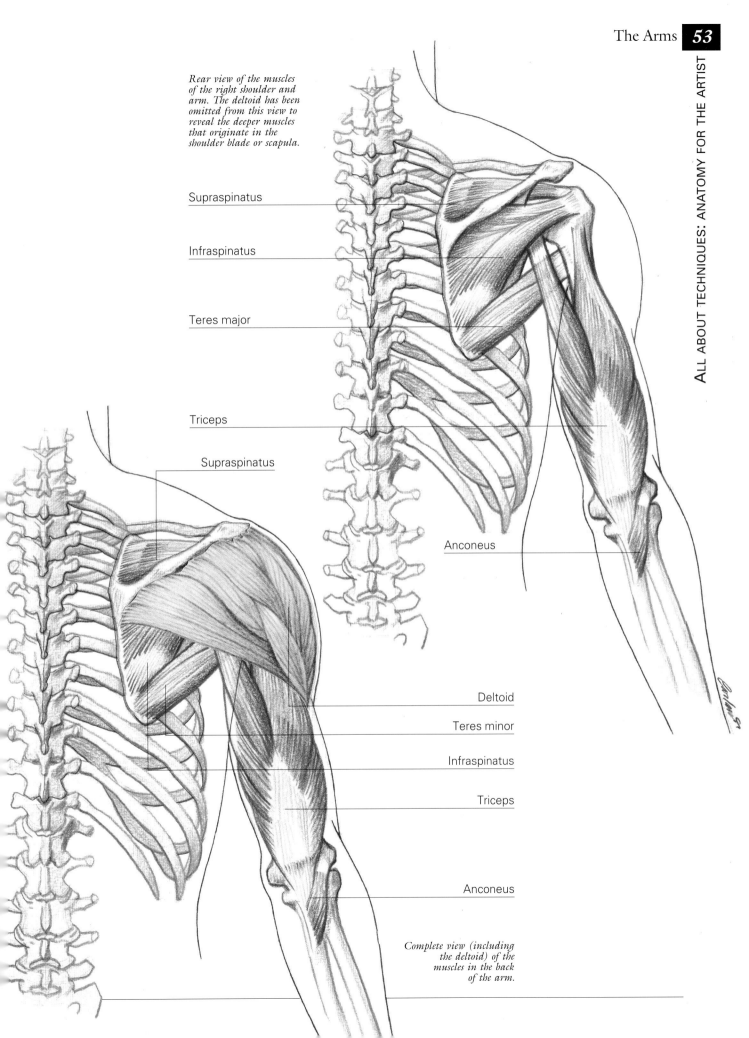

Rear view of the muscles of the right shoulder and arm. The deltoid has been omitted from this view to reveal the deeper muscles that originate in the shoulder blade or scapula.

Supraspinatus

Infraspinatus

Teres major

Triceps

Supraspinatus

Anconeus

Deltoid

Teres minor

Infraspinatus

Triceps

Anconeus

Complete view (including the deltoid) of the muscles in the back of the arm.

MUSCLES IN THE FRONT OF THE ARM

The front of the arm has just a few muscles, but they are important ones: the biceps, the brachialis, and the coracobrachialis. The biceps is the only one that inserts into the shoulder blade (in the upper protuberances of the anterior face, the coracoid apophysis); the other two arise on the humerus. All these muscles have their lower insertions in the elbow joint and the upper ends of the radius and ulna.

THE BICEPS

The biceps is the muscle closest to the surface on the forward part of the upper arm. It originates in two places in the shoulder, and that produces two muscle heads (the long and the short). The long head of the biceps originates in the upper part of the shoulder blade and slips through the hollow in the head of the humerus; the short head arises in the coracoid apophysis. Both heads (also referred to as the long biceps and short biceps) join at their lower end in a single tendon that passes in front of the elbow joint and inserts in the upper part of the radius. The biceps is responsible for flexing the forearm and for supination.

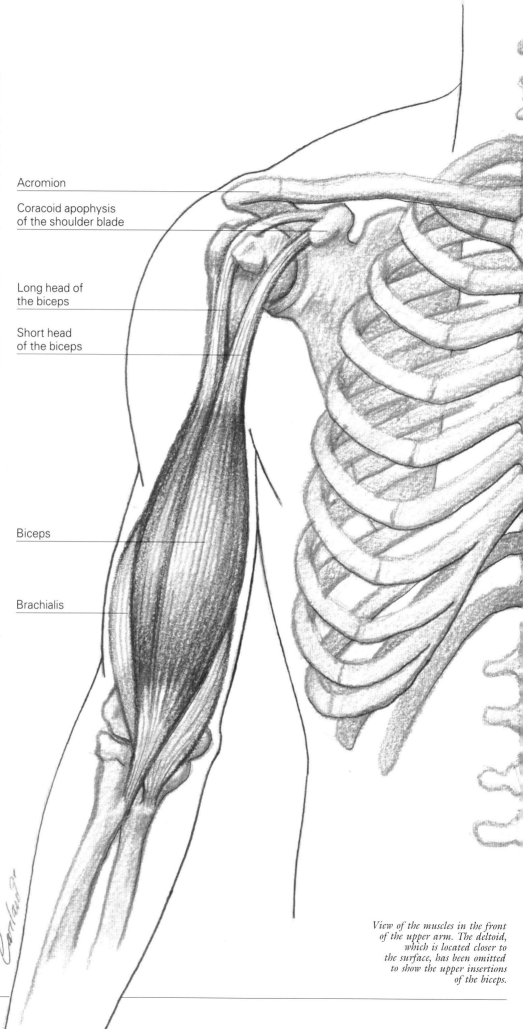

Acromion

Coracoid apophysis of the shoulder blade

Long head of the biceps

Short head of the biceps

Biceps

Brachialis

View of the muscles in the front of the upper arm. The deltoid, which is located closer to the surface, has been omitted to show the upper insertions of the biceps.

THE BRACHIALIS

The brachialis muscle arises in the lower half of the front face of the humerus and ends at the forward face of the upper portion of the ulna. Compared with the biceps, this is a deeper muscle, but it is broader than the biceps and sticks out from it on both sides. It is used in flexing the forearm.

THE DELTOID AND THE BICEPS

These two muscles are the most powerful ones of the upper arm. Their artistic representation symbolizes the strength and physical vigor of the male figure more than any other muscle, with the possible exception of the pectorals. The deltoids give width to the shoulders and frame the sides of the thorax, just as the clavicles and the trapezius frame its upper part. In drawing the deltoid, we have to keep in mind that the curve begins right at the end of the clavicle and goes down until it is interrupted by the curve of the biceps above the midpoint of the upper arm. The curve of the biceps is shorter: it appears above the midpoint of the arm and is interrupted before reaching the level of the elbow. In a female figure, the shape of both muscles is much less pronounced, especially the biceps, which appears to form a cylindrical shape with the triceps.

Deltoid

Biceps

Brachialis

Complete view of the muscles in the front of the upper arm. This view includes the deltoids, whose fibers completely encircle the shoulder joint.

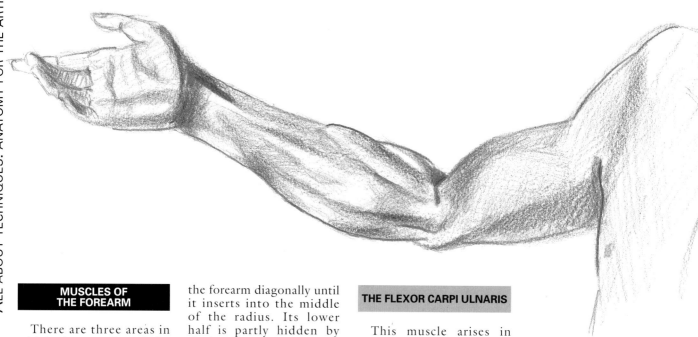

MUSCLES OF THE FOREARM

There are three areas in which the muscles of the forearm are distributed: the anterior, the posterior, and the outer. The anterior region is also called the palmar because it occupies the same plane as the palm of the hand when it is in the position of holding a tray. The posterior region is the one opposite the palmar region (the plane of the elbow), and it is the one that faces downward in the gesture just mentioned. Finally, the outer region is the one that faces outward in that same position.

ANTERIOR REGION

The anterior region is made up of eight muscles. Of these, only four are located near the surface and visible in the external relief: the pronator teres, the flexor carpi radialis, the palmaris longus, and the flexor carpi ulnaris. These are elongated muscles that have a common origin in a tendon that arises in the epitrochlea, and they insert into the bones of the wrist (the carpus) and the hand (the metacarpus).

THE PRONATOR TERES

This muscle originates in the epitrochlea and goes down

the forearm diagonally until it inserts into the middle of the radius. Its lower half is partly hidden by the brachioradialis, and an aponeurotic prolongation of the biceps crosses it in its upper half. It is used in pronation of the forearm; it pulls the radius toward itself when it contracts.

THE FLEXOR CARPI RADIALIS

This muscle is contiguous with the pronator teres (toward the inner face of the forearm). Like the pronator teres, it arises in the epitrochlea. It inserts into the second metacarpal (the metacarpal bone that corresponds to the index finger) by means of a tendon that crosses one of the furrows of the carpal bones. The flexor carpi radialis makes it possible to bend the wrist and move the palm closer to the forearm.

THE PALMARIS LONGUS

This muscle is located alongside the flexor carpi radialis and closer to the inner face of the forearm. It originates in the epitrochlea and ends with a broad tendon that inserts into the large aponeurosis of the palm. Like the flexor carpi radialis, the palmaris longus is used in bending the hand.

THE FLEXOR CARPI ULNARIS

This muscle arises in the epitrochlea and is the innermost of the muscles of the anterior face. Its tendon goes down along the ulna and inserts into a bone of the carpus (the pisiform bone). It is used in flexing the hand toward its inner edge.

THE FLEXOR DIGITORUMS

The flexor muscles for the fingers occupy deeper layers than the muscles on the anterior face of the forearm. As their name indicates, they are used in flexing the fingers. Among other things, they make clenching the fist possible. Among these flexors is a distinction between the superficial and the deep muscles. Only the muscles closest to the surface are mentioned here—that is, the flexor digitorum superficialis and the flexor pollicis longus.

FLEXOR DIGITORUM SUPERFICIALIS

This is a broad, flat muscle that is covered by the muscles of the anterior face of the forearm. It consists of two heads. The first and longest comes from the epitrochlea and the broad area of the ulna. The second originates in the anterior edge of the radius. It

This forearm under tension shows the shape of the palmaris longus and the brachioradialis. The latter is presented in the section on the outer face of the forearm.

forms four tendons that slip through the furrows of the carpus and head toward the fingers (but not the thumb), and they insert into the second phalanx of each one. The mobility of the third phalanx depends on the tendons of the deep flexor, a muscle that is entirely covered by the superficial flexor.

FLEXOR POLLICIS LONGUS

This muscle arises in the central part of the radius and inserts into the last phalanx of the thumb, passing through one of the channels in the carpus. Like the superficial and deep flexors of the fingers, the flexor pollicis longus is also visible on the surface of the forearm. As the name indicates, it is used in flexing the thumb.

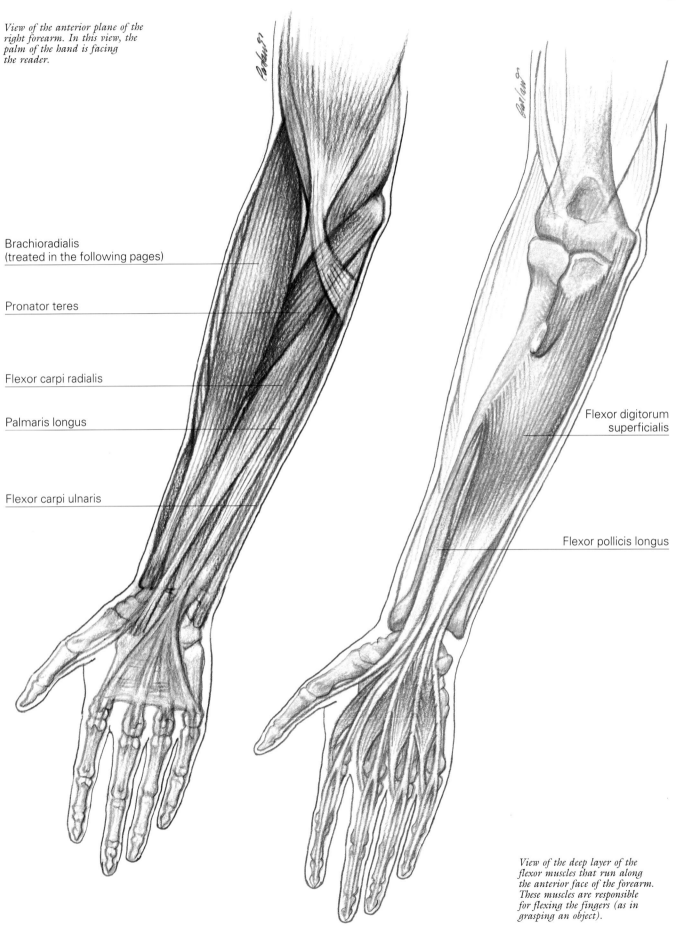

View of the anterior plane of the right forearm. In this view, the palm of the hand is facing the reader.

Brachioradialis
(treated in the following pages)

Pronator teres

Flexor carpi radialis

Palmaris longus

Flexor carpi ulnaris

Flexor digitorum
superficialis

Flexor pollicis longus

View of the deep layer of the flexor muscles that run along the anterior face of the forearm. These muscles are responsible for flexing the fingers (as in grasping an object).

POSTERIOR REGION

The posterior region of the forearm shares the same plane as the hand when the hand is in the anatomical position. It is made up of eight muscles. Four of them are close to the surface: the anconeus (described with the muscles of the upper arm), the extensor carpi ulnaris, the extensor digiti minimi, and the common extensor of the fingers. This superficial layer is particularly visible from the outside in the upper part of the forearm, closest to the elbow.

THE EXTENSOR CARPI ULNARIS

This muscle is located next to the flexor carpi ulnaris (which was described with the muscles of the anterior region), but it lies further to the outside than that muscle. It originates in the epicondyle of the humerus and the upper edge of the ulna, and it inserts into the base of the metacarpus of the wrist. It is an extensor and an adductor for the hand. In other words, it bends the wrist rearward so that the back of the hand moves closer to the forearm, and at the same time, it moves the back of the hand inward.

THE EXTENSOR DIGITI MINIMI

This is a slender muscle that arises in the epicondyle of the humerus and joins the tendon that goes to the little finger; this is one of the four tendons into which the extensor digitorum divides. The function of this muscle is the same as that of the extensor carpi ulnaris; in other words, it is used for extension and adduction of the hand.

THE EXTENSOR DIGITORUM

This is the most robust and the largest of all the muscles in the surface layer of the posterior region. It arises at the epicondyle of the humerus, goes down along the radius, and splits into four tendons in the wrist; these tendons insert into the three phalanges of each finger (not counting the thumb). This muscle is used in extending the wrist and for extending the phalanges and moving them closer to the bones of the metacarpus.

EXTENSOR AND ABDUCTOR POLLICIS LONGUS

These two muscles are part of the deep layer of the posterior region. However, their tendons are visible on the surface of the wrist when they are separated as far as possible from the fingers: these are the tendons that join the base of the thumb with the wrist. They originate in the midpoint of the radius and insert into the metacarpal bones.

OUTER REGION

This region includes the muscles that occupy the outer face of the arm—in other words, the one in the same plane as the thumb. These muscles are the brachioradialis, the first external radial, the second external radial, and the short supinator. The latter occupies a very deep layer and has no effect on the outer shape of the forearm.

THE BRACHIORADIALIS

This is the longest of all the forearm muscles. It originates in the lower outside area of the humerus and goes down along the radius until it inserts into the styloid apophysis of this bone. Its shape is visible beneath the skin of the forearm. Its function is to bend the forearm and keep it under tension in an intermediate position between pronation and supination—a position similar to that of a boxer getting ready to deliver a punch.

FIRST OUTER RADIAL

This muscle arises at the very lower end of the humerus under the insertion of the brachioradialis. It goes down the entire length of the radius partially covered by the brachioradialis and inserts in the rear face of the second metacarpal (the metacarpal of the index finger) after passing beneath the tendons of the long abductor and the extensor pollicis brevis. It is used in extension and abduction (lateral movement toward the outside) of the hand.

SECOND OUTER RADIAL

This muscle follows the same path as the first radial and is covered by it for almost its entire length. It originates right below the first radial (at the bottom of the humerus) and inserts into the third metacarpal (which corresponds to the middle finger). Like the second radial, it is used in extending the hand.

This illustration shows the size of the brachioradialis and the first radial, beneath which are visible the slender extensor muscles of the fingers.

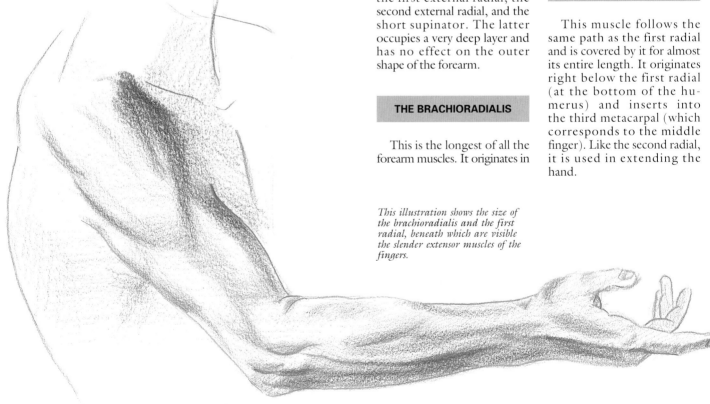

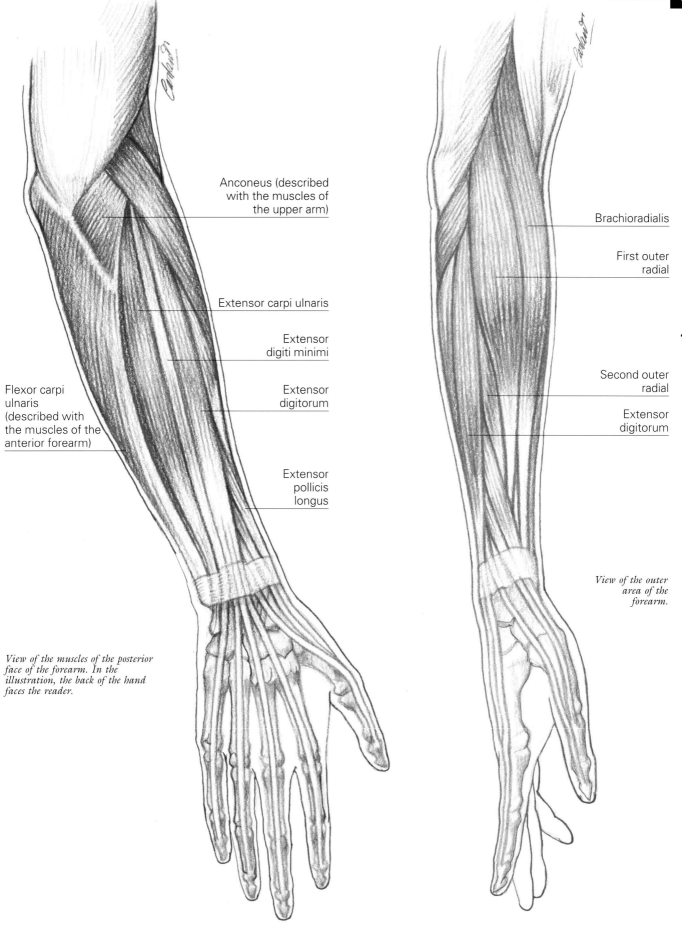

Anconeus (described
with the muscles of
the upper arm)

Extensor carpi ulnaris

Extensor
digiti minimi

Extensor
digitorum

Extensor
pollicis
longus

Flexor carpi
ulnaris
(described with
the muscles of the
anterior forearm)

Brachioradialis

First outer
radial

Second outer
radial

Extensor
digitorum

*View of the outer
area of the
forearm.*

*View of the muscles of the posterior
face of the forearm. In the
illustration, the back of the hand
faces the reader.*

THE ELBOW JOINT

The elbow joint serves a double function. It allows the arm to bend (flexion) or extend (extension). In addition, it allows the arm to turn on its axis (pronation and supination).

The upper arm muscles used in bending the elbow are the biceps and the brachialis; in the forearm, it is the brachioradialis. The muscles used in extending the elbow are the triceps and the anconeus. All these muscles were described in previous sections.

THE SHAPE OF THE ELBOW

The elbow joint has three major features: two due to the humerus and one due to the ulna. The shapes of the humerus are the epicondyle and the epitrochlea. The former is the least noticeable and is located on the outer face of the upper arm. The shape of the epitrochlea is much more salient, and it is located on the inner face. The shape of the ulna is the olecranon (the posterior face of the upper arm), and it is the most representative feature in the shape of the elbow.

PRONATION AND SUPINATION

Pronation and supination occur when the forearm turns on its axis. With the upper arm and the forearm at right angles, the pronation movement orients the palm of the hand downward, with the thumb facing inward; with supination, the palm faces upward, with the thumb point outward. These two movements are not to be confused with turns or rotations of the shoulder while the upper arm is stretched out. Pronation and supination involve only the forearm.

During pronation, the radius turns and crosses over the ulna. In supination, though, both bones remain parallel. The muscles that produce pronation are the pronator teres (studied previously) and the square pronator, which is part of the deep muscle layers of the forearm. As a result, it is of no consequence in the external anatomical shape. The muscles used in supination are the short supinator and the long supinator (studied previously) as well as the biceps.

Pulling on the arm accentuates the shape of the biceps, the brachialis, and the brachioradialis.

Biceps

Brachialis

Brachioradialis

The muscles used in flexing the elbow are located on the anterior face of the upper arm and the forearm; these are the muscles that allow the forearm to fold onto the upper arm and perform tasks related to this movement.

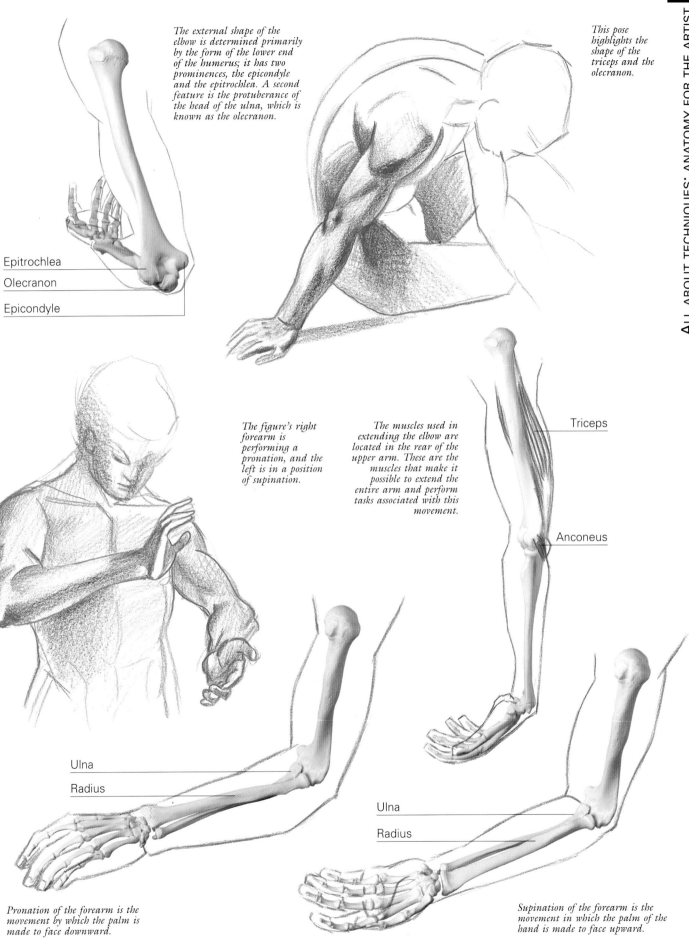

The external shape of the elbow is determined primarily by the form of the lower end of the humerus; it has two prominences, the epicondyle and the epitrochlea. A second feature is the protuberance of the head of the ulna, which is known as the olecranon.

This pose highlights the shape of the triceps and the olecranon.

Epitrochlea

Olecranon

Epicondyle

The figure's right forearm is performing a pronation, and the left is in a position of supination.

The muscles used in extending the elbow are located in the rear of the upper arm. These are the muscles that make it possible to extend the entire arm and perform tasks associated with this movement.

Triceps

Anconeus

Ulna

Radius

Ulna

Radius

Pronation of the forearm is the movement by which the palm is made to face downward.

Supination of the forearm is the movement in which the palm of the hand is made to face upward.

ARM MUSCLES AND MOVEMENTS

The illustrations on these pages are a compendium of what was explained on the previous pages. The arms perform extension, flexion, and turning or rotational movements. The result of a combination of these possibilities is a complete spectrum of muscular arrangements. Each illustration shows the arrangement of the muscles in a typical arm movement. These gestures correspond to different moments in the sequence involving an inward rotation of the arm. In the first four, the rotation is seen from the anterior face of the arm, and in the next four, from the posterior face. Many muscles are visible at different times of the rotation. However, we have to pay attention to identify them since they act like the strands of a rope and appear to be wrapped around the bones.

These illustrations are a visual guide to recognizing all the muscles of the arm in all phases of rotation. These are the shapes we need to take into account when drawing the body.

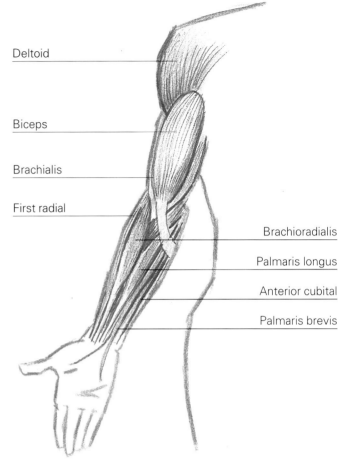

The distribution of the muscles of the upper arm and forearm when both are held in the anatomical position—that is, with the arm held straight and displaying the anterior face, with the palm facing forward.

Deltoid

Biceps

Brachialis

First radial

Brachioradialis

Palmaris longus

Anterior cubital

Palmaris brevis

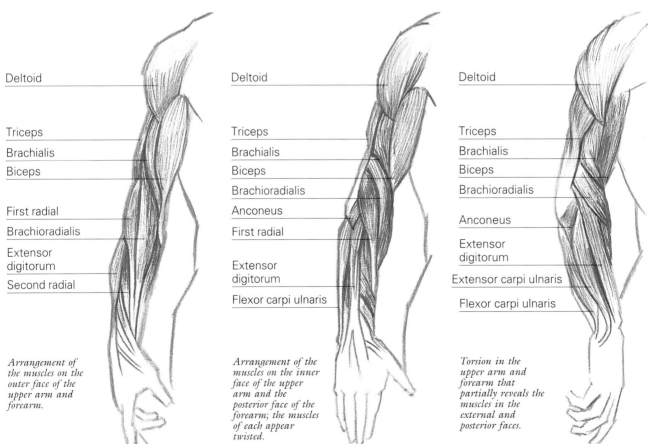

Deltoid

Triceps
Brachialis
Biceps

First radial
Brachioradialis
Extensor digitorum
Second radial

Arrangement of the muscles on the outer face of the upper arm and forearm.

Deltoid

Triceps
Brachialis
Biceps
Brachioradialis
Anconeus
First radial

Extensor digitorum

Flexor carpi ulnaris

Arrangement of the muscles on the inner face of the upper arm and the posterior face of the forearm; the muscles of each appear twisted.

Deltoid

Triceps
Brachialis
Biceps
Brachioradialis

Anconeus

Extensor digitorum

Extensor carpi ulnaris

Flexor carpi ulnaris

Torsion in the upper arm and forearm that partially reveals the muscles in the external and posterior faces.

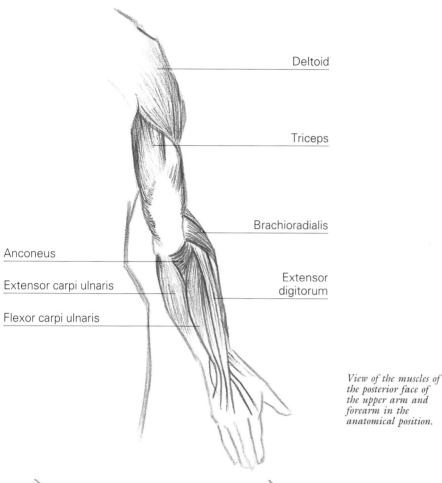

Deltoid

Triceps

Brachioradialis

Anconeus

Extensor carpi ulnaris

Flexor carpi ulnaris

Extensor digitorum

View of the muscles of the posterior face of the upper arm and forearm in the anatomical position.

SUGGESTIONS FOR DRAWING THE UPPER ARM AND FOREARM

In order to understand clearly the arrangement of the muscles in the arms, we have to imagine the upper arm as a stationary bar or a column and the forearm as a movable bar that joins the upper arm at the elbow. As the forearm rotates, the muscles twist around that bar like the fibers of a rope rotating on themselves. We have to keep in mind that in most instances, figures will present one or both forearms in a position that involves that type of muscular tension—in other words, in a position equivalent to one of the poses depicted on these pages. However, showing every muscle individually in the forearm will never be necessary or appropriate. Generally, suggesting the orientation of the brachioradialis (long supinator) on the anterior face or the extensor carpi ulnaris (anterior cubital) on the posterior face will be adequate. In depicting very muscular figures, it may be necessary to highlight other muscles such as the first radial or the palmaris longus on the anterior face or the extensor digitorum and the flexor carpi ulnaris (posterior cubital) on the posterior face.

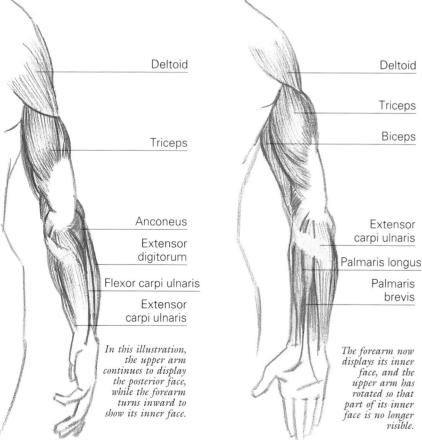

Deltoid

Triceps

Anconeus

Extensor digitorum

Flexor carpi ulnaris

Extensor carpi ulnaris

In this illustration, the upper arm continues to display the posterior face, while the forearm turns inward to show its inner face.

Deltoid

Triceps

Biceps

Extensor carpi ulnaris

Palmaris longus

Palmaris brevis

The forearm now displays its inner face, and the upper arm has rotated so that part of its inner face is no longer visible.

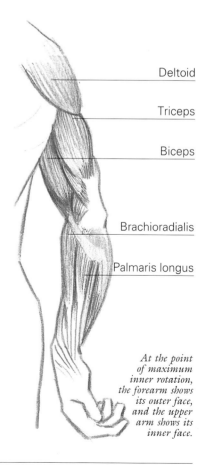

Deltoid

Triceps

Biceps

Brachioradialis

Palmaris longus

At the point of maximum inner rotation, the forearm shows its outer face, and the upper arm shows its inner face.

DRAWING THE ARMS

A practical application of the study of arm anatomy requires a basic knowledge of the muscles as well as careful observation of reality. These two requirements are basic in drawing any kind of figure. However, they are particularly crucial in the case of the arms since arms contain many muscles and there are many possibilities that can arise in their external shape during movement. These pages show a few carefully rendered illustrations. Each one represents the upper arm, the forearm, or both together in a different movement. All the movements depicted are characterized by muscular tension to highlight the shapes.

During flexion, when the arm is tensed to the maximum, the most prominent muscles are always the biceps, the brachioradialis (long supinator), and the extensor carpi ulnaris.

In this flexion of the arm, in addition to the shape of the biceps, we can clearly see the shape of the brachioradialis and the palmaris longus in the anterior face of the forearm.

This view of the upper arm shows the shape of the triceps and the brachialis and, above them, the mass of the biceps. There is a visible furrow between the two muscle groups.

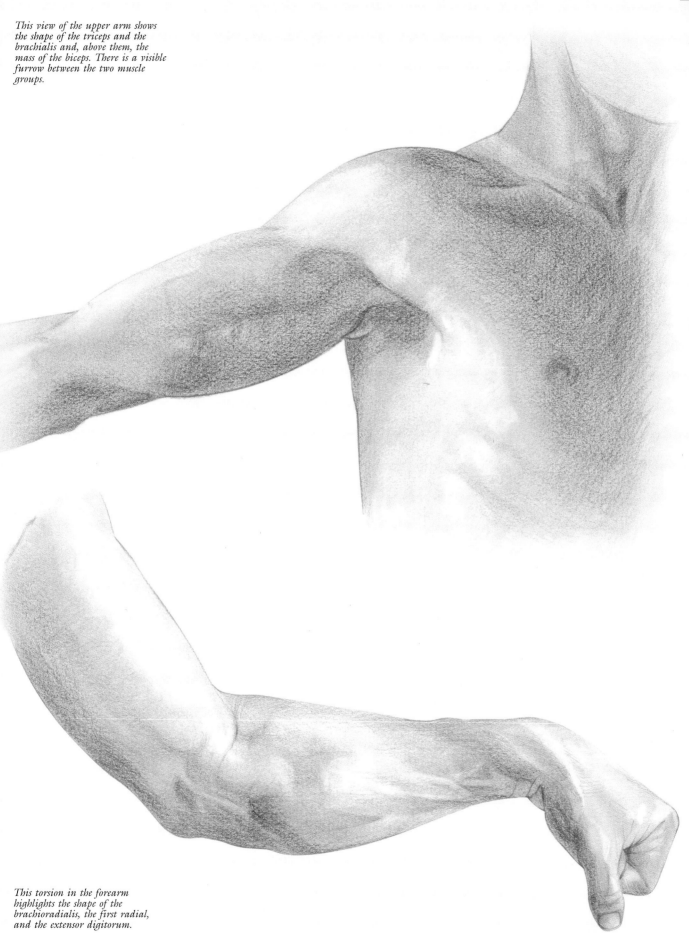

This torsion in the forearm highlights the shape of the brachioradialis, the first radial, and the extensor digitorum.

The Hands

The hands have more joints than any other part of the body. In the following pages, we will describe the many tiny bones and muscles that make up the anatomy of the hands. In addition to the muscles of the hands themselves, there are also the muscles located in the forearm whose sole purpose is to move the hands. Finally, the last pages will deal with the proportions of the hands and how to draw them correctly.

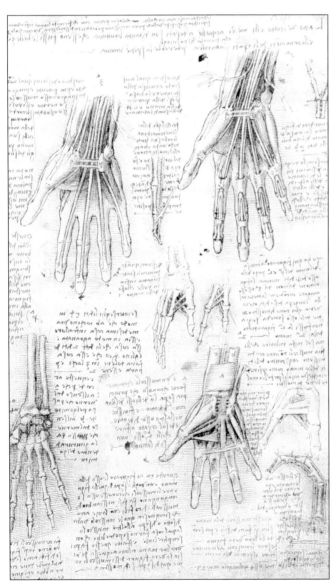

Leonardo da Vinci, Study of Hands. Royal Library, Windsor Castle (Windsor, England).

BONES OF THE HAND

There are three parts to the bones of the hands: the wrist or carpus, the palm or metacarpus, and the fingers or phalanges.

THE CARPUS

The carpus is made up of eight small bones of compact and irregular shape arranged in two rows. The upper row corresponds to the wrist joint, and the lower one corresponds to the joint between the wrist and the bones of the metacarpus. The bones of the upper row, starting on the thumb side, are the scaphoid, the lunate, the triquetral, and the pisiform. The lower row is made up of the trapezium, the trapezoid, the capitate, and the hamate.

The scaphoid, the lunate, and the triquetral bones form a joint with the radius. The hamate, the capitate, the trapezoid, and the trapezium form a joint with the wrist bones (starting with the little finger).

The bones of the carpus make up a curved partition that is concave in shape when viewed from the anterior face of the hand (the palm). From both ends of this partition there extends a tendon like a bridge. The tendons of the flexor muscles for the fingers, located in the forearm, pass under this tendon.

THE METACARPUS

The metacarpus is made up of five long, slender bones. These are known as the metacarpals, and they extend from the carpus to the phalanges. The metacarpals are numbered from one to five starting with the thumb. They are all of different length. The longest of all is the second metacarpal (for the index finger), and the shortest and thickest one is the first (for the thumb). The rest, in descending order by length, are the third, the fourth, and the fifth. The joints that connect the metacarpals and the first phalanges give rise to the knuckles that are visible in the back of the hand.

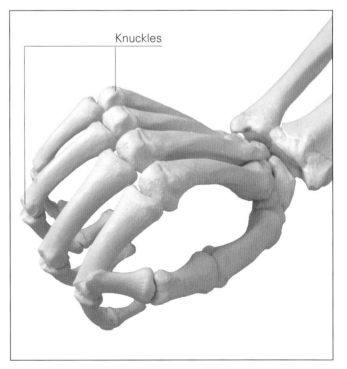

Knuckles

The joints involving the metacarpals and the phalanges are the knuckles on the back of the hand and in the fingers.

THE PHALANGES

These are long, thin bones that form joints with one another. They are designated as proximal (first), middle (second), and distal (third) phalanges. These three phalanges are progressively shorter, and the third or distal phalanges are thinner and shorter. The thumb has just two phalanges.

The bones of the right hand seen from the anterior face (the palm). The bones of the carpus are indicated in blue, the metacarpals in yellow, and the phalanges in three different shades of green. There are just two shades for the phalanges of the thumb.

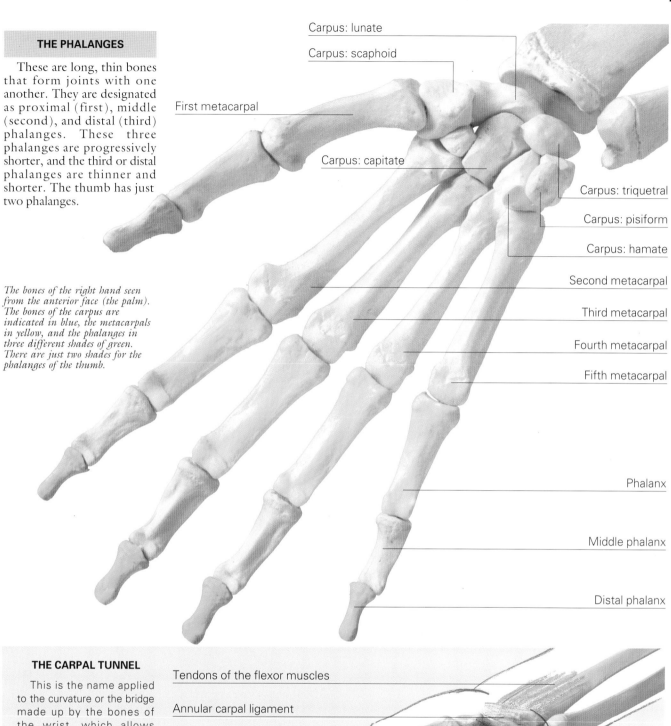

Carpus: lunate
Carpus: scaphoid
First metacarpal
Carpus: capitate
Carpus: triquetral
Carpus: pisiform
Carpus: hamate
Second metacarpal
Third metacarpal
Fourth metacarpal
Fifth metacarpal
Phalanx
Middle phalanx
Distal phalanx

THE CARPAL TUNNEL

This is the name applied to the curvature or the bridge made up by the bones of the wrist, which allows passage of the tendons from the forearm muscles. This curved form also affects the shape of the hand. It keeps the metacarpals from extending along a completely flat plane. Rather, they are slightly concave. When the hand is relaxed, the little finger and the thumb curve toward the inside of the palm.

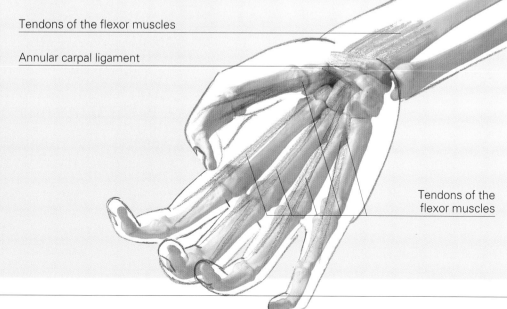

Tendons of the flexor muscles
Annular carpal ligament
Tendons of the flexor muscles

MUSCLES OF THE HAND

The hand muscles are distributed between the back and the palm. Most of them are found in the palm. They are small flexor muscles of the fingers that make flexing the fingers possible. The back of the hand is covered by the tendons that come from the muscles on the posterior face of the forearm. These are responsible for extending the hand rearward. The muscles of the palm are grouped in three areas or regions: the thenar eminence, the middle region, and the hypothenar eminence. The first mentioned is the area at the base of the thumb; the second is the center of the palm; and the third is the base of the little finger or the edge of the hand.

MUSCLES OF THE THENAR EMINENCE

The thenar eminence is made up of four small muscles grouped in a bundle. These are the abductor pollicis brevis, the opponens, the flexor pollicis brevis, and the adductor pollicis. All these muscles control the movement of the thumb, and they are the source of the characteristic swelling in this part of the hand.

THE ABDUCTOR POLLICIS BREVIS

This is the muscle of the thenar eminence that is closest to the surface. It originates in the scaphoid bone of the carpus. It inserts into the outer edge of the first phalanx (the phalanx of the thumb), which it flexes and causes to turn inward.

THE OPPONENS

This muscle is completely covered by the short abductor and does not appear in the illustration even though it does stand out under the abductor near the edge of the palm. It originates in the trapezium bone of the carpus and inserts in the first metacarpal (the metacarpal of the thumb). Its function is to flex this metacarpal.

FLEXOR POLLICIS BREVIS

This muscle is located immediately beneath the opponens. It originates at the trapezium and trapezoid bones in the carpus, and its lower insertion is in the first (proximal) phalanx of the thumb. Its function is to move the thumb inward and forward in a gesture analogous to holding a set of playing cards.

ADDUCTOR POLLICIS

This is a thick, triangular muscle located in the palm of the hand nearly perpendicular to the direction of the thumb and partially hidden. It originates in the metacarpal of the middle finger and inserts in the first (proximal) phalanx of the thumb. Its function is to move the thumb inward, that is, toward the palm of the hand.

HYPOTHENAR EMINENCE

The muscles of the hypothenar eminence, located in the fleshy edge of the hand, are the abductor digiti minimi, the flexor digiti minimi brevis, and the opponens of the little finger. Along with the muscles of the thenar eminence, these are the most varied and the strongest muscles of the hand. This is indicated by the greater mobility in the thumb and little finger areas, compared with the rest of the fingers, with respect to all functions involving grasping, holding, and manipulating objects.

Lumbricals

Adductor pollicis

Flexor pollicis brevis

Flexor digiti minimi brevis

Abductor pollicis brevis

Abductor digiti minimi

View showing the muscles of the anterior face of the right hand. In the palm of the hand, the muscles are distributed in three main areas: the thenar eminence (at the base of the thumb), the middle region or palm, and the hypothenar region at the base of the little finger.

ABDUCTOR DIGITI MINIMI

This is a small muscle in the innermost part of the hand. It originates in the pisiform bone of the carpus and inserts in the base of the first phalanx of the little finger. Its function is to move the little finger outward. Its shape is clearly visible on the surface, where it contributes to the shape of the hand.

FLEXOR DIGITI MINIMI BREVIS

Similar in shape to the abductor digiti minimi, this muscle follows a more oblique path relative to the little finger; it originates in a more central bone of the carpus (the hook of hamate and flexor retinaculum). This muscle inserts in the inner edge of the first phalanx of the little finger. Its function is to move the little finger toward the palm of the hand.

OPPONENS DIGITI MINIMI

This muscle is located under the two tendons; it is almost entirely hidden by them and does not appear in the illustration. It originates in the hamate bone of the carpus and inserts in the metacarpal of the wrist. Its function is to move the little finger inward and forward in a gesture of opposing the little finger to the thumb.

THE PALM

The palmar region, as the name indicates, is located in the center of the hand. It is made up of the interosseous and lumbrical muscles. These are small muscles, and therefore they are not capable of great effort. Their only function is to separate or move the fingers together and facilitate their articulation.

INTEROSSEOUS

These muscles get their name because of their location in the spaces between the metacarpal bones. There are two types of interosseous bones: palmar and dorsal, depending on whether they are located in the palm or the back of the hand. All these muscles originate in the metacarpal bones and end with their respective insertions in each of the first phalanges of the fingers, with the exception of the thumb. The palmar interosseous are adductors for the fingers (moving them toward the center of the hand); the dorsal interosseous are flexors for the fingers as well as abductors (moving them away from the center of the hand).

LUMBRICALS

These are four small muscles located closer to the surface than the palmar interosseous. They do not originate at a bone but, rather, at another muscle or, more specifically, at the tendons of other muscles: at the tendons of the common flexor of the fingers. They insert into the first phalanges of all the fingers except the thumb. The lumbricals are for flexion and abduction (separation) of the four fingers.

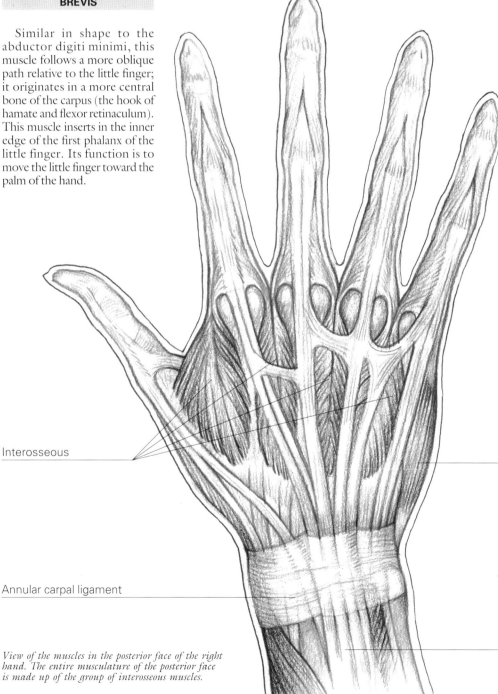

Interosseous

Abductor digiti minimi

Annular carpal ligament

Tendons of the common extensor of the fingers

View of the muscles in the posterior face of the right hand. The entire musculature of the posterior face is made up of the group of interosseous muscles.

SHAPE AND PROPORTION OF THE HANDS

The hands can be an artistic subject unto themselves because of their mobility and articulation. They are the part of the body that can present the greatest number of different positions since they are made up of five appendages with three joints in each one.

Next we will study the general proportions of the hands and offer a few useful hints so that artists can represent them properly.

PROPORTIONS

Ideally, the total length of the hand (from the base of the thumb to the end of the middle finger) is equal to twice its width. When framing the drawing of a hand in a rectangle of these proportions, the midline of the rectangle (the one that divides it into two equal squares) will coincide with the knuckles and the last phalanx of the thumb on the back and with the prominence at the base of

the fingers on the palm. This indicates that the length of the middle finger is equivalent to half the total length of the hand. The index and ring fingers are the same length, a little shorter than the middle finger, and the little finger extends approximately to the last (distal) phalanx of the ring finger.

THE THUMB

The thumb deserves a couple of marginal comments because its shape and movement are clearly different; it is also distinguished by the way it fits into the general proportions of the hand. With the fingers together, the tip of the thumb continues the nearly perfect arc formed by the joints of the first and second phalanges of the other fingers. With abduction of the thumb (moving it away from the palm), its tip traces another ideal arc that is not an exact extension of the previous one since it starts at the origin of the metacarpal of the thumb rather than at the metacarpal of the middle

finger. However, when the thumb is separated most widely from the other fingers, the artist can see that the joint that connects the first and second phalanges is really aligned with the extension of the arc previously mentioned.

The thumb is located in a different plane from the rest of the fingers so that when the hand is viewed in profile, the thumb appears further to the front than the other fingers. Conversely, in a dorsal view of the hand, the thumb is seen more in profile.

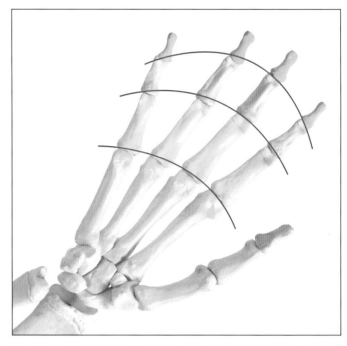

The joints of the metacarpal bones and the phalanges are arranged in nearly concentric arches that are especially noticeable when the fingers are separated.

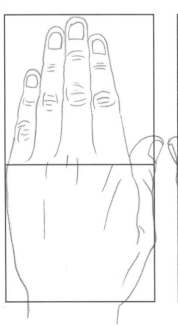

The hand can be contained inside a rectangle that is twice as long as it is wide. The midline of this rectangle coincides approximately (on the back of the hand) with the knuckles of the metacarpals.

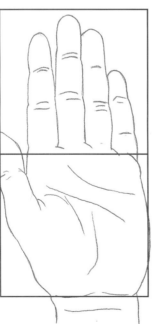

The midline of the rectangle that gives proportion to the hand coincides (on the palm) with the base of the fingers.

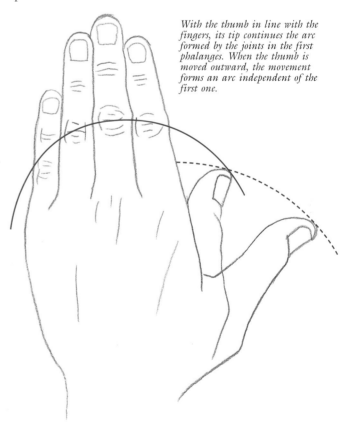

With the thumb in line with the fingers, its tip continues the arc formed by the joints in the first phalanges. When the thumb is moved outward, the movement forms an arc independent of the first one.

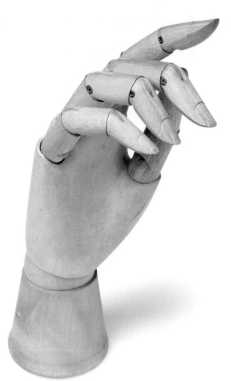

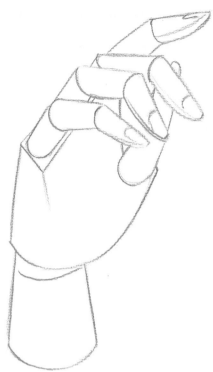

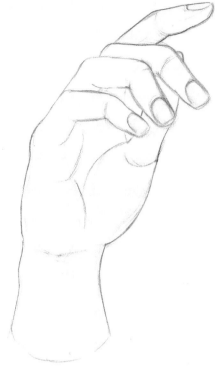

An articulated wooden hand is a very useful accessory for artists since it allows a practical study of all possible finger positions and provides an immediate model for drawing.

By using the position of the articulated hand, we can make sketches that correspond to the palm and each of the fingers to get the proportions correct.

It is an easy transition from the rough sketch to the finished drawing. We merely need to transform the joints of the articulated hand into real joints and make the movement look more natural.

This position of the articulated hand suggests the action of a pianist: each finger is in a different position.

By using the gesture of the articulated hand, the fingers are drawn, paying attention to their position and the relative proportions.

LOCATION OF THE JOINTS

The joints in the bones are located along different, fairly concentric arcs. These ideal arcs can also be located in any position of the hand as long as the fingers are located in the same plane. This is a great aid to the artist. It means that the position and the size of any finger can be deduced easily from the position and size of any other finger.

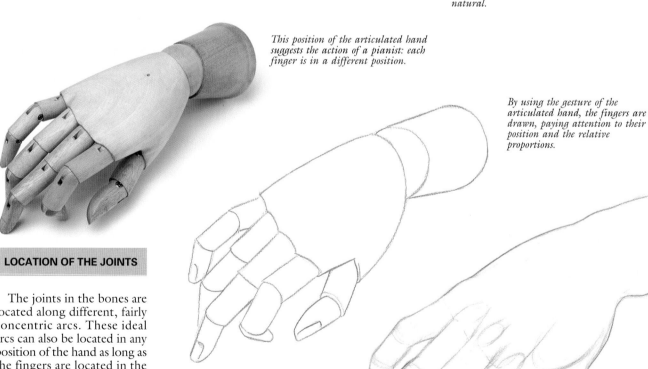

The straight lines from the previous sketch are rounded and softened to achieve a natural and realistic representation of the hand.

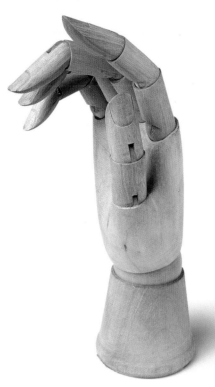

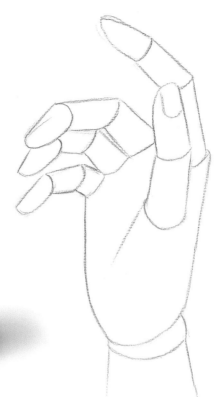

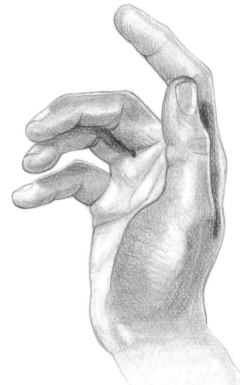

The articulated hand can adopt practically any gesture of a real hand, and the artist merely needs to adjust the somewhat stylized proportions to the realities of a specific hand.

Here is the sketch based on the position of the articulated hand; the point of view has been slightly changed to adapt it to the purposes of the final drawing.

The finished drawing, properly modeled and shaded, is a slight modification of the initial position of the articulated hand. Naturally, in arriving at this result, the artist must also refer to a real hand since the wooden model offers only a general outline of the movement.

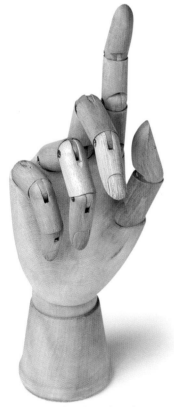

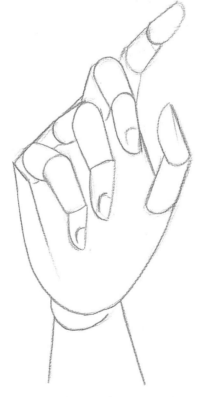

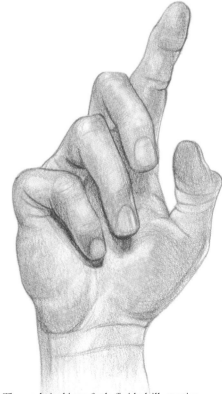

Here is a more frontal position than the previous one. It shows how the fingers are jointed along the palm and creates foreshortening (shortening due to perspective) in most of the phalanges.

The rough sketch reflects the position of the articulated hand with few changes and provides a good basis for a realistic illustration.

The result is this perfectly finished illustration in which the schematic shapes of the articulated hand have been modified by a detailed observation of a real hand in the same or a similar position.

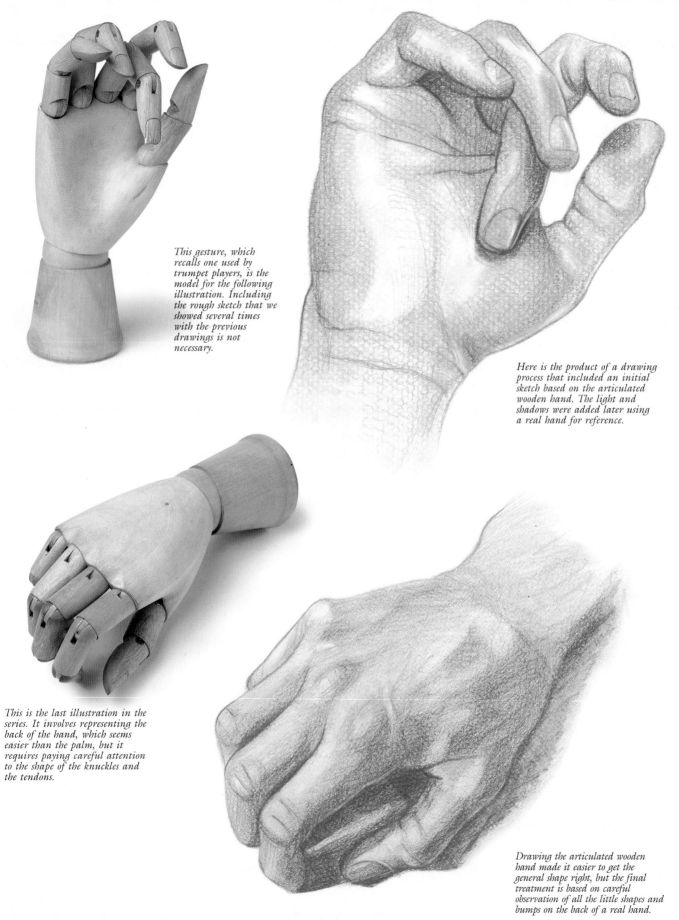

This gesture, which recalls one used by trumpet players, is the model for the following illustration. Including the rough sketch that we showed several times with the previous drawings is not necessary.

Here is the product of a drawing process that included an initial sketch based on the articulated wooden hand. The light and shadows were added later using a real hand for reference.

This is the last illustration in the series. It involves representing the back of the hand, which seems easier than the palm, but it requires paying careful attention to the shape of the knuckles and the tendons.

Drawing the articulated wooden hand made it easier to get the general shape right, but the final treatment is based on careful observation of all the little shapes and bumps on the back of a real hand.

The Legs

rom an anatomical viewpoint, the legs are considered the lower limbs. Each leg is divided into four areas: the pelvis, the thigh, the lower leg or calf, and the foot. The pelvis was already presented in this book, and the foot will be dealt with later. Right now we will study the thigh and the lower leg or calf.

BONES OF THE LEG

The bones of the leg, consisting of the thighbone and the bones of the lower leg, are four in number: the femur or thighbone, the kneecap or patella, the tibia, and the fibula. These last two are the bones of the lower leg or calf.

Leonardo da Vinci, Drawings of Leg Bones and Muscles. Royal Library, Windsor Castle (Windsor, England).

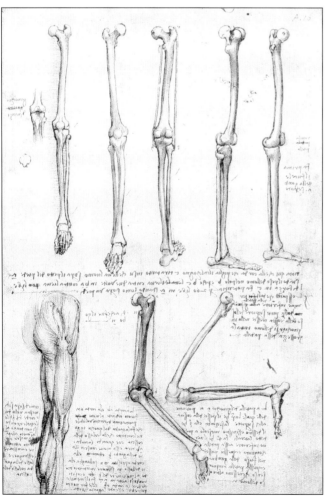

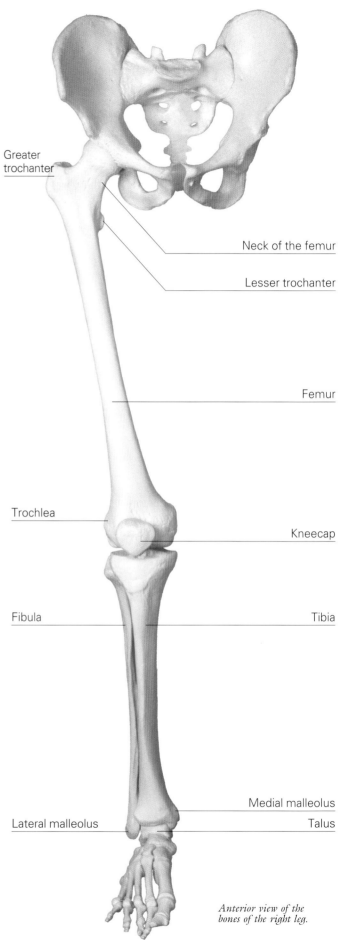

Greater trochanter

Neck of the femur

Lesser trochanter

Femur

Trochlea

Kneecap

Fibula

Tibia

Medial malleolus

Lateral malleolus

Talus

Anterior view of the bones of the right leg.

THE FEMUR

The femur is the longest and strongest bone in the body. At its upper end, it joins with the pelvis (the iliac bone of the pelvis). At its lower end, it rests on the tibia. The body of the femur is nearly triangular in cross section, rather than cylindrical. At the lower end, it broadens to form a sort of inverted column, similar to that of the tibia at its upper end. This makes it possible for both bones to form a thick body at the knee joint, thereby improving resistance to the pressures and loads to which the leg is subjected. The upper end of the femur has a rounded head similar to the top of the humerus. This head joins the body of the bone through a section known as the neck of the femur. At the junction of the body of the femur with the neck is a thick tuberosity known as the greater trochanter on the outer face of the bone; there is also another smaller one known as the lesser trochanter on the inner face of the femur. The other part of the greater trochanter is slightly visible on the outside of the hip. On the posterior face of its lower end, the femur has some prominent features associated with the joint; they are fairly symmetrical and are known as condyles. These shapes continue toward the anterior face and constitute a joint surface that resembles a pulley; it is known as a trochlea. The outer face of the trochlea is visible on the outer part of the leg.

THE KNEECAP

The kneecap is a short, nearly triangular-shaped bone that forms a joint with the trochlea of the femur. Its main function is to protect the tendon of the quadriceps, to which it is attached. This sturdy tendon slides through the femoral trochlea like a rope through a pulley. The kneecap acts as a shield that protects the tendon, and it is perfectly visible on the outside of the knee.

THE TIBIA

The larger of the bones in the lower leg is the tibia; it is located on the inner part of the calf. At the top, it forms a joint with the femur and at the lower end, with the talus, which belongs to the carpus (the ankle bones). As with the femur, the tibia is nearly triangular in cross section. The tibia has a clear influence on the outer shape of the calf; it gives rise to a flat area located in the inner front part of the leg. Also, the protuberance of its lower end produces the shape of the medial malleolus of the ankle.

THE FIBULA

This is a large, slender bone located toward the outside and behind the tibia. Its lower end forms a joint with the tibia and the talus (an ankle bone). Between the fibula and the tibia is a space that is actually closed by a strong membrane that serves as an insertion point for the leg muscles.

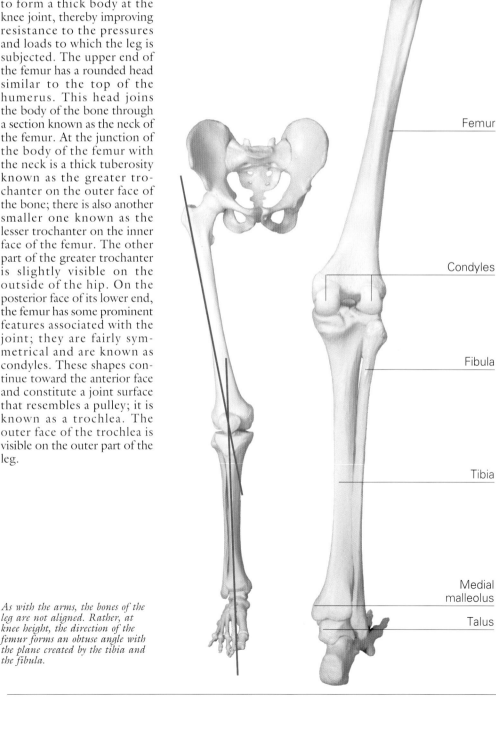

Greater trochanter

Lesser trochanter

Femur

Condyles

Fibula

Tibia

Medial malleolus

Talus

As with the arms, the bones of the leg are not aligned. Rather, at knee height, the direction of the femur forms an obtuse angle with the plane created by the tibia and the fibula.

Posterior view of the bones of the right leg.

SPECIFIC PARTS OF THE LEGS

The bony and muscular shapes of the legs are more pronounced than in the arms if we compare both limbs in repose. Because of their support function, the muscles of the lower limbs are larger and always show some tension that makes them even more noticeable. When seen from the front, the shape of the quadriceps stands out, along with the knee and the tibia. In a lateral view, the calf muscles are particularly noticeable. In a rear view, the popliteal hollow, the calf muscles, and the hamstring muscles are visible, among other features. All the muscles and bones indicated here are described in the pages devoted to the muscles and bones of the gluteals, the thigh, and the calf.

ANTERIOR VIEW

The most visible features in a frontal view of the leg are the shape of the quadriceps,

the kneecap, and the outlines of the calf muscles dominated by the tibia. The illustration on this page also shows the shape of the adductor muscles of the thigh and the sartorius.

OUTER SIDE VIEW

If we observe the first illustration on the following page, we see the large mass of the thigh, dominated by the

quadriceps, the shape of the tibia, the fibula, and the calf muscles in the lower leg. Both legs clearly show the fold that forms above the kneecap when the quadriceps muscle is totally relaxed.

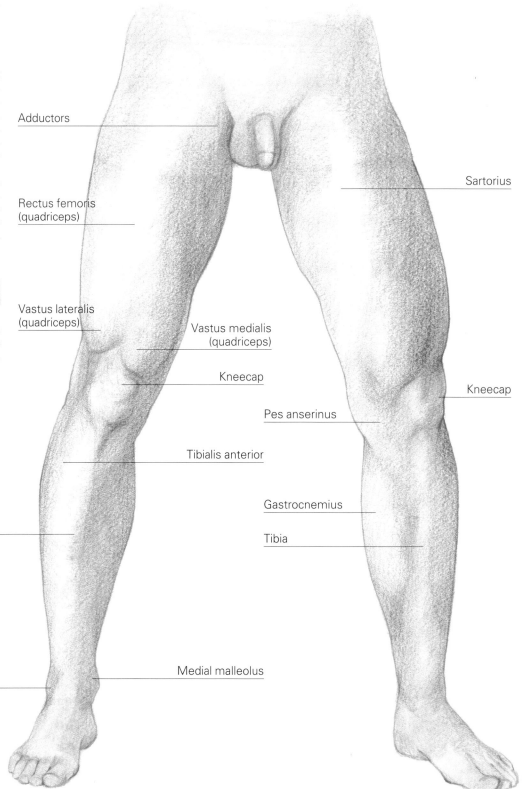

Adductors

Rectus femoris (quadriceps)

Vastus lateralis (quadriceps)

Vastus medialis (quadriceps)

Kneecap

Tibialis anterior

Tibia

Lateral malleolus

Sartorius

Kneecap

Pes anserinus

Gastrocnemius

Tibia

Medial malleolus

Anterior view of the legs.

POSTERIOR VIEW

Under tension, the leg reveals many shapes of both muscles and tendons. In the upper leg the muscles that stand out are the quadriceps and the biceps femoris; in the lower leg it's the calf muscles, the soleus, and the peroneals. The tendons of the hamstring, the fasciae latae, and the semitendinosus muscle are also visible, as is the Achilles tendon.

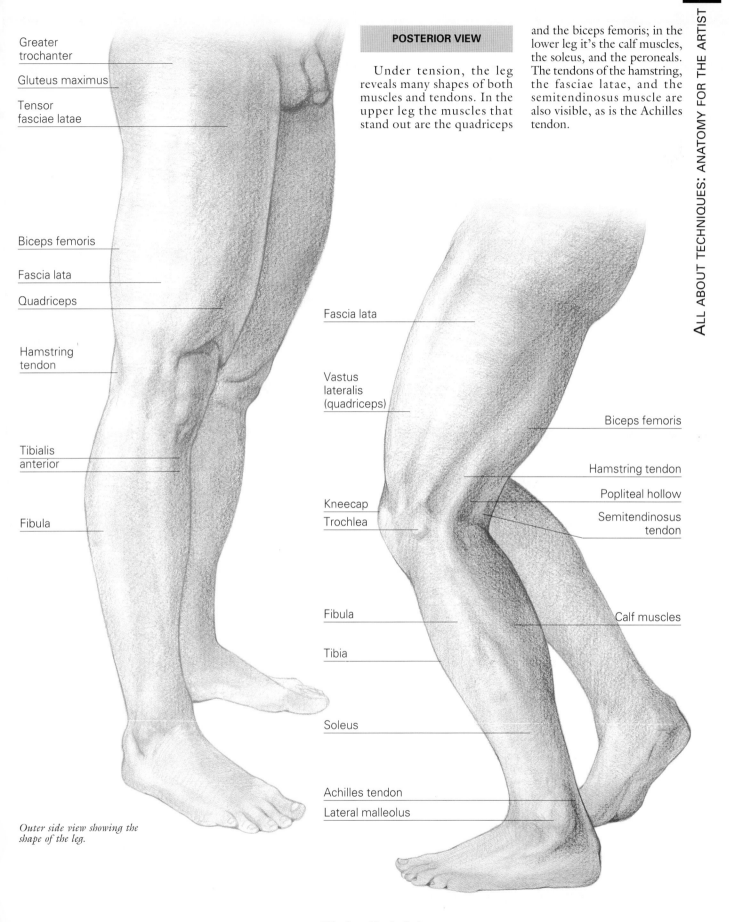

Greater trochanter

Gluteus maximus

Tensor fasciae latae

Biceps femoris

Fascia lata

Quadriceps

Hamstring tendon

Tibialis anterior

Fibula

Fascia lata

Vastus lateralis (quadriceps)

Biceps femoris

Hamstring tendon

Popliteal hollow

Semitendinosus tendon

Kneecap

Trochlea

Fibula

Calf muscles

Tibia

Soleus

Achilles tendon

Lateral malleolus

Outer side view showing the shape of the leg.

Side view of leg in flexion.

THE GLUTEAL MUSCLES

The gluteal muscles are four in number: the gluteus maximus, the gluteus medius, the gluteus minoris, and the tensor fasciae latae. Generally speaking, all these muscles except for the gluteus minoris are close to the surface of the leg. There is also a set of six deep muscles located in the gluteal region; they occupy the space defined by the pelvis, the upper end of the femur, and the sacrum. This group of muscles will not be treated here since they have no effect on the outer shape of the hip.

THE GLUTEUS MAXIMUS

This is the largest and most powerful muscle of the body. It is located at the rear of the pelvis. It consists of two superimposed planes or fascicles that follow the same oblique path from top to bottom, starting at the rear of the iliac crest and the posterior of the sacrum and continuing to the upper part of the femur. The gluteus maximus makes up all the muscular shape of the buttocks, which tends to be larger than the true muscle mass because of the typical adipose deposits in the gluteal area, especially in female figures.

The function of the gluteus maximus is to extend the thigh with respect to the pelvis (moving the thigh rearward) and turning it outward. In addition, this muscle makes it possible to maintain the vertical position of the trunk and incline it to the rear.

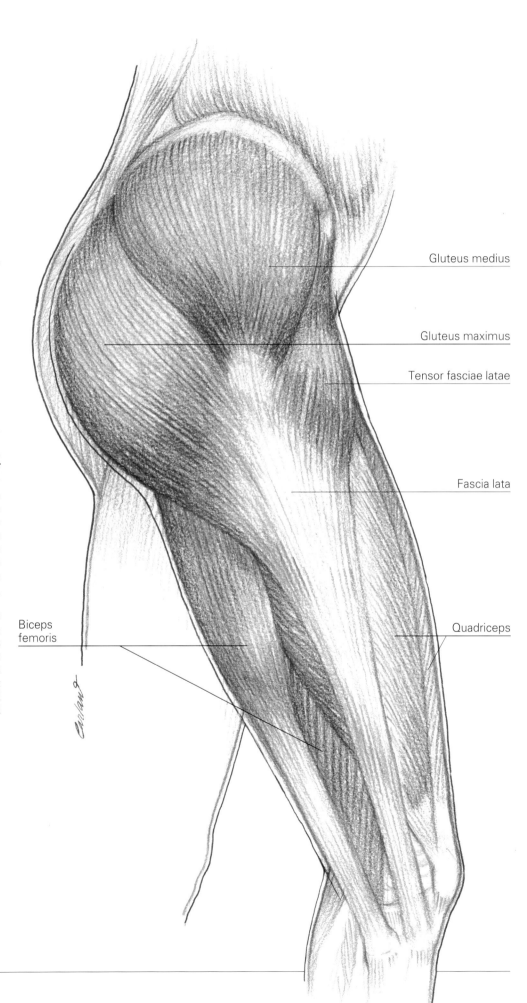

Gluteus medius

Gluteus maximus

Tensor fasciae latae

Fascia lata

Quadriceps

Biceps femoris

Outer side view of the gluteal muscles and the right thigh.

THE GLUTEUS MEDIUS

This muscle is located on the outer face of the hip and is shaped like a fan. It originates in the middle of the outer iliac fossa (underneath the iliac crest). Its fibers converge toward the bottom, where they insert into the outer face of the greater trochanter. The muscle fibers are covered by an aponeurosis that extends the fascia lata upward in such a way that the gluteus medius can be confused with it in anatomical drawings. When the gluteus medius contracts, it causes abduction of the thigh. It also makes rotating the thigh inward possible.

Raphael, Study of Nude Men. *Graphische Sammlung Albertina (Vienna, Austria). In the figure seen from the back, the shapes of the gluteus maximus and the gluteus medius are visible as well as the slight protuberance of the greater trochanter of the femur under the latter muscle. The function of the gluteus maximus, as the tension in the figure demonstrates, is to extend the leg rearward.*

THE GLUTEUS MINORIS

This small muscle originates in the outer iliac fossa in front of the gluteus medius; it too inserts in the outer face of the greater trochanter. It is covered by the tensor fasciae latae. Its action is the same as that of the gluteus maximus and the gluteus medius.

THE TENSOR FASCIAE LATAE

The fascia lata is a fibrous band that goes around the whole outer face of the muscle. The tensor fasciae latae is located in the upper part of this band. It is a small muscle that covers the gluteus minoris and follows the same direction. The tensor originates in the iliac spine and ends in the upper part of the fascia lata. This muscle is responsible for flexion, abduction, and inward rotation of the thigh as well as for extending the knee and rotating it outward when bent.

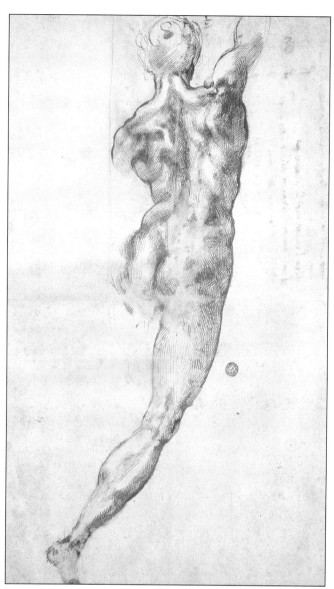

Michelangelo, Rear View of Nude Figure. *Royal Library, Windsor Castle (Windsor, England). The contraction of the gluteus maximus, which is clearly visible in the drawing, is responsible for extending the leg.*

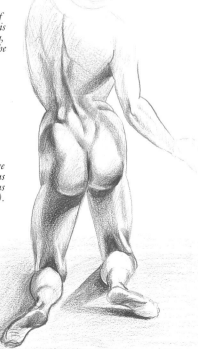

This drawing shows the large shapes of the gluteus maximus and the gluteus medius (above the former muscle).

THE THIGH MUSCLES

As with the forearm, the muscles of the thigh can be studied according to their position in the anterior, posterior, inner, or outer face of the thigh. Two muscles are on the anterior face: the sartorius and the quadriceps femoris. The posterior face has three muscles: the biceps femoris or hamstring, the semitendinosus, and the semimembranosus. The outer face is dominated by the fascia lata, and the inner face has the adductors and the gracilis.

OUTER FACE: THE FASCIA LATA

Strictly speaking, this is not a muscle but rather a broad, thick, fibrous sheet that descends vertically along the entire thigh until it inserts into the outer face of the head of the tibia. Its function was described earlier in the section that dealt with the tensor fasciae latae.

ANTERIOR FACE: THE SARTORIUS

This is the longest of all the muscles in the body. It is a slender muscle that runs close to the surface for its entire length and wraps around the thigh. It originates in the iliac spine and continues around the thigh along the inner surface until it inserts into the upper and inner part of the tibia. This insertion takes place in a tendinous area known as the pes anserinus, which is also where the rectus femoris and the semi-tendinosus muscles insert. The sartorius has a combined effect on the hip and the knee. It flexes the thigh and the knee. And it allows the thigh to rotate outward.

ANTERIOR FACE: THE QUADRICEPS FEMORIS

This is a large muscle that surrounds the femur and is divided into four heads. They are connected at the bottom by a powerful tendon that they share. This tendon inserts into the kneecap and the upper part of the tibia. The deepest head corresponds to the crural muscle that surrounds the femur, and it is not visible under the skin. The femoris muscle is surrounded and completely encased by the large heads of the vastus lateralis and the vastus medialis, which form a type of sheath around the femur. The fourth head of the quadriceps is the rectus femoris, which crosses the two vastus muscles in the front and goes from the iliac spine to the common tendon.

The quadriceps, which is one of the most powerful muscles in the body, extends the knee (the movement of kicking something). When the knee is bent, it contributes to rotation of the calf.

POSTERIOR FACE: THE BICEPS FEMORIS

In its upper part, the biceps femoris or hamstring has two heads that originate in the ischial bones of the pelvis and the upper part of the femur. These two heads join in a strong tendon that inserts into the posterior, outer face of the head of the ulna. The biceps femoris allows flexing the leg at the knee and extending the thigh outward from the torso.

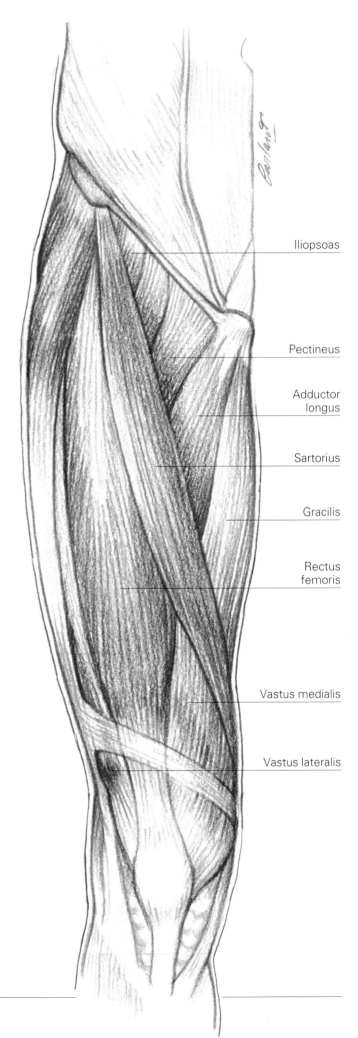

Iliopsoas

Pectineus

Adductor longus

Sartorius

Gracilis

Rectus femoris

Vastus medialis

Vastus lateralis

View of the anterior face of the thigh. The lower labels do not refer to the quadriceps but to its three superficial heads: the vastus lateralis, the vastus medialis, and the rectus femoris.

POSTERIOR FACE: THE SEMITENDINOSUS

This is an elongated muscle that originates at the ischium of the pelvis and attaches at the tendinous area known as the pes anserinus, along with the tendons of the gracilis and the sartorius. All of these insert into the head of the tibia. This muscle is responsible for extending the thigh with respect to the pelvis, and it rotates the calf inward.

POSTERIOR FACE: THE SEMIMEMBRANOSUS

Like the semitendinosus muscle, this muscle originates in the ischium of the pelvis and inserts into the inner, posterior face of the head of the tibia. It is covered by the semitendinosus muscle for nearly all of its extension and serves the same function as that muscle.

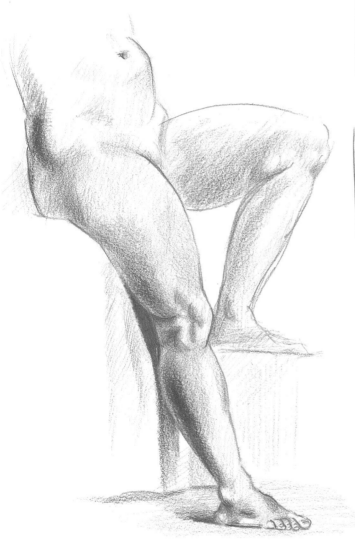

The anatomical shapes of the female figure are always more rounded, less angular, and less sinewy than those of the male. This characteristic is especially visible in the thigh. This drawing shows how the entire muscle mass of the outside face of the thigh is contained in a large shape that is interrupted only by the jumble of tendons (from the biceps femoris, the fascia lata, and the quadriceps) at the knee. The muscles of the calf are likewise contained in a single shape provided by the calf muscles on the posterior face and by the tibialis anterior.

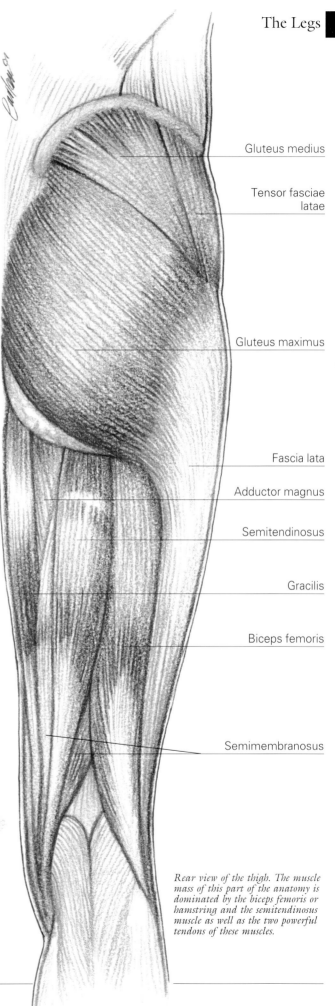

Gluteus medius

Tensor fasciae latae

Gluteus maximus

Fascia lata

Adductor magnus

Semitendinosus

Gracilis

Biceps femoris

Semimembranosus

Rear view of the thigh. The muscle mass of this part of the anatomy is dominated by the biceps femoris or hamstring and the semitendinosus muscle as well as the two powerful tendons of these muscles.

INNER FACE:
THE PECTINEUS

This is a short, flat muscle that originates in the pubis and inserts in the upper and inner part of the femur. The fatty layer that covers it makes it scarcely visible on the outside. This is an adductor muscle for the thigh, in other words, a muscle that moves the thigh toward the central axis of the body.

INNER FACE:
THE ADDUCTORS

As the name indicates, the adductors perform the function described under the pectineus. There are three adductors: the brevis, the longus, and the magnus. All of them originate in the pubis and insert along the inner face of the femur. These muscles move the thigh inward, and all of them together help shape the upper and inner face of the thigh.

INNER FACE: THE GRACILIS

This is a long, slender muscle that originates in the pubis and descends vertically to join the tendons in the pes anserinus. It inserts into the inner face of the head of the tibia. It is also a thigh adductor in addition to promoting flexion of the calf with respect to the thigh.

INNER FACE:
THE ILIOPSOAS

This muscle has two parts. The shorter part originates on the inner face of the iliac crest and the longer one on the apophysis of the last dorsal vertebra and the five lumbar vertebrae. These two bodies insert into the lesser trochanter. This muscle is not visible under the skin; its function is to flex, adduct, and rotate the thigh inward.

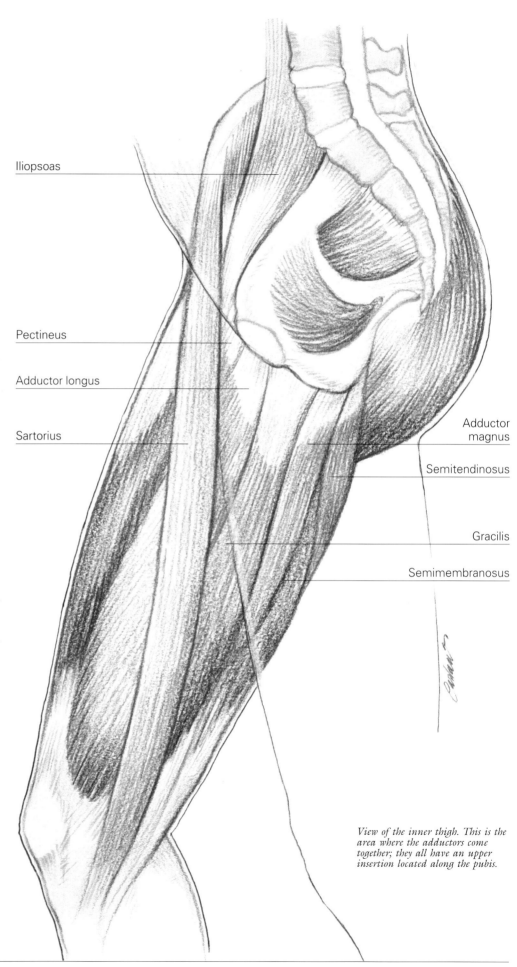

Iliopsoas

Pectineus

Adductor longus

Sartorius

Adductor magnus

Semitendinosus

Gracilis

Semimembranosus

View of the inner thigh. This is the area where the adductors come together; they all have an upper insertion located along the pubis.

THE CALF MUSCLES

The four typical regions of muscle areas (anterior, posterior, outer, and inner) are reduced to three in the case of the calf since their inner area is dominated by the tibia, and there are no muscles that can be seen from the other faces. As a result, these pages will show three views: the anterior, the posterior, and the outer.

Tibialis anterior

Gastrocnemius

Peroneus longus

Tibia

Soleus

Extensor digitorum longus

Extensor hallucis longus

Annular ligament of the tarsus

Anterior view of the calf muscles. The main shape is determined by the tibia, on both sides of which the muscles are arranged.

ANTERIOR VIEW

The muscles of the calf that are identifiable in an anterior view are the tibialis anterior, the extensor digitorum longus, the extensor hallucis longus, and the peroneus longus. The first three are located between the tibia and the fibula. They go from the upper part of the tibia down to the foot. They pass through a solid, tendinous ring located in the ankle that holds them to the skeleton: the annular ligament of the tarsus, which originates in the heel bone (the one furthest to the rear of the foot) and goes around the ankle, attaching to the medial malleolus.

TIBIALIS ANTERIOR

This muscle originates in the upper part of the outer face of the tibia, in the interosseal ligament that connects it to the fibula, and, partially, in a tuberosity of the head of the tibia. It goes down along this bone until it turns into a long tendon that goes under the annular ligament of the tarsus and inserts into the first metatarsal of the foot (the metatarsal of the big toe). The shape of the tibialis anterior can be seen in a side view of the calf as a slight bulge in the front face between the lower part of the knee and the upper part of the instep. It is an adductor muscle, and its function is to pull up on the inner edge of the foot.

EXTENSOR DIGITORUM LONGUS

This muscle has practically the same origin as the tibialis anterior. It descends along the same path as that muscle (although further toward the outside), likewise passing beneath the annular ligament of the tarsus and dividing into four tendons. These tendons extend to the last four toes (all the toes except for the big toe), and they insert into the second and third phalanges after dividing again. Their function is to extend the toes as well as to flex and abduct the foot.

EXTENSOR HALLUCIS LONGUS

This muscle is located between the tibialis anterior and the extensor digitorum longus, and these muscles hide it almost completely. It originates in the lower part of the inner face of the fibula, goes down along this bone, and slips under the annular ligament of the tarsus, inserting at the base of the second phalanx of the big toe. It is used to extend this toe. When it contracts in conjunction with the two previous muscles, the tension in its tendon is clearly visible under the skin of the foot.

THE TWO PERONEUS MUSCLES

These muscles really belong to the outer face of the calf, but they are mentioned here because they are also visible in a frontal view. The one closer to the surface is the peroneus longus. It originates at the head of the fibula and the head of the tibia. It goes down vertically along the fibula until it forms a long tendon that slips beneath the lateral malleolus, like a rope in a pulley. Next, it crosses the sole of the foot and inserts into the first metatarsal (the metatarsus of the big toe). It is used in extending the foot, lowering its outer edge and the tip of the foot, and turning it toward the outside, as in classical dance steps.

The peroneus brevis originates in the middle, outer area of the fibula, and its tendon follows the same path as that of the peroneus longus. However, it inserts in the metatarsal of the little toe. This muscle is used for abduction of the foot and for turning it outward.

POSTERIOR VIEW

The posterior view of the calf is dominated by the powerful shape of the calf muscles. This shape is due to two layers of muscle. The innermost one is the soleus, and the outer one is the calf muscle gastrocnemius. Both muscles join at the Achilles tendon, which inserts into the heel bone.

THE SOLEUS

This is a broad, thick muscle that is covered by the gastrocnemius. Its flanks are visible on both sides of the gastrocnemius. It originates on the posterior face of the head of the fibula and the upper part of the tibia, and it goes down vertically to insert into the Achilles tendon. It is used in extending the foot with respect to the leg and also for rotating the foot inward.

THE GASTROCNEMIUS

These are the strongest muscles of the calf and are made up of two bodies of muscle. Their two tendons originate in two condyles of the posterior face of the femur, and they have a common insertion in the Achilles tendon. These two muscles account for the characteristic curve of the calf. In conjunction with the soleus, the gastrocnemius make it possible to stand on tiptoe, and they are also used in bending the knee.

THE ACHILLES TENDON

This is the largest and strongest of the tendons in the body. It occupies the lower half of the rear face of the calf, and the calf muscles and the soleus connect to it. Its lower insertion is into the heel bone.

DEEP MUSCLES

In addition to the muscles already mentioned, there are some other ones that occupy deeper layers and that are not visible on the surface of the calf: the plantaris, the flexor digitorum longus, the tibialis posterior, the flexor hallucis longus, and the popliteal. All these muscles are nearly or completely hidden beneath the mass of the soleus and the gastrocnemius.

Posterior view of the calf muscles. In the posterior face, the shape of the calf is almost entirely dominated by the large volume of the gastrocnemius and the Achilles tendon. The soleus muscle protrudes slightly on both sides of this tendon (the inner and outer faces of the calf). It is encased between the gastrocnemius and the peroneus longus.

The knee joint and the shape of the calf are less pronounced in female figures than in males. Still, the curvature of the calves is visible in the rear, as is the slight prominence of the tibialis anterior muscle in the front.

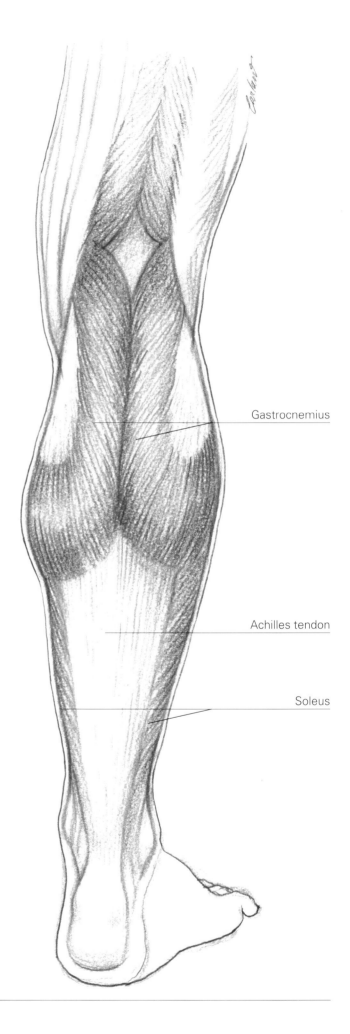

Gastrocnemius

Achilles tendon

Soleus

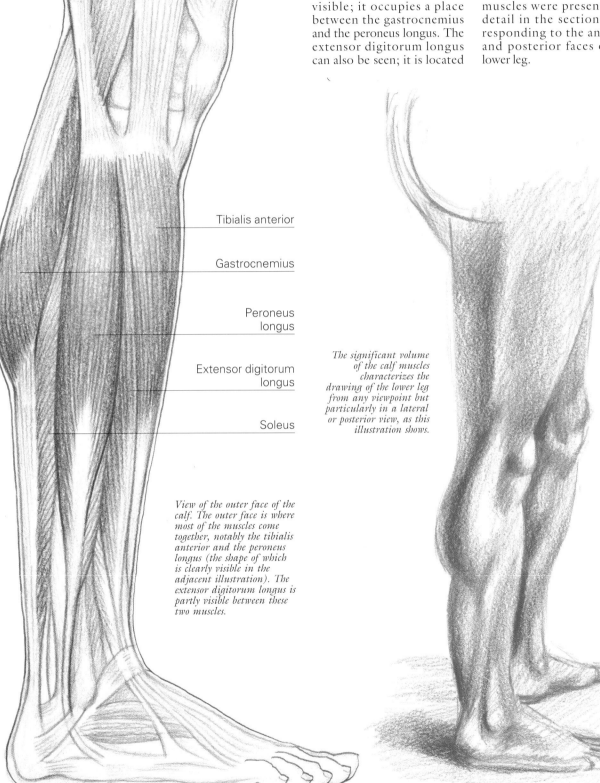

OUTER VIEW

The peroneal muscles appear along the entire outer face of the calf, especially the peroneous longus, which runs from the knee to the lateral malleolus. The soleus is also visible; it occupies a place between the gastrocnemius and the peroneus longus. The extensor digitorum longus can also be seen; it is located between the mentioned peroneal muscle and the tibialis anterior. The latter muscle is the one that provides the characteristic profile to the anterior face of the lower leg, much as the calf muscles make up the contours of the posterior face. All these muscles were presented in detail in the sections corresponding to the anterior and posterior faces of the lower leg.

Tibialis anterior

Gastrocnemius

Peroneus longus

Extensor digitorum longus

Soleus

The significant volume of the calf muscles characterizes the drawing of the lower leg from any viewpoint but particularly in a lateral or posterior view, as this illustration shows.

View of the outer face of the calf. The outer face is where most of the muscles come together, notably the tibialis anterior and the peroneus longus (the shape of which is clearly visible in the adjacent illustration). The extensor digitorum longus is partly visible between these two muscles.

THE SHAPE OF THE KNEE

The shape of the knee is an important anatomical feature in any representation of the legs. The shape of the knees changes, depending on the position. When the legs are completely bent, the knee looks like a fairly flat surface. When the legs are straight, though, the shape of the kneecap is clearly visible on the joint that connects the femur with the tibia.

MOVEMENT OF THE KNEECAP

The kneecap is supported laterally in the knee joint by ligaments that are connected to the condyles of the femur and the menisci (joint surfaces) that separate the femur from the tibia. However, the kneecap is especially supported in a vertical direction by the powerful tendon of the quadriceps. In flexion, it tends

to be framed by the femoral condyles, thereby protecting the knee joint. When the leg is straightened (in the anatomical position), the kneecap appears to be set more deeply into the joint. In addition to the shape of the kneecap itself, we have to mention the shape produced by the capsule containing the synovial fluid (the liquid that lubricates the joints). In flexion, the capsule is under tension and reveals the shape of the bones. When the leg is extended, the capsule relaxes and causes characteristic folds on the kneecap and sometimes below it.

When the knees are completely bent, the shape of the kneecap completely disappears since this bone is framed between the femur and the tibia. The shape of the kneecap in such cases is rounded and flattened in the front. In its upper part, it reveals the protuberances of the thick condyles at the base of the femur.

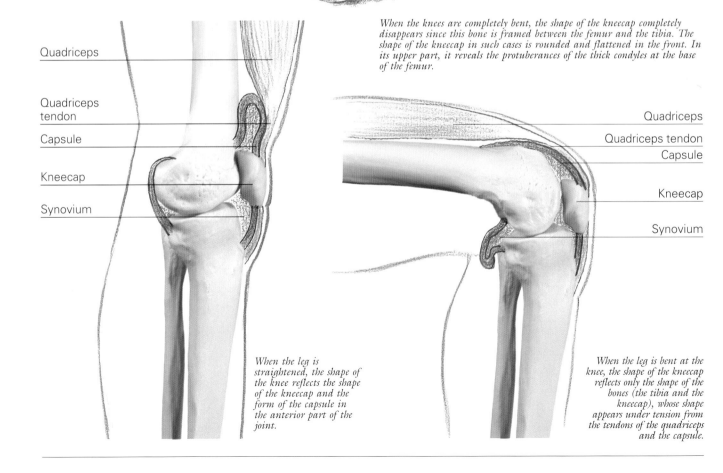

Quadriceps

Quadriceps tendon

Capsule

Kneecap

Synovium

Quadriceps

Quadriceps tendon

Capsule

Kneecap

Synovium

When the leg is straightened, the shape of the knee reflects the shape of the kneecap and the form of the capsule in the anterior part of the joint.

When the leg is bent at the knee, the shape of the kneecap reflects only the shape of the bones (the tibia and the kneecap), whose shape appears under tension from the tendons of the quadriceps and the capsule.

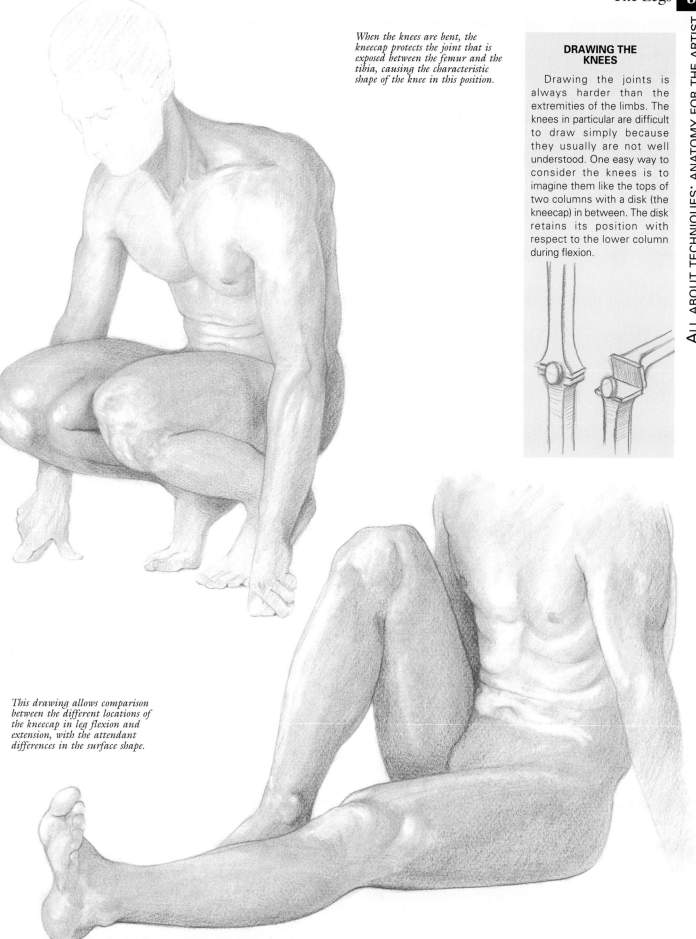

When the knees are bent, the kneecap protects the joint that is exposed between the femur and the tibia, causing the characteristic shape of the knee in this position.

DRAWING THE KNEES

Drawing the joints is always harder than the extremities of the limbs. The knees in particular are difficult to draw simply because they usually are not well understood. One easy way to consider the knees is to imagine them like the tops of two columns with a disk (the kneecap) in between. The disk retains its position with respect to the lower column during flexion.

This drawing allows comparison between the different locations of the kneecap in leg flexion and extension, with the attendant differences in the surface shape.

A GENERAL VIEW OF THE LEGS

The illustrations on these pages constitute a review of everything that has been presented concerning the leg muscles. Every illustration is a carefully reproduced partial view, whether of the thigh or the lower leg. Each shows the relative distribution of the most significant muscles for the outer shape of the leg. There are four views of both the thigh and the lower leg (anterior, exterior, posterior, and interior), so that the surface muscles of the leg are presented in their entirety.

Gluteus medius

Tensor fasciae latae

Gluteus maximus

Quadriceps

Fascia lata

Biceps femoris

Gluteus medius

Tensor fasciae latae

Gluteus maximus

Adductor magnus

Fascia lata

Semitendinosus

Biceps femoris

Gracilis

Semimembranosus

The posterior region of the thigh is characterized by the prominence of the gluteus maximus and, underneath it, three long muscles: the semitendinosus, the biceps femoris, and the semimembranosus.

The characteristic contours of the outer region of the thigh are due to the quadriceps on the anterior face and to the gluteus maximus and the biceps femoris (hamstring) on the rear face. The long fascia lata runs along the whole thigh from top to bottom.

Gluteus maximus

Sartorius

Pectineus

Adductor magnus

Semitendinosus

Gracilis

Quadriceps

The inner region of the thigh reveals many muscles that are also visible in the anterior and posterior views. This region is completely crossed by the sartorius.

Iliopsoas

Sartorius

Pectineus

Adductor longus

Gracilis

Quadriceps

Fascia lata

Anterior region of the thigh. The quadriceps, crossed by the long band of the sartorius, is clearly visible in this area.

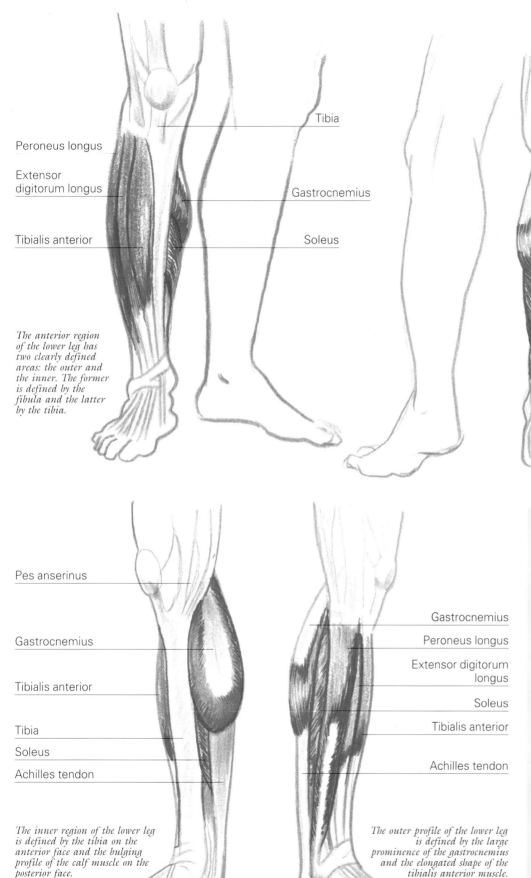

Peroneus longus

Extensor
digitorum longus

Tibialis anterior

Tibia

Gastrocnemius

Soleus

*The anterior region
of the lower leg has
two clearly defined
areas: the outer and
the inner. The former
is defined by the
fibula and the latter
by the tibia.*

Gastrocnemius

Achilles
tendon

Soleus

*The posterior area
of the lower leg is
dominated almost
entirely by the
large shape of the
calf muscle, which
extends downward
into the Achilles
tendon.*

Pes anserinus

Gastrocnemius

Tibialis anterior

Tibia

Soleus

Achilles tendon

*The inner region of the lower leg
is defined by the tibia on the
anterior face and the bulging
profile of the calf muscle on the
posterior face.*

Gastrocnemius

Peroneus longus

Extensor digitorum
longus

Soleus

Tibialis anterior

Achilles tendon

*The outer profile of the lower leg
is defined by the large
prominence of the gastrocnemius
and the elongated shape of the
tibialis anterior muscle.*

SUGGESTIONS FOR DRAWING THE LEGS AND CALVES

In most representations of the thigh, the shape is determined by the quadriceps and the biceps femoris or hamstring. In very muscular figures, the shape of the fascia lata can be made to stand out on top of the previous muscle. On the inner face of a thigh under tension, the path of the sartorius can be seen near the knee. With regard to the lower leg, the calf muscles are the basic shape to be included, but we also have to remember the slight curve produced by the tibialis anterior muscle on the anterior face of the lower leg. In very muscular figures, the peroneus longus may also be visible. The same observations apply in representations of female figures, but the drawing has to contain ample shapes and rounded forms.

The Feet

Even though the feet resemble the hands, there are some important differences based on their function. The bony parts are similar, but they are arranged differently. Also, the muscles are arranged similarly with respect to the differences between the dorsal and plantar regions (the latter dealing with the sole of the foot). However, the greatly reduced mobility of the toes and the sole of the foot compared with that of the fingers and the palm of the hand means that the muscles of the foot are of much less interest to artists.

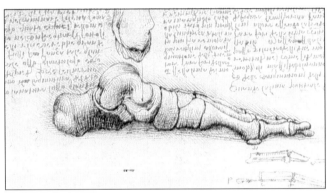

Leonardo da Vinci, Study of Feet *(detail: viewpoint opposite the original image). Royal Library, Windsor Castle (Windsor, England).*

BONES OF THE FEET

The bones of the feet are divided into three sections: the bones of the tarsus, the bones of the metatarsus, and the bones of the toes. The first group is similar to the bones of the carpus (the wrist); the second to the bones of the metacarpus; and the third to the phalanges of the fingers.

THE TARSUS

The tarsus is a group of bones that take up almost half the foot and support the weight of the body. There are seven short, stout bones that form joints with one another. Like the bones of the carpus, they are arranged in two groups. The posterior group is made up of two superimposed bones: the talus and the calcaneus or heel bone. The anterior group is comprised of five bones: the navicular, the cuboid, and three bones known as cuneiforms.

The talus is a short bone located in the upper part of the tarsus. It forms a joint with the tibia and the fibula. In other words, it receives the entire weight of the body and transmits it to the navicular bone, on which it rests. The talus is partly covered up by the lower end of the tibia and the fibula, which fit onto it somewhat like a wrench on a nut, allowing longitudinal but not lateral movement.

The calcaneus is the largest of the bones in the tarsus. It is located furthest to the rear, and it forms joints with the talus (above) and the cuboid (in front). This bone is responsible for the shape of the heel, and it is the insertion point for the Achilles tendon.

The navicular bone occupies an intermediate position between the calcaneus and the forward bones of the tarsus. It forms a joint at the top with the talus and at the front with the bones of the forward part of the tarsus.

Finally, the bones of the forward part of the tarsus are, from inner to outer (from the big toe to the little), the three cuneiform (wedge-shaped) bones and the cuboid.

THE METATARSUS

The metatarsus consists of a set of bones that are analogous to the metacarpus of the hand. It is made up of

Top view of the bones of the left foot: in blue, the bones of the tarsus; in yellow, the bones of the metatarsus; and in green, the phalanges (from light green to dark green: proximal phalanges, middle phalanges, and distal phalanges).

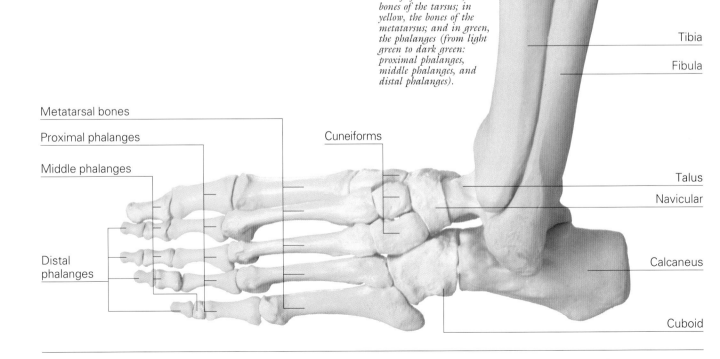

Metatarsal bones

Proximal phalanges

Middle phalanges

Distal phalanges

Cuneiforms

Tibia

Fibula

Talus

Navicular

Calcaneus

Cuboid

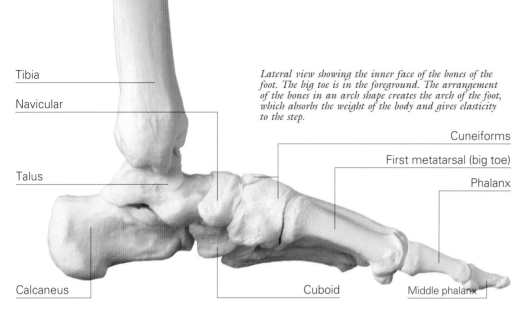

Tibia

Navicular

Talus

Calcaneus

Cuneiforms

First metatarsal (big toe)

Phalanx

Cuboid

Middle phalanx

Lateral view showing the inner face of the bones of the foot. The big toe is in the foreground. The arrangement of the bones in an arch shape creates the arch of the foot, which absorbs the weight of the body and gives elasticity to the step.

five parallel bones that make up a slightly arched fan that covers the arch of the foot. The first metatarsal (corresponding to the big toe) is quite a bit thicker than the others. It differs from the metacarpal of the thumb by being incapable of opposing the other toes; as a result, its mobility is greatly reduced.

THE TOES

As with the fingers, the toes are made up of three phalanges, except the big toe, which has just two. These phalanges, as in the hand, are called the proximal phalanx (first), the middle phalanx (second), and the distal phalanx (third).

PROPORTIONS AND DRAWING THE FEET

Despite their irregular shape, the feet are much easier to draw than the hands simply because they have much less mobility. If you know how to represent the four basic views correctly (inner, outer, front, and rear), you can handle nearly any drawing of a figure with assurance of success. These four views are reproduced on this page, along with some other useful sketches to help you understand the shape and the proportions of the feet.

When seen from the side (on the inner or outer face), the foot can be represented schematically using a right triangle in which the heel is located in the right angle. This triangle can be divided into three equal parts, each of which is equal to the width of the ankle. The front part is occupied by the arch, and the rear is occupied by the heel. These proportional divisions can be applied most clearly on the outer face of the foot.

When seen from the front, the foot suggests a triangle whose base forms an arch along which the toes are aligned. In a rear view, the proportional sketch of the foot is made up by two isosceles triangles opposite one another at the sharpest angle. Any of these basic sketches is a good point of departure for doing a drawing of the feet.

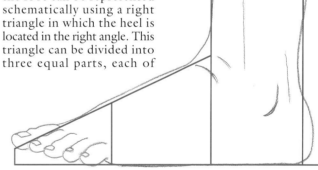

The shape of the foot is like a right triangle whose base is three times broader than the ankle. The toes are located in the front third of the triangle, and the heel occupies the rearmost third and sticks out from the right angle of the triangle.

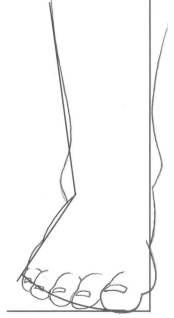

When seen from the front, the foot can be represented by a triangle with a curved base. The base curve or arc is a perfect guide for locating the toes properly.

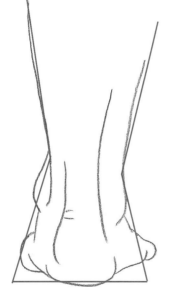

When seen from the rear, the proportion of the foot is like two opposing isosceles triangles. The narrowest area in the sketch corresponds to the position of the malleoli (the lateral malleolus is always higher than the medial one).

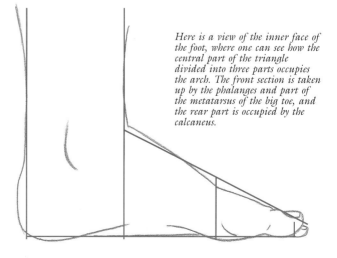

Here is a view of the inner face of the foot, where one can see how the central part of the triangle divided into three parts occupies the arch. The front section is taken up by the phalanges and part of the metatarsus of the big toe, and the rear part is occupied by the calcaneus.

The Head

The head has several anatomical peculiarities that distinguish it from the rest of the body. Its bony structure is like an oval-shaped box, a shape closed by bony walls, with no equivalent in the rest of the skeleton. Its muscular configuration is also peculiar since it contains many flat muscles, most of which have cutaneous insertions in addition to bony ones. In the following pages, we will describe the most important bones and muscles, in other words, those whose presence or action are evident in the external shape of the head and face.

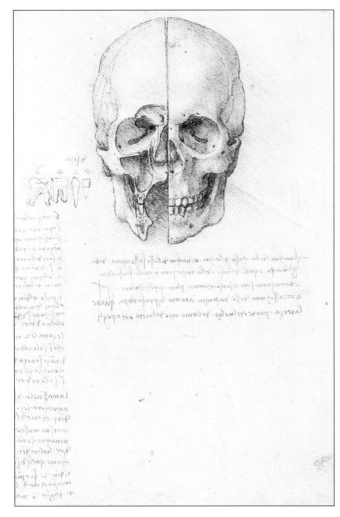

Leonardo da Vinci, Study of the Skull. *Royal Library, Windsor Castle (Windsor, England).*

Albrecht Dürer, Caricature Profiles, Book III *of* The Four Books of Human Proportions *(1557). National Library (Paris, France).*

BONES OF THE CRANIUM

The skull is a bony container whose cavity ends in the spinal column. The walls of the skull are made up of eight broad, flat bones. Two of these bones are in pairs—the parietal and the temporal—and four are individual bones: the occipital, the frontal, the sphenoid, and the ethmoid.

The occipital bone is located in the lower part of the base of the skull. The frontal occupies the entire anterior part (the forehead). The parietals are on the left and right sides of the upper part of the skull, between the frontal and the occipital, and they contact one another. The temporals occupy the left and right sides of the lower part, below the parietals. The ethmoid and the sphenoid are largely internal bones with little relevance to the outer shape. All these bones are joined through sutures, and they make up an ovoid casing.

BONES OF THE FACE

The bones of the face are made up of two large pieces: the upper jaw and the lower jaw or mandible. The upper jaw is in turn composed of various bones, of which only two contribute directly to the external shape of the face: the zygomatic bone and the nasal bones. The maxillary bones are the ones that surround the mouth and give it shape; the lower jaw is the only movable bone of the skull. The zygomatic bone is the one that gives shape to the cheek. It extends rearward from the face, creating the zygomatic arch, and also toward the outside of the eye sockets. The nasal bones are two small, identical bones that join at the midline or symmetrical center of the face, forming what is commonly known as the bridge of the nose.

FACIAL ANGLE AND VARIATIONS IN PROPORTIONS

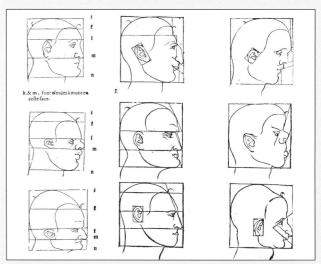

This is how we refer to the angle that two straight lines form when they intersect: one line joins the forehead to the incisor teeth, and the other joins the auditory canal to these same teeth. This angle varies according to the human races. It is somewhat sharper among those of African descent in comparison with Caucasians, who had turned it into a symbol of idealized beauty. The heads of classical statuary exhibit a facial angle of ninety degrees, that is, a perfect right angle. However, the head is capable of many other geometric relationships according to one or more general proportions (e.g., inclination of the forehead, the chin, or the nose; the distance between facial features; and so on). Artists such as Leonardo da Vinci and Dürer (who did the drawings above) experimented with these relationships in drawings that were halfway between scientific research and caricature.

SKULL AND PHYSIOGNOMY

Of the bones mentioned, some are much more influential than others in determining the physiognomy of the face. Thus, the zygomatic arch stands out clearly from the plane of the temporal bone, forming a depression in this area. This depression is commonly featured clearly in slender or bony faces, with a characteristic difference in level between the plane in which the ear is located and the plane of the temple. Also, the zygomatic bone is clearly represented in thin faces (especially in older persons), both in the area of the eye socket and the cheek. The nasal bones also have a dramatic effect on the physiognomy in forming the shape of the nose. The same can be said of the lower jaw, whose lower edges and angles are visible in slender faces.

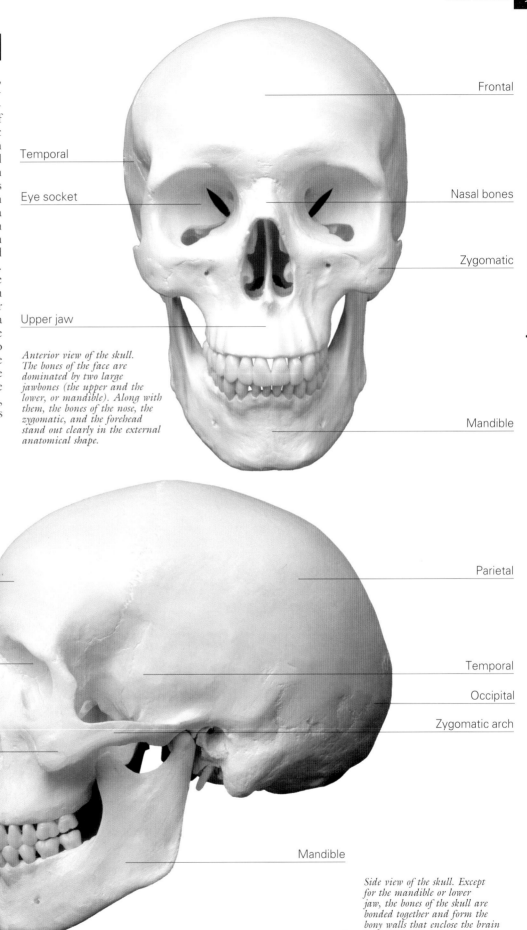

Frontal

Temporal

Eye socket

Nasal bones

Zygomatic

Upper jaw

Mandible

Anterior view of the skull. The bones of the face are dominated by two large jawbones (the upper and the lower, or mandible). Along with them, the bones of the nose, the zygomatic, and the forehead stand out clearly in the external anatomical shape.

Frontal

Parietal

Eye socket

Nasal bones

Temporal

Occipital

Zygomatic

Zygomatic arch

Upper jaw

Mandible

Side view of the skull. Except for the mandible or lower jaw, the bones of the skull are bonded together and form the bony walls that enclose the brain cavity.

MUSCLES OF THE HEAD

Among the muscles of the head, it is appropriate to mention two groups: the chewing muscles, which insert into bones and are located on the sides of the head, and the cutaneous muscles, which insert into the bones and beneath the skin. The latter muscles are responsible for the superficial modifications that produce facial expressions; the former are used in chewing. The main chewing muscles are the temporalis and the masseter.

TEMPORALIS

This muscle is located in the temporal fossa. It is fan shaped, and it completely covers the bone with the similar name. Its lower insertions are in the upper part of the mandible, where it inserts after slipping through the zygomatic arch. Its function is to raise the mandible. This muscle is visible only while chewing.

MASSETER

This is a rectangular muscle located in the cheek area. Its upper insertion is in the zygomatic arch, and the lower is in the rear angle of the mandible. Its function is to raise the mandible. In slender people, the contraction of the masseter is visible on the side of the face if they clench their teeth when they become angry.

CUTANEOUS MUSCLES

In all, there are twenty cutaneous muscles. They produce facial expressions and move only the skin, not bones. They occupy the cranial arch and the face. When they contract, they produce folds perpendicular to the direction of the muscle fibers. The function of these muscles in producing facial expressions means that each of them is known by an anatomical name and the name of the typical expression it produces.

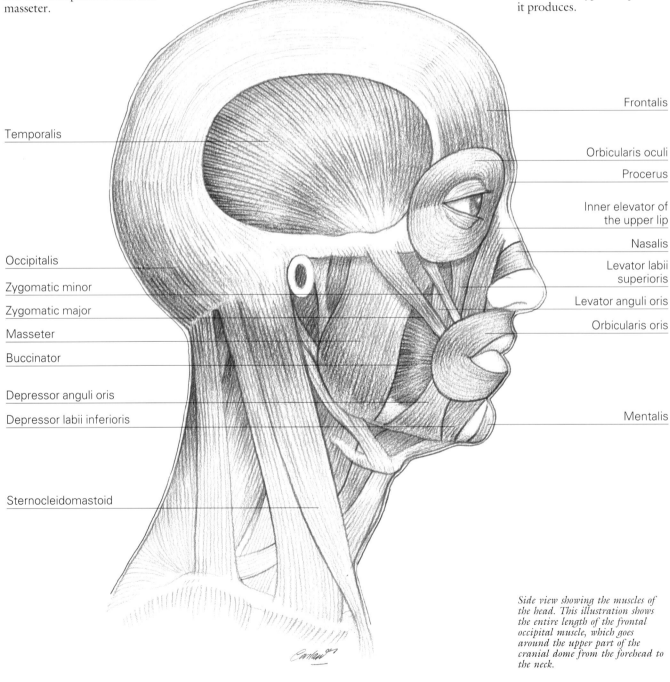

Temporalis

Occipitalis

Zygomatic minor

Zygomatic major

Masseter

Buccinator

Depressor anguli oris

Depressor labii inferioris

Sternocleidomastoid

Frontalis

Orbicularis oculi

Procerus

Inner elevator of the upper lip

Nasalis

Levator labii superioris

Levator anguli oris

Orbicularis oris

Mentalis

Side view showing the muscles of the head. This illustration shows the entire length of the frontal occipital muscle, which goes around the upper part of the cranial dome from the forehead to the neck.

OCCIPITOFRONTALIS

This muscle occupies the forehead and the entire cranial dome and, in fact, is made up of two flat muscles, the occipital and the frontalis (in the nape of the neck and the forehead, respectively). They are connected by a broad aponeurotic sheet attached to the neck. The insertions of both muscles have two muscular tongues that give rise to the aponeurosis once they reach the upper part of the cranial arch. In the frontal area, these muscular tongues have their lower end in the skin of the eyebrow. This is the muscle responsible for the transverse wrinkles in the forehead and for raising the eyebrows; it is used when a person is attentive or expresses surprise.

SUPERCILIARY MUSCLES

These are two small, deep muscles located between the two frontal muscles at the level of the eyebrows. They are used to raise the inner end of the eyebrows, and they cause the vertical wrinkles in the area between the eyebrows. This expression commonly associated with these muscles is one of pain.

ORBICULARIS OCULI

This is a flat, circular muscle that surrounds the eye sockets and moves the eyelids. Since it is made up of many tiny fascicles, it can contract in many different ways, but the main one is to close the eyelids. It also produces contraction in the eyelids to produce an expression of intense concentration. It can also be used to lower the eyebrows by tensing the skin of the forehead in meditative expressions. In a more general way, it contributes to many facial expressions when its movement is combined with that of other facial muscles (laughter, pain, sadness, and others).

PROCERUS

This muscle is located in the triangle formed by the eyebrows and the root of the nose. It is a small muscle whose contraction produces horizontal wrinkles on the forehead and brings the eyebrows closer together, causing them to dip at their inner edge. The contraction of this muscle is characteristic of a threatening or an angry expression.

ZYGOMATIC MAJOR

This is an oblique elevator for the corner of the mouth, where the cutaneous insertion is located. The bony insertion is in the outer part of the zygomatic bone. When this muscle contracts, it broadens the mouth opening and pulls the corners of the mouth upward and rearward, producing wrinkles beneath the cheeks. This is the muscle used in laughing.

ZYGOMATIC MINOR

This muscle is parallel to the zygomatic major. Its bony insertion is in the other face of the zygomatic bone, and its cutaneous insertion is deeper inside the opening of the lips than that of the zygomatic major. Its contraction raises the upper lip in an expression of displeasure or even sorrow.

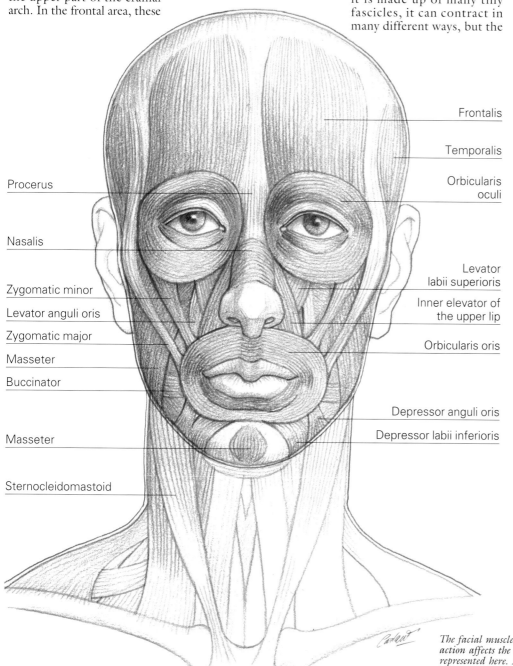

Procerus
Nasalis
Zygomatic minor
Levator anguli oris
Zygomatic major
Masseter
Buccinator
Masseter
Sternocleidomastoid

Frontalis
Temporalis
Orbicularis oculi
Levator labii superioris
Inner elevator of the upper lip
Orbicularis oris
Depressor anguli oris
Depressor labii inferioris

The facial muscles. All the surface muscles whose action affects the shape and expression of the face are represented here. Among the muscles mentioned in the text, only the superciliary (which occupies a deeper layer) is not shown in the illustration.

INNER ELEVATOR OF THE UPPER LIP

This is a pair of muscles located in the furrow that separates the nose from the cheeks. Its bony insertion is in the inner edge of the eye socket. Its cutaneous insertion is in the wings of the nose and near the middle part of the upper lip. When it contracts, it moves the upper lip upward, dilating and raising the wings of the nose, giving the lips a turn downward and outward. This is the muscle used in crying.

LEVATOR LABII SUPERIORIS

This muscle is located between the zygomatic minor and the inner elevator. Its bony insertion is in the lower inside part of the zygomatic bone. Its cutaneous insertion is in the edge of the upper lip. When it contracts, it pushes the middle of the upper lip upward in an arc. Its action is commonly associated with that of the two previous muscles, and it gives rise to expressions of sadness, discontent, and repugnance.

LEVATOR ANGULI ORIS

This is a pair of muscles located in a deeper layer than the one occupied by the previous muscles. Their bony insertion is in the upper and anterior area of the upper jaw, and their cutaneous insertion is in the upper lip. Their function is to raise the upper lip over the canine teeth. This is a highly developed muscle in carnivorous mammals, and it expresses threat and hostility.

NASALIS

This muscle is made up of two triangular fascicles that originate in an aponeurosis in the tip of the nose. They extend to both sides and insert into the skin in the inner area of the cheeks. Their contraction creates wrinkles on both sides of the nose and tenses the cheeks. The related facial expression is one of intense displeasure or disgust.

ORBICULARIS ORIS

This is the muscle that surrounds the mouth, and it is responsible for the fleshy nature of the lips. The muscle consists of an upper and a lower half. It is an antagonistic muscle with a function opposite all other muscles; when it contracts, it opens the lips. The inner part of the muscle can contract independently, producing gestures like the one that characterizes the act of whistling. If only the outer part is contracted, the lips project forward, in an action typical of kissing or sucking.

BUCCINATOR

This is the muscle that gives thickness to the cheeks and closes the mouth on the side. Its bony insertions are in the alveoli of the molars, and the cutaneous insertion is in the fibers of the orbicularis oris. It is used in chewing and in the action of blowing, where the cheeks inflate to pressurize the air contained in the mouth and expel it forcefully.

MENTALIS

This is a small, oval muscle that surrounds the front of the chin. Its bony origin is in a small fossa located in the front part of the mandible (below the dental alveoli), and its cutaneous insertion is in the skin of the chin. When it contracts, it causes the lower lip to move upward, and it creates a bulge in the skin of the chin. This is the muscle of anger and the dramatic expression of aggressive rage.

DEPRESSOR ANGULI ORIS

This is a pair of muscles whose bony insertion is in the lower borders of the mandible and whose cutaneous insertion is located deep inside the skin of the lower lip. When these muscles contract, they produce an expression of anger or disgust.

COORDINATED ACTION OF THE FACIAL MUSCLES

Only complementary muscles whose actions are independent of one another can participate in making facial expressions. For example, an elevator muscle of the eyebrows, such as the frontalis, cannot work in conjunction with the orbicularis oculi, which makes the eyelids close. Therefore, muscles such as the frontalis and the orbicularis oculi are known as antagonists.

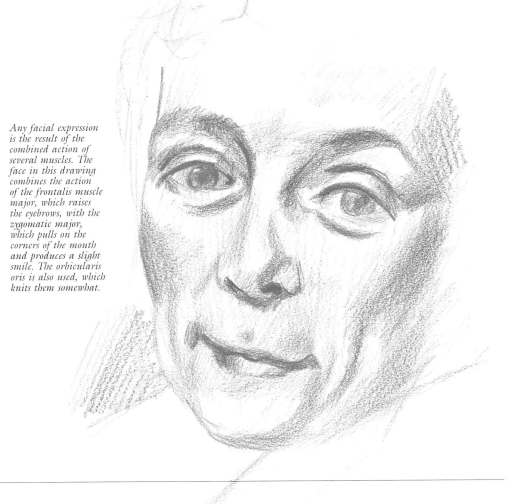

Any facial expression is the result of the combined action of several muscles. The face in this drawing combines the action of the frontalis muscle major, which raises the eyebrows, with the zygomatic major, which pulls on the corners of the mouth and produces a slight smile. The orbicularis oris is also used, which knits them somewhat.

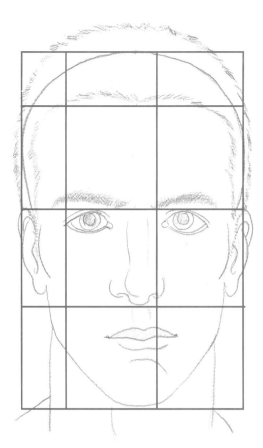

Modular division of a frontal view of the head. When seen from the front, the proportion of the head is equal to three and a half modules for height (not counting the thickness of the hair) and two and a half modules for width. This proportion is generally valid for most drawings.

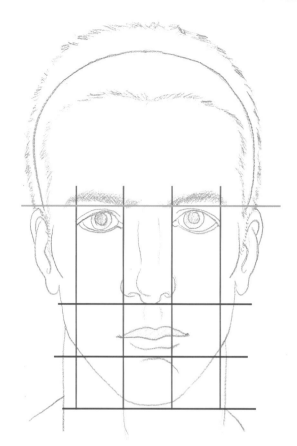

Useful references for drawing the head. The green line relates the upper edge of the ears to the level of the eyebrows. The magenta lines show that the distance between the eyes is equivalent to one eye. The blue lines show the distance between the base of the nose and the edge of the lip and between that reference point and the point of the chin.

PROPORTIONS OF THE HEAD

Among all the variations that the head and face can entail, some basic proportions give a man's and a woman's head a truly human appearance.

The model used here is based on dividing the human head into proportional sections. Each of these sections is a useful reference for arranging the facial features. An artist who masters this basic layout will be able to draw male and female heads, whether children or adults, using the correct proportions.

VERTICAL DIVISIONS

The basic model of the human head is approximately equivalent to three and a half times the height of the forehead (from the start of the hairline to the level of the eyelashes). That means that

the forehead is the basic module or measurement that determines the proportions of the rest of the face. By dividing the height of the head into three and a half units by means of horizontal lines, the location and proportions of the following elements can be determined: the top of the head or cranium, not counting the thickness of the hair; the hairline; the location of the eyebrows and the height and location of the ears; the lower part of the nose; and the lower part of the face or the lower limit of the chin.

LOCATION OF THE MOUTH

Once the basic parts of the head are done, it is possible to locate a new, useful reference point for drawing a new line in the middle of the lower module (the module that separates the base of the nose from the lower limit of the

chin). The lower limit of the mouth is located approximately on this new reference. We have to keep in mind that these proportional divisions are references that do not apply precisely to any head in particular. However, they are an adequate approximation that can be used as a practical guide.

HORIZONTAL DIVISIONS

By applying the same module of the forehead to the width of the head, the artist sees that the width is comprised of two and a half units. By keeping these divisions in mind, as well as the previous ones, the following norm can be formulated: the height and width of the human head seen from the front form a rectangle that measures three and a half units high by two and a half wide. For practical

reasons, the partitions for width are located right and left in such a way that the half unit is at the left edge of the head.

DISTANCE BETWEEN THE EYES

By dividing the major modules of the width partitions into two equal parts, we obtain a total of five equal partitions for the entire width of the head (four obtained by dividing the two modules, plus one remaining half module). It is immediately evident that these partitions are precisely the width of the eyes, and that is another important reference. In addition, it is also clear that the distance between the eyes is equivalent to one of these partitions; in other words, it equals the width of one eye.

DIVISIONS IN PROFILE

By using the same module in the head seen in a side view, it is clear that the total size of the head is equal to three and a half times the height of the forehead. In other words, the head in profile corresponds precisely to the shape of a square with the same number of divisions for height and width. Once the head in profile is subdivided into vertical and horizontal modules, it contains some interesting reference points for locating the ear (at the edge of the third module) as well as for locating the eye and the lips. By dividing the first vertical module into three parts, we see that the central subdivision frames the eye and much of the mouth.

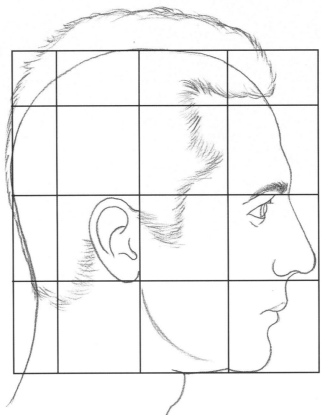

MALE AND FEMALE HEADS

The dimensions and proportions of the head and face of a woman are the same as those of a man. The differences are minor. They can be summarized in a couple of essential features: the face is slightly smaller, the eyes are a little larger, the nose and mouth are also a little smaller, and the mandible is less angular. All these differences have no effect on the basic partitions or references.

In profile, the modular division of the head is a square: three and a half modules high by three and a half wide. These modules are the same as the ones already seen in the frontal view of the head.

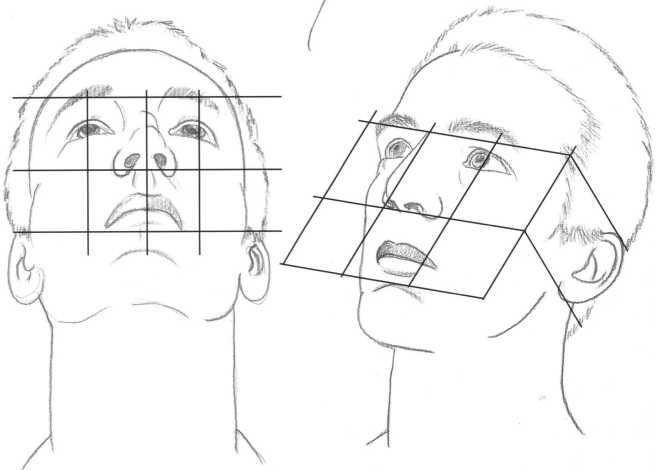

The modular divisions of the head can also serve in drawing in perspective: the divisions merely need to be placed into perspective.

In this foreshortening, the horizontal distances are maintained, but the vertical ones are shortened to create the perspective.

FACIAL EXPRESSIONS

The study of head proportions is necessarily associated with a study of facial features, even though there is no room in this book for a detailed study of drawing facial features. As a point of interest, we include here a few exceptional drawings by the baroque painter José Ribera as proof of the importance that a great master gave to this type of study. The images have great instructional value since they show the preliminary drawing that underlies each of the finished works. The rest of the illustrations suggest something related. By starting with a very schematic drawing within the capabilities of any beginner, it is possible to create detailed eyes, mouths, noses, and ears.

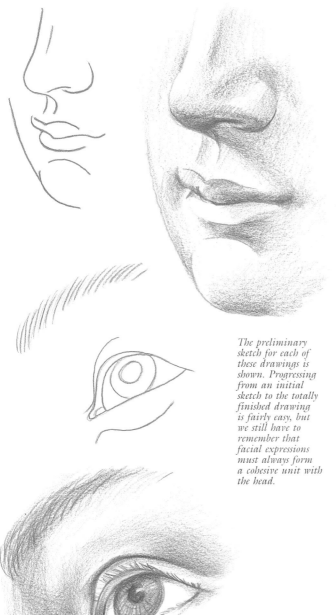

The preliminary sketch for each of these drawings is shown. Progressing from an initial sketch to the totally finished drawing is fairly easy, but we still have to remember that facial expressions must always form a cohesive unit with the head.

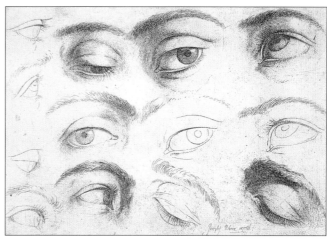

José Ribera, Study of Eyes. *Graphische Sammlung Albertina (Vienna, Austria). In this drawing, it is possible to follow the drawing of the eyes from the first basic lines to the finished work with all shading in place and filled with life. Even a consummate artist like Ribera appreciated this type of exercise.*

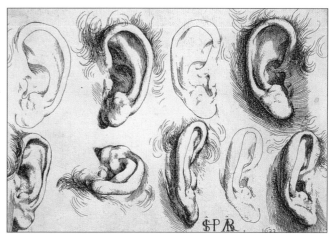

José Ribera, Study of Ears. *Graphische Sammlung Albertina (Vienna, Austria). The ears are a fairly complicated shape, and it changes depending on the point of view from which they are observed. Here are several different views and levels of elaboration.*

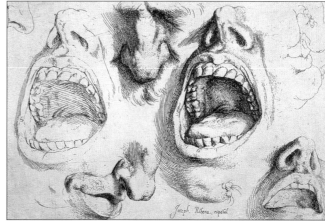

José Ribera, Study of Noses and Mouths. *Graphische Sammlung Albertina (Vienna, Austria). Ribera's realism can take on dramatic qualities even in works that appear as neutral as these; surely these wonderfully rendered mouths are the product of direct observation.*

Synthesizing Anatomy

By way of review, this part will present a series of graphic examples that put everything together that has been studied in this book. All the anatomical features and factors, as well as the complex configuration of the bones and muscles of the human body, must constitute a basis on which artists develop their graphic and pictorial work. However, the extreme complexity of those features cannot be confronted directly without risk of overloading the drawing with tangential details. As a result, we have to use practical sketches that pull all the anatomical features together with a minimum of lines.

Luca Cambiaso, Falling Figures. *Galleria degli Uffizi (Florence, Italy). In all times, artists have sought methods of simplifying the human shape and its anatomy with a view to generalizing the representation and capturing the most important traits for drawing and painting.*

SYNTHESIZING THE TORSO

In order to represent the torso easily, we have to imagine it like a rectangle topped off by another rectangle (the head). If we divide the whole sketch into four parts, the top part should be as long as one-fourth of the total length. The three remaining parts (the larger rectangle) correspond to the torso, and we can locate the basic anatomical references in the way we will describe. The lower fourth is equivalent to the distance between the pubis and the navel, and the quarter immediately above that to the distance between the navel and the lower line of the pectorals. That leaves one section, the upper part of the torso, where we have to locate the neck and the level of the shoulders. The neck occupies the upper third of this partition. As a result, the level of the shoulders is established at the base of the neck.

DOING A SKETCH

The basic sketch of the torso helps when drawing a frontal, a rear, or a side view. In each case, the relevant anatomical features have to be included. In a frontal view, therefore, we add the lines that represent the clavicles, the elevation of the trapezius from the shoulders to the neck, the limits of the rectus abdominis, the serratus, and the external oblique. In a rear view, we have to mark the upper limits of the gluteals, the latissimus dorsi, the trapezius, and the area of the teres major. In a side view, we simply have to transpose all these references and adapt them to the proper areas of this view. In all cases, the same basic sketch serves as a point of departure.

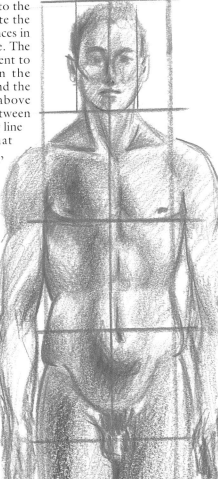

The sketches proposed here make it possible to draw the trunk of a figure in a simple manner based on its basic proportions and a series of schematic lines.

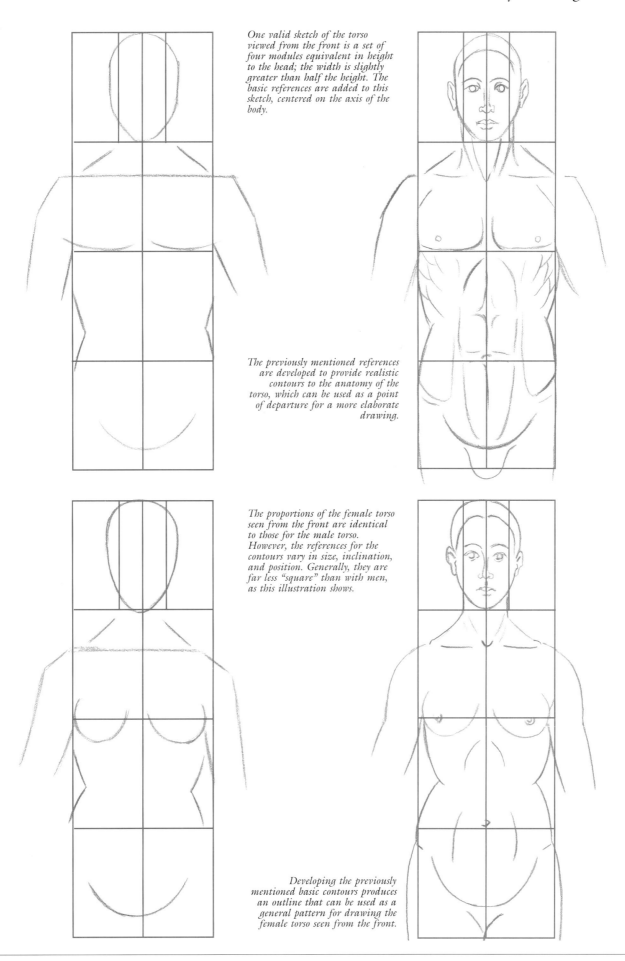

One valid sketch of the torso viewed from the front is a set of four modules equivalent in height to the head; the width is slightly greater than half the height. The basic references are added to this sketch, centered on the axis of the body.

The previously mentioned references are developed to provide realistic contours to the anatomy of the torso, which can be used as a point of departure for a more elaborate drawing.

The proportions of the female torso seen from the front are identical to those for the male torso. However, the references for the contours vary in size, inclination, and position. Generally, they are far less "square" than with men, as this illustration shows.

Developing the previously mentioned basic contours produces an outline that can be used as a general pattern for drawing the female torso seen from the front.

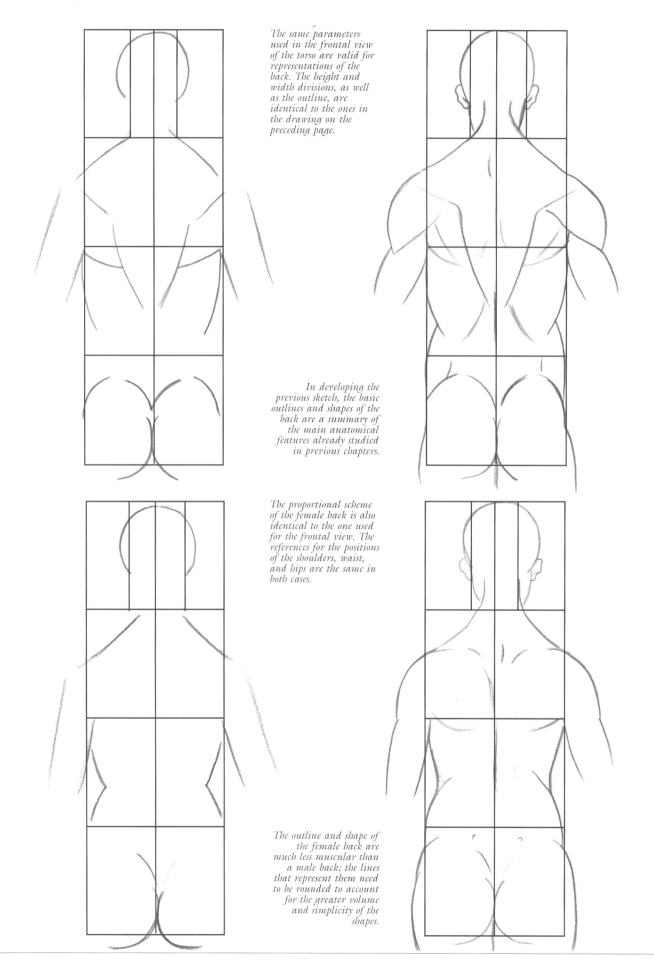

The same parameters used in the frontal view of the torso are valid for representations of the back. The height and width divisions, as well as the outline, are identical to the ones in the drawing on the preceding page.

In developing the previous sketch, the basic outlines and shapes of the back are a summary of the main anatomical features already studied in previous chapters.

The proportional scheme of the female back is also identical to the one used for the frontal view. The references for the positions of the shoulders, waist, and hips are the same in both cases.

The outline and shape of the female back are much less muscular than a male back; the lines that represent them need to be rounded to account for the greater volume and simplicity of the shapes.

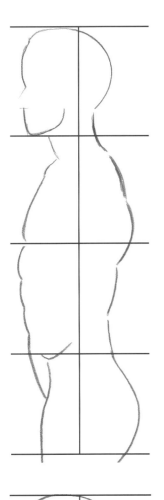

Framing a lateral view of the torso in a rectangle is not easy. The vertical divisions are maintained, but the width has to be estimated based on irregular contour lines that communicate the shape of the thorax and the shoulder.

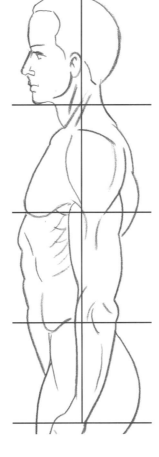

Based on the previous outlines, the anatomical shapes are drawn with greater precision, and the arms are added; the following pages will describe how to sketch them.

OUTLINING THE PROFILE

The outline of the torso seen in profile is more irregular than in a frontal view, but the schematic references still serve to orient the drawing of the various anatomical shapes. The upper division or the first quarter of the layout coincides in front with the chin and in the back with the base of the neck. The division of the second fourth coincides with the lower edge of the pectorals in front and with the greatest concavity of the spinal column in the rear. The third division, at the waist, coincides in front with the level of the navel and in the rear with the maximum convex area of the lumbar vertebrae. Finally, the lowest level is located at the top of the thigh in front and in the lower area of the gluteals in the rear.

As with the male torso, the lateral view of the female trunk has to be drawn using approximations based on proportional divisions for height equivalent to four heads.

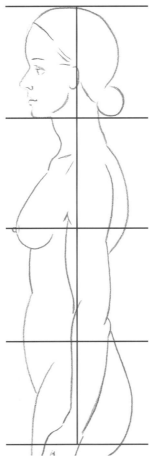

The basic outlines can be drawn more precisely to produce a useful layout for drawing the female torso seen from the side.

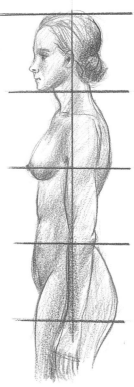

Once the layout for the figure seen in profile has been completed, we have to recall the anatomical features explained in the previous sections to provide shape and volume to the drawing.

THE ARMS

In order to represent the generic shape of the arms quickly, we have to use the simplest layout possible but without undue simplification. This means that from the beginning, it must be clear that the upper arm and the forearm (in the anatomical position seen from the front) do not follow the same direction. Rather, they form a slight angle at the elbow. In addition, there is a small change in direction in the axis of the arm when it reaches the wrist. As a result, it is best to draw the axis of the whole arm first, with its changes in angle, and then insert the schematic forms. For the upper arm, these are a rectangle, and for the forearm, and the hand, two trapezoids of different sizes, as we can see in the illustrations on this page. Note that the upper arm is a little longer than the forearm and that the latter is in turn a bit longer than twice the length of the hand from the wrist to the end of the middle finger.

This layout works for frontal, lateral, and rear views of the arm. The muscular features have to be added to it, as these illustrations indicate.

The frame of reference is half the forearm, in other words, half the distance from the elbow joint and the wrist. The total length of the arm is comprised of seven of these units. We also have to consider that the whole arm is not arranged in a straight line but, rather, changes direction at the elbow and the wrist. By considering these factors, the arm can be framed using straight lines.

The general shapes of the upper arm and forearm are approximated on the preceding straight lines, preserving the slight change in orientation that occurs in the elbow and the wrist. The proportional divisions are a good reference for adjusting the outlines.

Finally, the anatomical outlines of the upper arm and forearm are created once their proportions have been adjusted to the modular divisions marked at the start of the drawing.

To draw a rear view of the arm, proceed in a way similar to the previous exercise. In this case, however, the orientation of the upper arm, the forearm, and the hand is reversed.

The outline of the arm as seen from the rear is quite similar but not identical to the frontal view; we have to take these differences into account to create a correct and convincing representation.

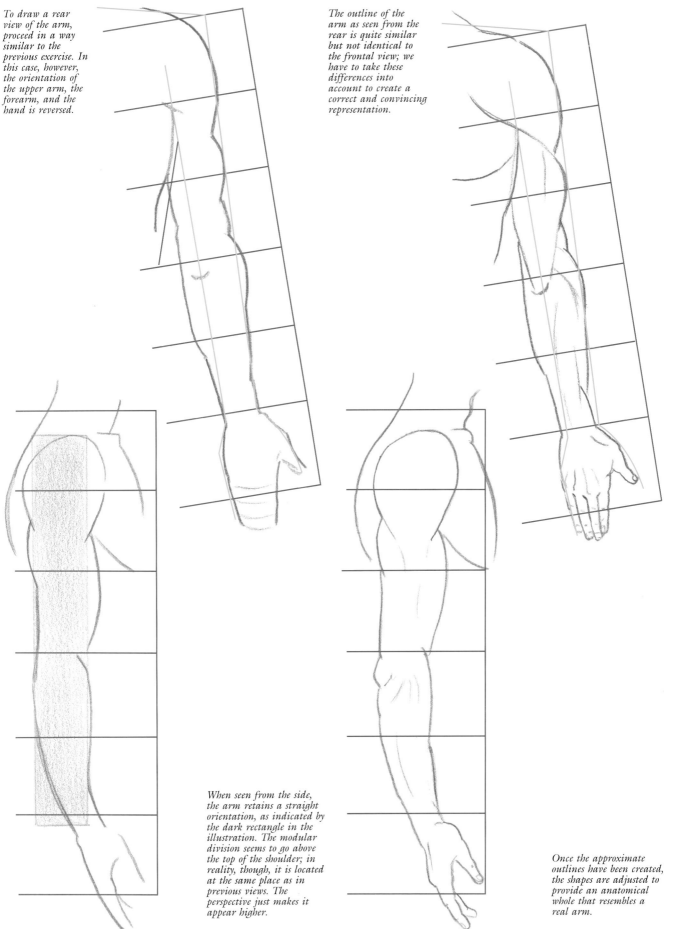

When seen from the side, the arm retains a straight orientation, as indicated by the dark rectangle in the illustration. The modular division seems to go above the top of the shoulder; in reality, though, it is located at the same place as in previous views. The perspective just makes it appear higher.

Once the approximate outlines have been created, the shapes are adjusted to provide an anatomical whole that resembles a real arm.

THE LEGS

The leg can be represented schematically using a trapezoid whose inner line is a vertical straight line and whose outer side is an oblique line that rises from the inside toward the outside. The lower side (the knee joint) is much narrower than the top one, which drops down at an angle from the outside toward the inside following the direction of the groin. The basic muscle references can be located easily on this basic layout as these illustrations show. The most useful layout for drawing the calf in a frontal view is a curve that descends from the outside to the inside with respect to its axis. This curve suggests the outer profile of the calf, and the inner profile is another curve with a shorter radius and an opposite orientation, which suggests the shape of the calf muscle. The base of these curves should end in a triangle that frames the shape of the foot. In order to represent the whole foot, we must first keep in mind that the axis of the leg does not follow the same direction as the calf. Secondly, the length of the upper leg (measured from the highest part of the groin to the kneecap) is almost double that of the calf (not counting the ankle).

OTHER VIEWS OF THE LEG

When seen from the rear, the layout of the upper leg and the calf is the same as in a frontal view; the only minor differences are in the muscle references. In a side view, the artist should use simpler layouts, such as rectangles of different widths, to which the characteristic outlines are added. The illustrations clearly show how to proceed in this instance.

The general layout for a frontal view of the leg consists of a trapezoidal shape corresponding to the thigh and three arches that approximate the shape of the calf (two for the outline and one for the direction of the tibia). The model for the proportional divisions is half the distance from the knee to the sole of the foot, so the leg is divided into a total of four parts.

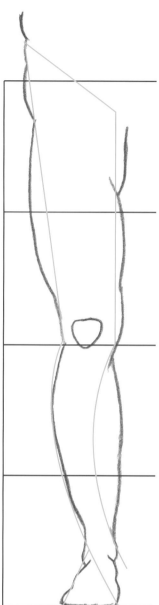

This drawing is a simple elaboration of the preceding basic layouts whose lines make the general shape of the thigh and the calf immediately visible.

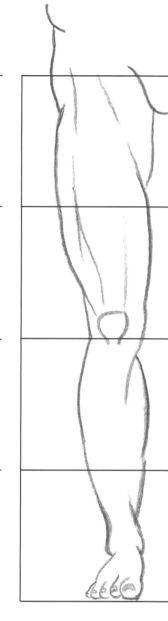

Then the final outlines of the leg are drawn in; these are simplified shapes that can be easily used for a more elaborate drawing.

LAYOUTS FOR THE FEMALE LEG

The layouts for the female leg maintain the same proportions as the male leg reproduced here. However, once the particular proportions have been established for drawing the leg of a nude female, we have to avoid marking the muscle shapes with the same intensity as with a male. We must draw continuous curves, especially the one that goes down from the waist to the knee, so that there is no obvious muscle. The same can be said of the inner curve of the thigh and the one that goes from the knee to the ankle. The inner shapes should also be avoided, with the exception of the large prominence that the tibia forms along the lower leg.

The layout for a rear view of the leg is the same as for a front view, but everything is reversed. In addition, everything that was said in the text for the first illustration of this series also applies to this one.

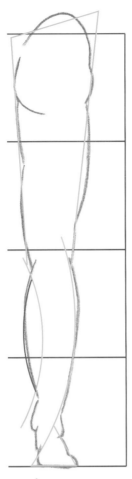

In a rear view, the upper third of the thigh is taken up by the gluteals and the upper half of the lower leg consists of the calf muscle. All the other profiles are nearly identical to the ones in the frontal view.

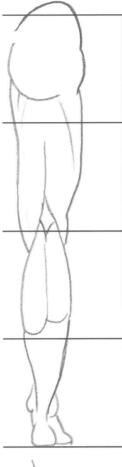

The inner anatomical shapes of the leg are reduced to the essential to serve as a general orientation, especially for shading the shapes since this involves shapes more than outlines.

A side view of the leg can be summed up in a simple sketch based on a trapezoid for the thigh and an elongated rectangle for the lower leg; the foot is framed in a triangle. The proportional divisions are invariable.

The preceding layout allows us to draw the outlines with greater precision, following the guidelines and the basic shapes of the initial sketch.

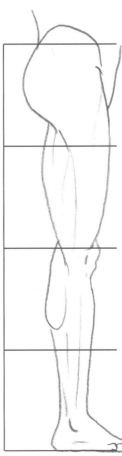

The transition from the preceding drawing to this one is nearly immediate. It consists of going over the basic anatomical lines that create an impression of the shape of the thigh and the calf.

THE FIGURE IN MOTION

The previous layouts are very useful for gaining an idea of how to put together anatomical features and creating a quick and efficient representation. All of them apply to drawing the figure in either a quick sketch or a detailed and realistic study. However, when we have to represent movement, we cannot rely on a layout in all cases. By movement we mean the natural activity of any figure since it is a given that human figures generally do not adopt the anatomical position. Any type of pose presents the artist with various parts of the anatomy in perspective or foreshortening. This foreshortening may involve distortions of the basic shapes presented in the previous pages. Rectangles turn into trapezoids or rhomboids; open curves can become much tighter; and in general, the dimensions of the various body parts are reduced. As a result, for each type of pose, we have to come up with layouts that correspond most effectively with the anatomical features. While remembering that these layouts always need to be made up of simple lines and shapes, in these pages we will show how to construct various figures using simple shapes derived from the previous ones and adapted to each case.

This figure is constructed in all its parts by using the basic framework for the trunk, the arms, and the legs seen in the preceding pages. The basic axes of the movement are indicated in blue: shoulders, hips, waist, and arm and leg joints. The main thing in this type of schematic drawing is establishing the proper proportions among the parts.

USING AXES AS A STARTING POINT

The first thing that an artist has to do in drawing figures is to construct the layout of the pose based on basic axes: the axis of the torso and the axes of the arms and the legs. The axis of the torso runs from the head to the pubis. Its possible points of inflection are at the neck, the chest, and the waist. While remembering the

proportions of the torso mentioned earlier, these axes must be established correctly from the outset. The same can be said of the axes of the arms and legs, each with its points of inflection at the joints and its proportions shortened as needed due to perspective. Once this linear skeleton has been drawn, the typical basic shapes for each anatomical area are superimposed, centered on each axis and adjusted to perspective. The muscle indications are added to these flat shapes so they can be developed later on into the final drawing.

LAYING OUT AND SKETCHING FIGURES

The best way to practice drawing these layouts is to begin by doing quick figure sketches—rough, schematic sketches based on the basic layout lines. Little by little, the artist will get used to the basic proportions and will easily be able to do a schematic representation of any pose. Trying to do a finished drawing right from the start can lead to magnification of errors in the basic proportions. Adding the finishing touches to a figure that has well-proportioned basic lines is easy.

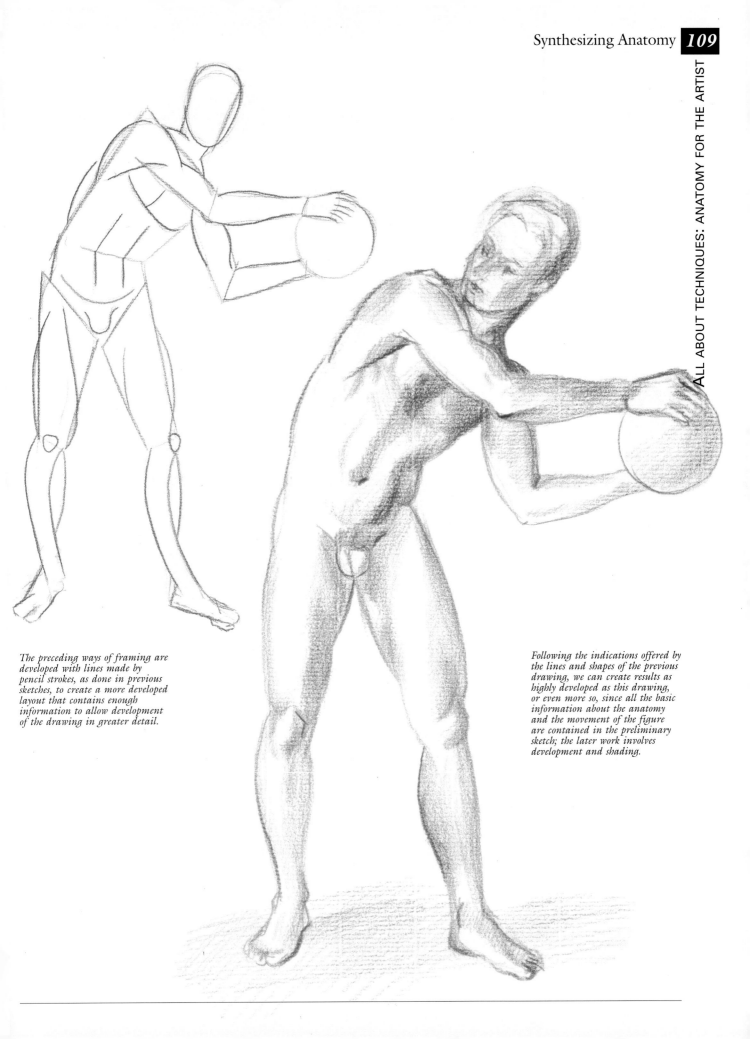

The preceding ways of framing are developed with lines made by pencil strokes, as done in previous sketches, to create a more developed layout that contains enough information to allow development of the drawing in greater detail.

Following the indications offered by the lines and shapes of the previous drawing, we can create results as highly developed as this drawing, or even more so, since all the basic information about the anatomy and the movement of the figure are contained in the preliminary sketch; the later work involves development and shading.

If the initial sketch is well proportioned, adjusting the outlines of each limb is not hard. All it involves is remembering the general anatomical shape of the body and applying it to each case, modifying the dimensions and the proportions of the general sketch.

Basic frameworks are useful for any type of figure and pose as long as the appropriate adjustments for each case are completed. In this instance, the adjustments have to be done on the leg resting on the floor and on the arm that rests on the other leg. In both cases, the shapes are seen in perspective or foreshortening.

Shading the figure is a relatively simple operation if you work on a line drawing that matches anatomical reality. The lines of the sketch disappear under the strokes used for shading, and the drawing acquires the unity required in any accurate representation of a nude figure.

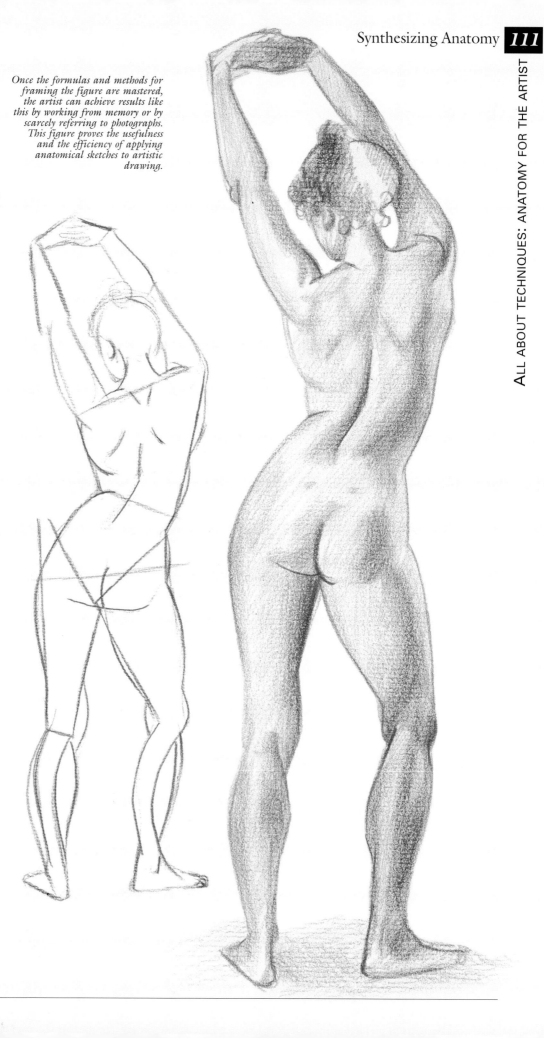

Once the formulas and methods for framing the figure are mastered, the artist can achieve results like this by working from memory or by scarcely referring to photographs. This figure proves the usefulness and the efficiency of applying anatomical sketches to artistic drawing.

This last pose has more movement than the previous ones, but it is not any more complicated. The framework applies the same shapes and outlines. It is precisely in that framing that the artist has to capture the movement through the proper inclination of the axes of the body parts.

The sensation of movement is much greater once the anatomical outlines and shapes are adjusted. The correctness of these shapes and profiles is one consequence of the correct initial framing.

Anatomy in Practice

In the following pages, all the anatomical information studied so far will be put into practice. This does not so much involve drawing through anatomy as arriving at anatomy through drawing. In other words, by starting with a correct basic drawing, we will see how anatomy reinforces the artistic experience. In this section, we will show the process of constructing various figures based on knowledge of their anatomical features, using the most common drawing procedures. Every drawing is based on a careful approach to anatomy, on the basis of which every painter or illustrator can develop an individual interpretation of the human figure. The explanations and illustrations that precede these pages are an essential guide for the artist.

ANATOMICAL FEATURES

The anatomical features that this drawing implies are centered in the scapular belt, that is, the bony group consisting of the top of the sternum, the clavicles, the scapulaes, and (to a lesser extent) the first ribs and cervical vertebrae. Visualizing the arrangement of the skeleton underneath the skin is very important in any pose. Accommodating the muscle shapes on the basis of that arrangement becomes easy. Part of that relief involves the shape of the sternocleidomastoid and the breasts. In dealing with a female figure in a relaxed pose, the remaining muscles are not highlighted but are integrated harmoniously into a smooth outer contour.

THE DRAWING PROCESS

The drawing process for this first exercise is based on the use of colored chalk. The pieces of chalk are square bars very similar to pastels. In fact, they are pastels that are harder than normal, so they can be used to make lines and colored areas.

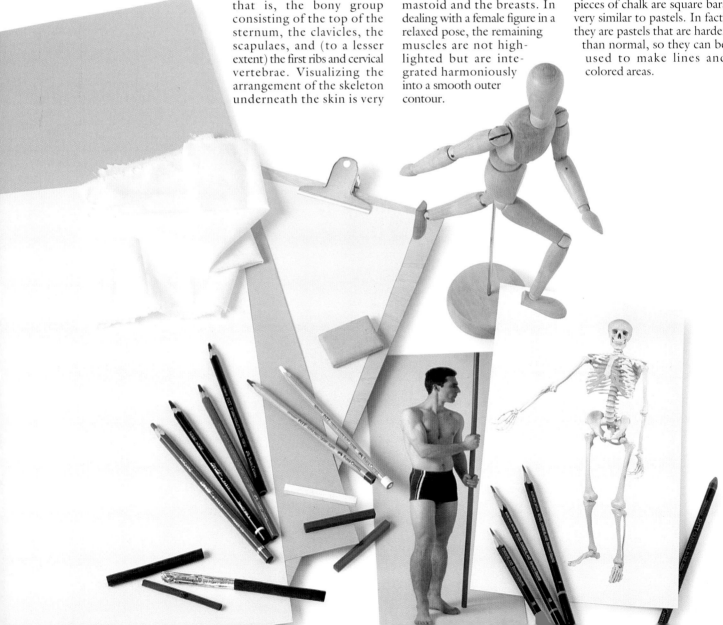

Traditionally sanguine, sepia, ocher, white, and black chalks have been used to create chromatically harmonious results that match our expectations for the drawing of a nude. The lines and colors done in chalk can be blended together to create smooth, continuous shapes.

THE WORK PROCESS

The drawing begins with a quick sketch based on the figure's general outline. The skeleton is arranged inside these outlines to be sure that the outline corresponds to the correct anatomical proportions. The following is a work based on developing the shapes, the shading, and the treatment of reflected light, using the entire spectrum of shading offered by the selected chalk colors.

1. The first step involves drawing the general outline of the figure. This is just an approximate outline. It is constructed with light lines, without focusing on details or trying to create shadows.

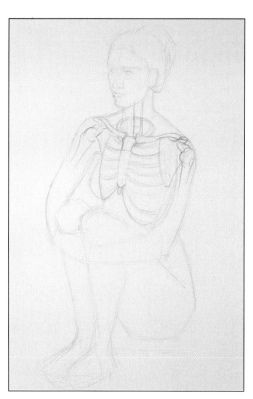

2. The bones of the scapular belt are fitted into the general outline to check that the proportions and the external shape of the neck and chest are correct.

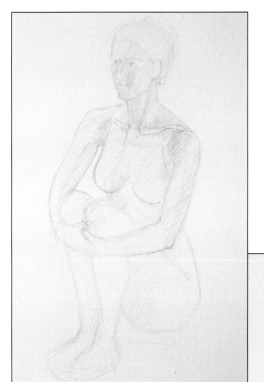

3. If the drawing of the bones is done correctly, adjusting the outline of the figure to the configuration of the skeleton is easy, highlighting the shapes formed by the clavicles, the shoulder blades, and the acromion, which are the major reference points in the shoulders.

4. The drawing of the skeleton is also a basic reference for mentally calculating the volume taken up by the muscles and the area they cover. Getting to know the location of the bones makes evaluating the proper distribution of the muscle masses easier.

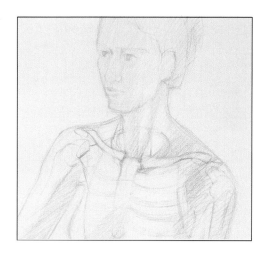

5. In this illustration, we can see the beginnings of the shading that are a natural consequence of anatomical accuracy. These shadows correspond to the basic muscle shapes of the figure's neck and shoulders.

REPRESENTING THE SKELETON

The skeleton can be drawn from memory if the artist (Yvan Mas in this case) has learned the location of the bones—a task that is accomplished after long practice. Otherwise, the artist can use photo references like the ones that have been used in this book, adapting them to individual poses.

6. The initial shading is applied to the entire body to create a balanced vision of the whole. However, the work will center on the bust, and the rest will be less polished.

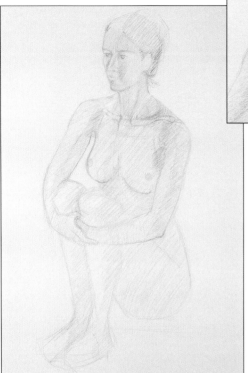

7. Here we can see that the drawing of the bones serves to define and specify anatomical shapes; the clavicle is visible beneath the skin for almost its entire length.

8. The effect of relief is gradually reinforced by means of shading in some important areas, such as the armpit and the shoulder.

SHADING

The arrangement of light and shadow on the body is a natural consequence of the anatomical shapes and the muscular development of every figure. When the artist has a clear idea of the muscle anatomy, creating the general shading without consulting a live model is possible.

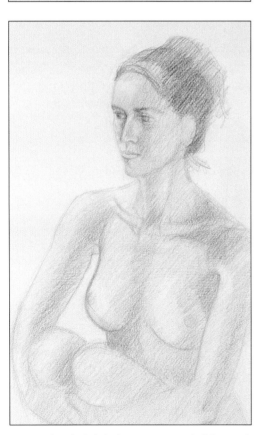

10. The facial features can be detailed only when the shading of the head is at the same stage as the rest of the body. In principle, the facial features should be sketchy, without trying to create a pronounced expression.

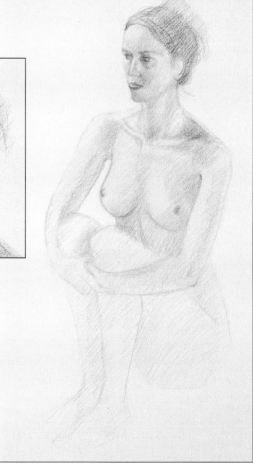

9. Even though the hair is not an anatomical feature, it is still a very important part of the drawing. It must be granted as much importance as the other parts of the figure.

11. The transitions between light and shadow have been softened, and now the drawing is a harmonious blend of lines and colors adjusted to the anatomical features of the subject.

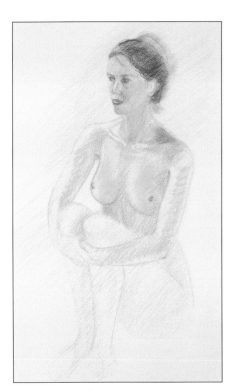

12. *In this drawing, the lighter shades match the color of the ground (a light, cream-colored paper). In order to highlight them even more, the outside of the figure is shaded, the contrast between light and shadow is accentuated, and the hair is darkened a bit.*

13. *The shading of the outside needs to be more intense in the most highly illuminated area; the other half can be left without shading or shaded very lightly.*

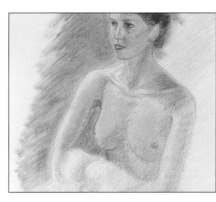

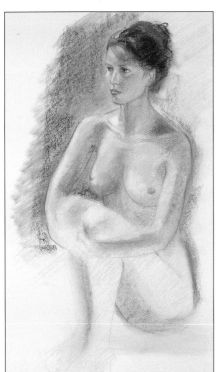

14. *The darkest accents are gone over again in the last phase of the work: the shadows of the hair, the breast, the shoulder, as well as the background shade, which contributes significantly to the overall shape of the figure.*

15. *The bust is perfectly finished, with all the anatomical features properly defined. The rest of the figure is left in rough form, even though it is carefully adjusted as to proportion and shape.*

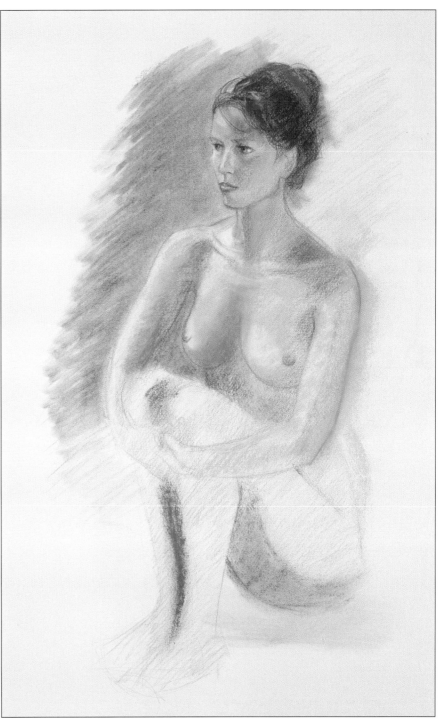

The Male Torso

Ever since ancient Greece, the torso has been the most commonly depicted anatomical region. It is not just an anatomical region but also a powerful symbol of the strength, vigor, and beauty of the human body. This exercise shows the process of drawing a male torso using charcoal as the sole medium. This exercise also includes representing the head and the facial features, which must be presented in harmony with the rest of the drawing.

ANATOMICAL FEATURES

The anatomical features included in the drawing of a torso are, as we know, the thoracic cage, the scapular belt, the pectoral muscles, the rectus abdominis muscles, the serratus muscles, the deltoids in the shoulders, and the shape of the neck. To all this we still must add the muscles of the neck and the physiognomy of the head. As with the preceding exercise, we begin with a quick sketch that includes the skeleton, which will serve as a guide for the project.

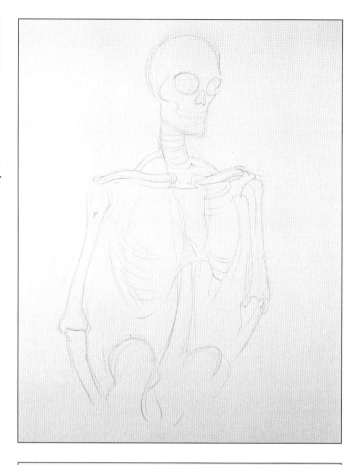

1. Laying out the skeleton is practically a prerequisite for any anatomical drawing. In any case, it is a good idea when putting anatomical studies into practice. In this instance, the skeleton was drawn in with a blue-colored pencil.

2. A graphite pencil with a moderately hard lead that produces a fine line is used to outline the figure, paying attention to the areas where the skeleton is visible beneath the skin: the shoulders, the clavicles, and the sternum.

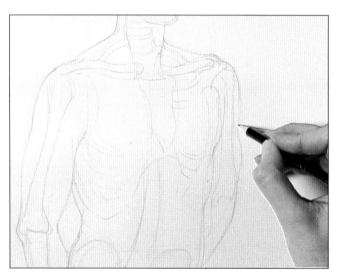

3. The results of the previous anatomical study might suffice as a finished drawing. However, here it is only a linear support for further shaping.

THE DRAWING PROCESS

We will use charcoal on white paper. Charcoal is the most direct of the drawing tools. It must be used energetically, based on intense contrasts between light and shadow. It is not a medium that favors minute, delicate elaboration. The strokes are broad, and the gradations and blending occupy an area that with other techniques corresponds to fine lines and detailed shading used in other media. In this case, the artist is using a charcoal pencil rather than a stick; this allows for greater precision, especially in the initial stages of the project. Usually, artists use rags and erasers for thinning, modifying, and removing charcoal, plus their own fingers for blending the details. In addition, a blue-colored pencil and a graphite pencil were used in the early stages of the drawing.

THE WORK PROCESS

The first phase of the work by Ferran Sostres involves a line drawing to frame in the skeleton and the outline of the figure. The point of the conventional pencil (a graphite pencil and a colored pencil) merely brushes the paper, and the lines are very faint. There is no need to belabor the shapes or add any shading. Once the anatomical adjustments are complete, the artist uses the charcoal energetically to create dark shadows and striking contrasts that define the entire relief of the body. Finally, the artist shades the transitions between light and shadow to provide unity to the whole drawing.

4. Now the charcoal pencil is being used. Its point is much broader and the lines are darker than with a conventional graphite pencil. It is used to locate the shadows by accumulating strokes where these shadows are darkest.

5. Here is an initial approximation of the shading that allows for checking the proper distribution of the muscle masses. The pectorals stand out clearly, as do the relief of the clavicles, the neck, the deltoids, the trapezius, and the facial features.

6. The head also deserves a treatment in accordance with the rest of the figure. The shadows of the chin and the forehead are important in the appearance of the head and face.

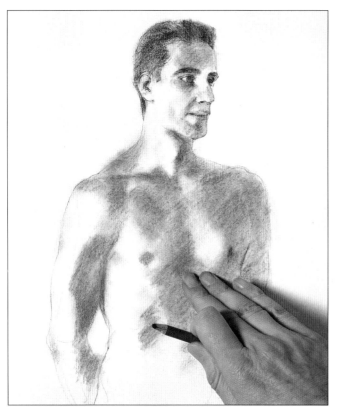

7. *This illustration shows that the fingers are the best tool for blending the lines and shadows from the charcoal; they allow excellent control and even greater precision than rags or any other utensil.*

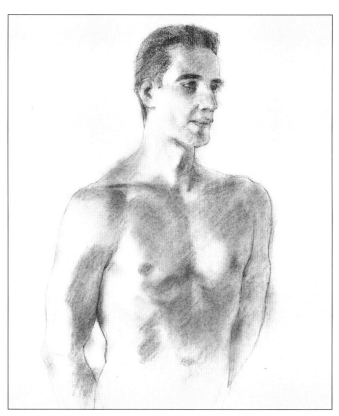

8. *The difference between the drawings before and after the blending is remarkable. In fact, the blending serves to unify the shapes and create a relationship between light and shadow as well as to accentuate the sculptural presentation of the figure.*

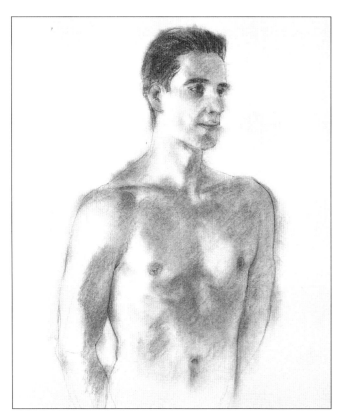

9. *Once all the figure's shapes have been unified, they are molded and highlighted further. In other words, the shadows are accentuated or lightened, depending on the desired effect. The hair is darkened to create the necessary contrast with the face.*

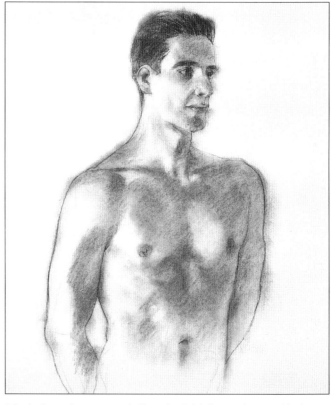

10. *As the work progresses, the lines that initially served as a guide for shading become less visible; the blending melts them together until they disappear almost entirely.*

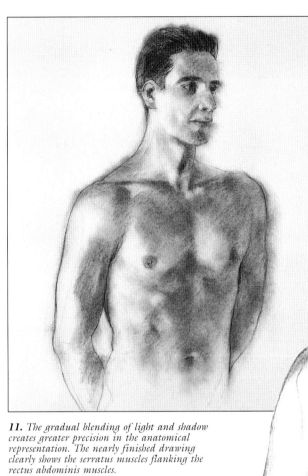

11. *The gradual blending of light and shadow creates greater precision in the anatomical representation. The nearly finished drawing clearly shows the serratus muscles flanking the rectus abdominis muscles.*

12. *As a final touch, the artist uses an eraser to remove the charcoal that went outside the figure's outline.*

13. *Here is the final product. Ferran Sostres has added the lines of the skeleton once again to show that all the shading corresponds to a clearly resolved anatomical reality.*

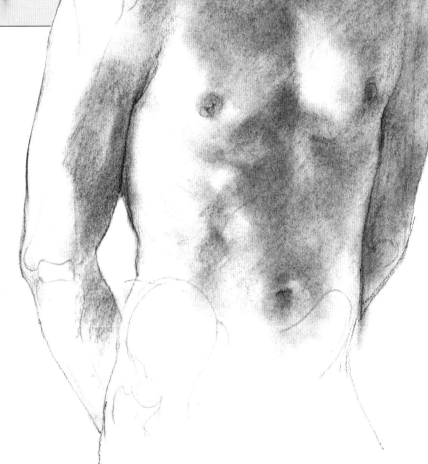

A Standing Female Figure

The drawing that we will now examine is a very complete anatomical study since it involves depicting the entire frontal view of a female figure. The pose also presents a very harmonious movement, which has to be resolved along with all the anatomical features that it involves. The position of the arms and the hips produce specific shapes that work together dynamically. This is an interesting project that will be done using a tan spectrum of colored pencils.

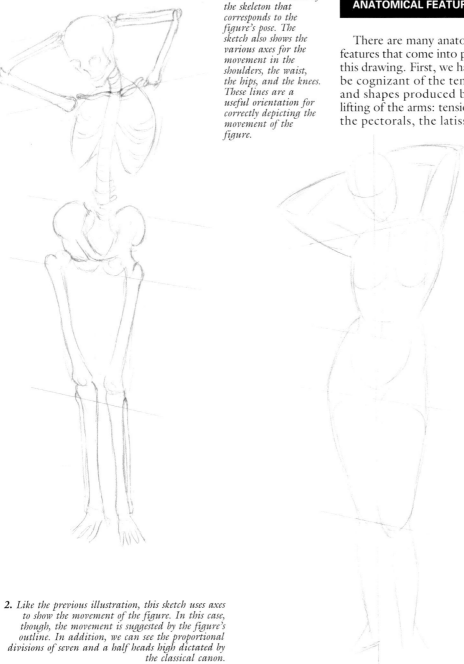

1. Here is the sketch of the skeleton that corresponds to the figure's pose. The sketch also shows the various axes for the movement in the shoulders, the waist, the hips, and the knees. These lines are a useful orientation for correctly depicting the movement of the figure.

ANATOMICAL FEATURES

There are many anatomical features that come into play in this drawing. First, we have to be cognizant of the tensions and shapes produced by the lifting of the arms: tensions in the pectorals, the latissimus

dorsi, and the deltoids. This movement accentuates the shape of the lower third of the thoracic cage as well as the rectus abdominis muscles. The movement in the hips is manifested primarily in their shape, and it causes characteristic wrinkles in the abdomen and the waist. Lastly, the legs clearly show the location of the sartorius in the front of the thighs.

THE DRAWING PROCESS

Colored pencils in an earthy spectrum are used: siennas, ochers, chestnuts, and browns. Colored pencils are media less commonly used than Conté crayon or charcoal. However, they offer wonderful possibilities for all kinds of works, especially for drawing the human figure. They can be used to create soft colors since they are not suited to bright or opaque colors. They can be used to create many delicate shades since the artist can accumulate many strokes without saturating the colored area. Colored pencils fall partway between drawing and painting, and they can be used to create extremely attractive results.

MUSCLES AND ADIPOSE DEPOSITS

The figure's subcutaneous relief is determined by the shape of the skeleton and the muscles plus the body's adipose deposits. The latter factor is particularly important in the female body. As a result, a drawing of female anatomy cannot be based solely on the proper distribution of muscles and bones. The buttocks, the thighs, the stomach, and the breasts relate directly to adipose layers as well as to the muscles they cover.

2. Like the previous illustration, this sketch uses axes to show the movement of the figure. In this case, though, the movement is suggested by the figure's outline. In addition, we can see the proportional divisions of seven and a half heads high dictated by the classical canon.

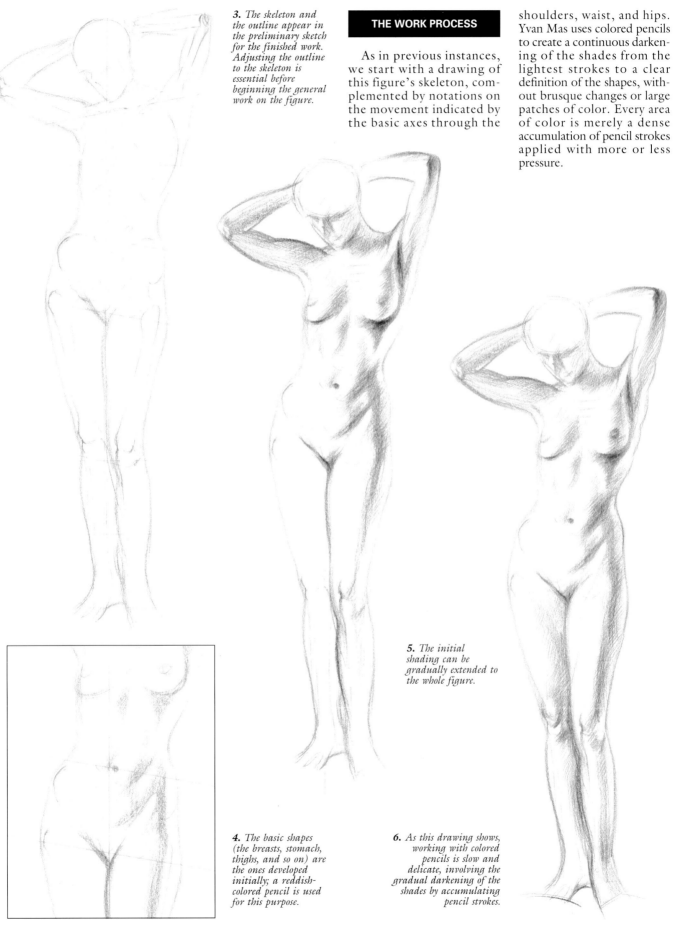

3. *The skeleton and the outline appear in the preliminary sketch for the finished work. Adjusting the outline to the skeleton is essential before beginning the general work on the figure.*

THE WORK PROCESS

As in previous instances, we start with a drawing of this figure's skeleton, complemented by notations on the movement indicated by the basic axes through the shoulders, waist, and hips. Yvan Mas uses colored pencils to create a continuous darkening of the shades from the lightest strokes to a clear definition of the shapes, without brusque changes or large patches of color. Every area of color is merely a dense accumulation of pencil strokes applied with more or less pressure.

5. *The initial shading can be gradually extended to the whole figure.*

4. *The basic shapes (the breasts, stomach, thighs, and so on) are the ones developed initially; a reddish-colored pencil is used for this purpose.*

6. *As this drawing shows, working with colored pencils is slow and delicate, involving the gradual darkening of the shades by accumulating pencil strokes.*

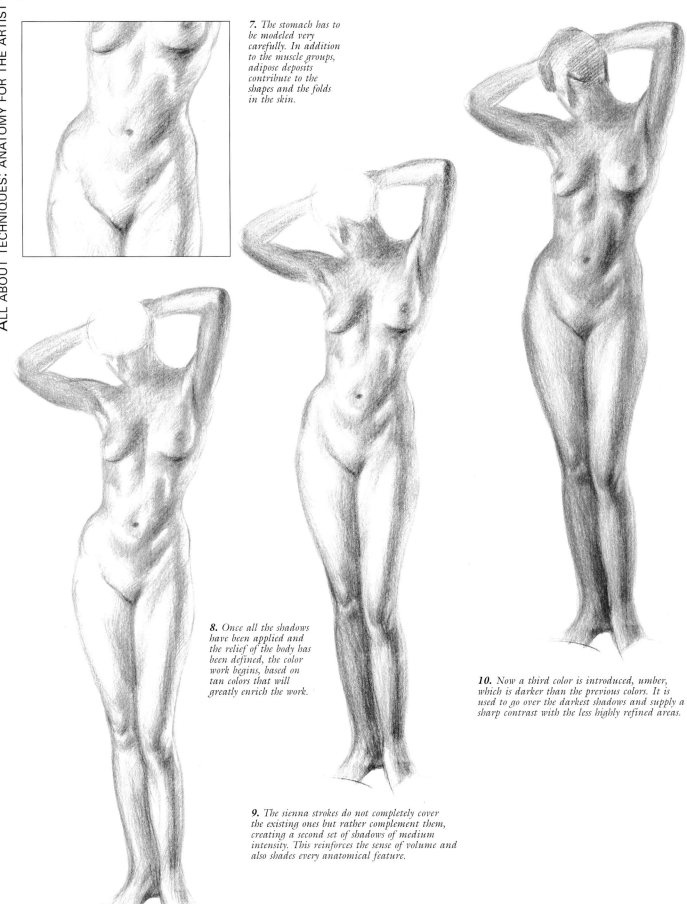

7. The stomach has to be modeled very carefully. In addition to the muscle groups, adipose deposits contribute to the shapes and the folds in the skin.

8. Once all the shadows have been applied and the relief of the body has been defined, the color work begins, based on tan colors that will greatly enrich the work.

10. Now a third color is introduced, umber, which is darker than the previous colors. It is used to go over the darkest shadows and supply a sharp contrast with the less highly refined areas.

9. The sienna strokes do not completely cover the existing ones but rather complement them, creating a second set of shadows of medium intensity. This reinforces the sense of volume and also shades every anatomical feature.

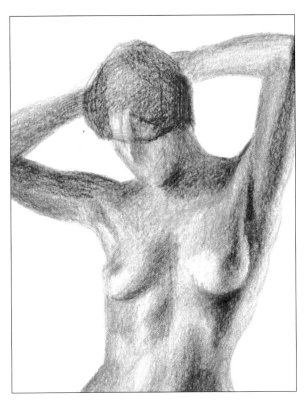

11. *The figure's hair has been left for last since its dark color needs to be in harmony with the rest of the dark shades in the drawing, and these are finalized only in the later stages of the work.*

12. *This drawing needs nothing more; the accuracy of the anatomical features combines with a delicate and very artistic, appealing treatment.*

The Male Back

The back is one of the most difficult anatomical subjects. It is harder to outline than the arms and legs, which, in the final analysis, are assemblies of cylinders. The back also does not have as pronounced a shape as the torso to help delineate each part. The back is quite flat. The only clear reference is the furrow of the spinal column. This scarcity of references is even greater in the pose selected for this exercise: a motionless figure standing squarely on his feet. As a result, a knowledge of anatomy becomes even more important. It forces the artist to keep in mind all the skeletal and muscular features that play an important role.

ANATOMICAL FEATURES

First, we need to mention the spinal column. The cervical lordosis (outward curvature) determines the relief at the seventh cervical vertebra, and the lumbar kyphosis (inward curvature) produces a typical furrow. Also, we need to point out the shape of the shoulder blades: the acromion in the upper part of the shoulder and the spine beneath which the bulge of the infraspinatus muscle appears. To all this we must add the muscles of the upper arms and the forearms, which are very visible in this pose. In short, this exercise will require a very complete review of the anatomy of these body parts.

THE DRAWING PROCESS

The chosen medium will once again be charcoal. This time, the shading will be softer, as required by the less prominent shapes that make up the back. As in the previous instance, the project will start with a pencil drawing in which all the relevant anatomical features will be properly established. In contrast to the previous exercise, this one will be done using a small stick of charcoal and a piece of white chalk for adding the white areas. Charcoal sticks produce a slightly coarser line than a charcoal pencil, but they are better for blending. They are also lighter in shade since they use no clay or binder in the lead to add rigidity and stability.

THE WORK PROCESS

As usual, Hector Fernandez begins this procedure with an initial sketch that contains the bones of the scapular belt, the spinal column, and the thoracic cage. Once this drawing is done correctly, the work progresses, respecting the skeletal features that may be visible beneath the skin.

1. First of all, the scapular belt is drawn. When seen from the back, this cluster of bones provides a very clear view of the shoulder blades and their spines. The shape of these spines needs to be preserved in that part of the back.

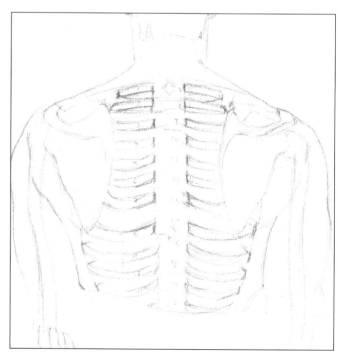

2. Here is the rest of the skeleton that has a bearing on this exercise. Even though the ribs do not appear on the outside, drawing them in is a good idea to check the correct positioning of the other bones with respect to the thoracic cage.

3. *Once the bones are positioned correctly, the lines from that preliminary drawing are erased, leaving only the outline of the figure.*

4. *In this instance, the shading is not an accumulation of pencil strokes but, rather, a direct application of color blended with the fingertips.*

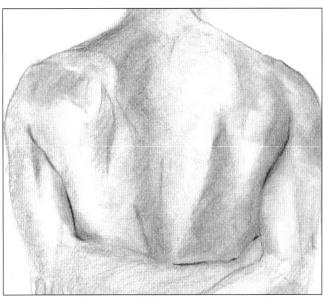

5. *The charcoal can be applied directly to the outside of the thigh before blending it. This involves some rough strokes whose shape and direction have nothing to do with the anatomical configuration; rather, they simply fill the space in preparation for blending.*

6. *The back now shows enough modeling to reveal the muscle relief in the sacrolumbar muscles on both sides of the furrow for the spinal column. The area of the scapulae is treated in a little more detail, but the anatomical features still do not stand out clearly.*

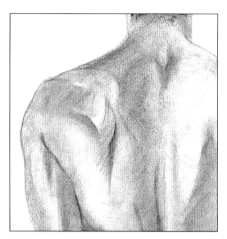

7. Here we can see the shape at the seventh cervical vertebra. The spines of the shoulder blades are also visible, along with the slight prominence of the acromion on the shoulder.

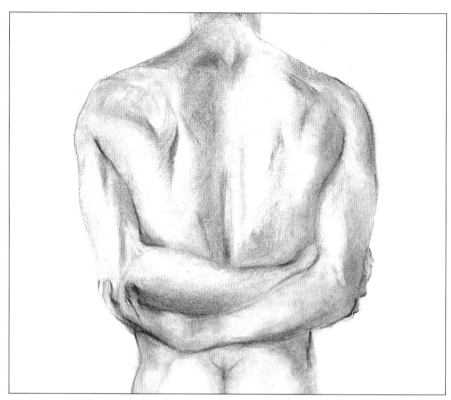

8. The broad basin at the lower half of the trapezius becomes increasingly clear: it is a V-shaped area that extends on both sides of the spinal column. The infraspinatus muscles are now visible under the spines of the shoulder blades.

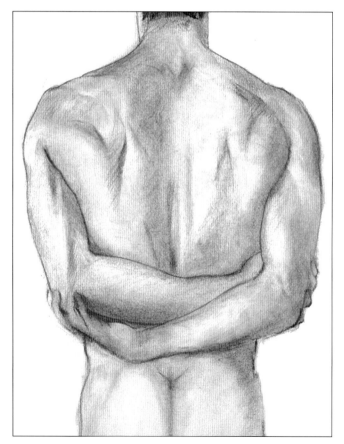

9. We also need to point out the resolution of the shapes in the arms and the appearance of the deltoid, the triceps, and the elbow in the right of the drawing.

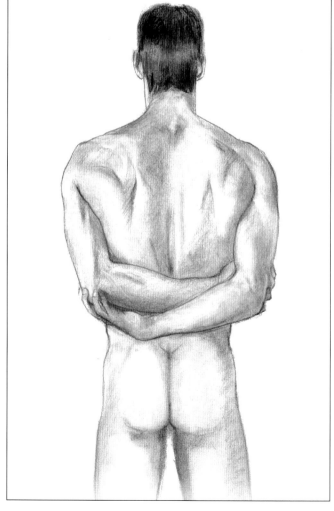

10. White chalk is used to highlight the lightest areas, which up to this point were the same muted color as the paper. These white areas reinforce the shaping and make defining the muscles easier.

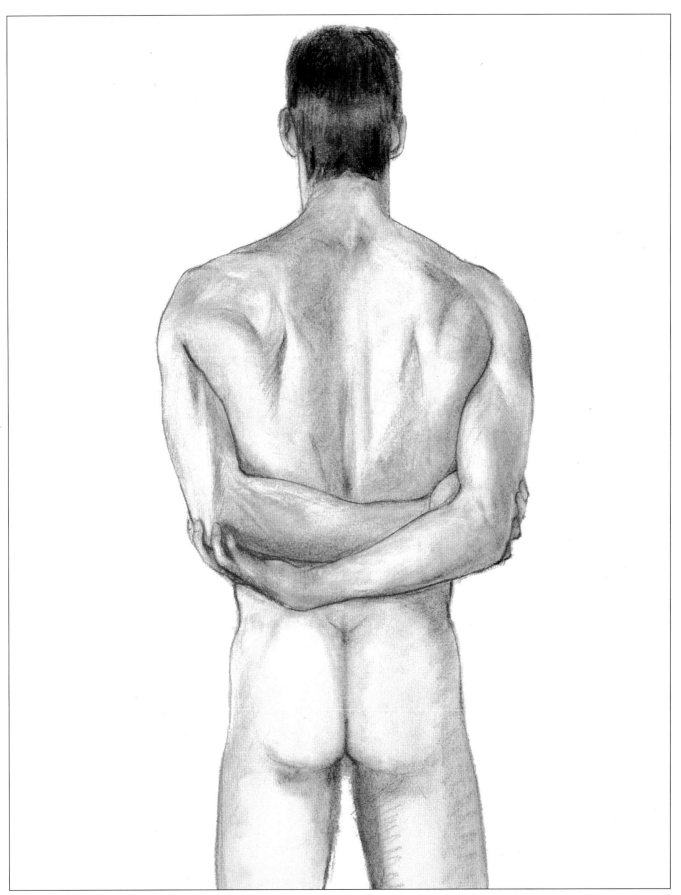

11. *Here is the end result. The entire relief of the back has been done properly, with the necessary linear and tonal harmony that is a credit to this type of drawing.*

Foreshortening of a Male Head

Foreshortening is a view in perspective. In terms of anatomy for the artist, foreshortening is a view from an angle located on some plane other than the body's frontal or lateral ones. It can be a view from above or below, or from any other point where parts of the body are seen in perspective. In this case, the viewpoint is a little lower than usual, and the figure's head and neck are turned away, so they appear in perspective. Using foreshortening requires being able to represent the skeleton and the anatomy in general from any point of view.

Once again the scapular belt is sketched in place, plus the muscles of the neck, seen from a less common angle than in the preceding exercises. The foreshortening of the head is even more pronounced, and the face is seen only in profile. All these features have to be planned and resolved in the drawing of the skeleton, in which the outline of the body is just an anatomical wrapping.

The medium will be a Conté crayon. Conté crayons are red oxide-colored chalk; they have been used since the Renaissance as an alternative to charcoal and ink. They produce a soft line, and their warm, earthy shade makes them well suited to drawing the human figure. They are used for drawing lines as well as blocks of color. They are used much like charcoal, although the shadows done in Conté are never as dark. As a result, in order to create slightly darker tones than the ones available with Conté, we will also use a piece of sepia chalk in some specific areas of the drawing.

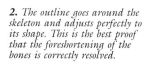

2. The outline goes around the skeleton and adjusts perfectly to its shape. This is the best proof that the foreshortening of the bones is correctly resolved.

1. Here is the drawing of the skeleton in foreshortening. Note how the thoracic cage and the head are rendered. The former is inclined to the side, thereby reducing one of the clavicles to a small piece. In the head, we can see the underside of the chin and the base of the skull.

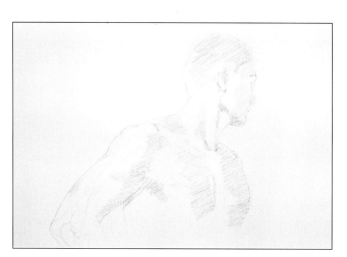

3. After erasing the drawing of the skeleton nearly completely, the lights and shadows are added to the body in a general fashion by accumulating gentle strokes where the shading is darkest.

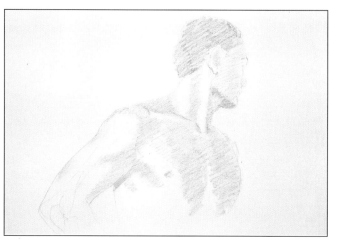

4. Here the strokes are more obvious. They are all oriented in the same direction, and they will subsequently be blended to create a smooth, continuous appearance.

THE WORK PROCESS

The following procedure will be the usual one in these exercises: drawing the skeleton and the body's outline, followed by general shading and then by paying greater attention to adding shadows to all the shapes that make up the body. The work with the Conté crayon, done by Ferran Sostres, is partway between colored pencil and charcoal. In fact, Conté technique is like working with a stick of pastel that is a little harder than usual.

5. *The tones are beginning to contrast with one another; they are more forceful in the shadowy areas and very gentle where the color of the paper shows through. This is the lightest color used in this drawing.*

6. *Here the blending of the strokes has begun, and the blocks of color are starting to become unified and provide continuity to the figure.*

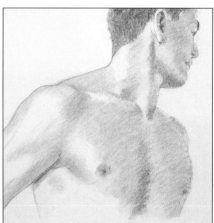

7. *The shade of sanguine in the hair, the darkest color in the drawing, has been deepened and darkened by adding some touches with sepia chalk.*

8. *Once the shading and foreshortening are resolved, and a few strokes have been added to the background to suggest the space that surrounds the figure, the exercise can be considered done.*

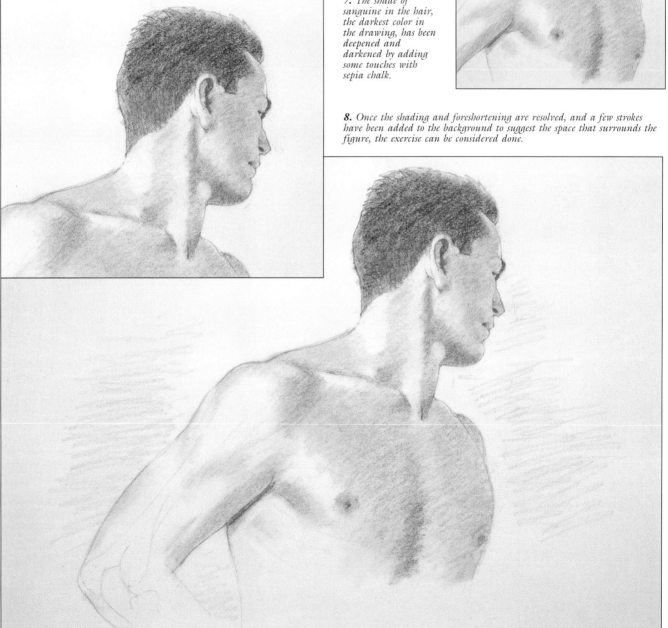

A Reclining Female Figure

If knowledge of anatomy is of any use to an artist, it is as a point of departure for correctly interpreting any posture and movement of the body. This exercise shows the development of a drawing in which the movement provides all the anatomical and artistic interest. This involves a global focus based more on the vision of the whole than on partial aspects of anatomical studies.

1. The preliminary sketch is based on stylized anatomical shapes created with simple forms: curves and straight lines that establish the proportions and the articulation of the limbs.

PRELIMINARY SKETCHES

Starting a drawing with basic sketches of the limbs involves putting each part into the whole, with a consideration of the true articulation of those limbs. Each partial sketch is a fairly geometric stylization drawn in simple shapes such as rectangular prisms and cylinders.

2. When the sketch is properly proportioned, the lines are rounded and softened to create an outline more in harmony with the anatomical reality.

3. The final outline of the figure has been gone over to soften the angles and provide continuity to the basic curves of the preliminary sketch.

ANATOMICAL FEATURES

The movement of the arms and legs are the main features of this pose: there are flexions and extensions that produce different shapes in the thorax and the hips. Specifically, we have to resolve the shapes of the gluteals and the legs, including the calves, plus the neck and chest. The most important thing is to get the all the joints correct within a harmonious whole, as the pose selected for this exercise deserves.

THE DRAWING PROCESS

We will use colored pencils again, in the same range of colors and with the same techniques as with the previous exercise. The only difference is in the gray shades that are used in the final stages of the work to introduce a chromatic counterpoint to the warm tones of the drawing, which are created once again using shades of tan. In this instance, the distribution of light and shadow is richer than in the previous exercise because the articulation of the limbs is more complex.

THE WORK PROCESS

This time Yvan Mas does not draw the skeleton. Rather, he draws a generic layout of the figure using simple sketches of the body parts. Naturally, drawing these sketches requires a solid knowledge of the essential anatomical features and the general proportions of the body.

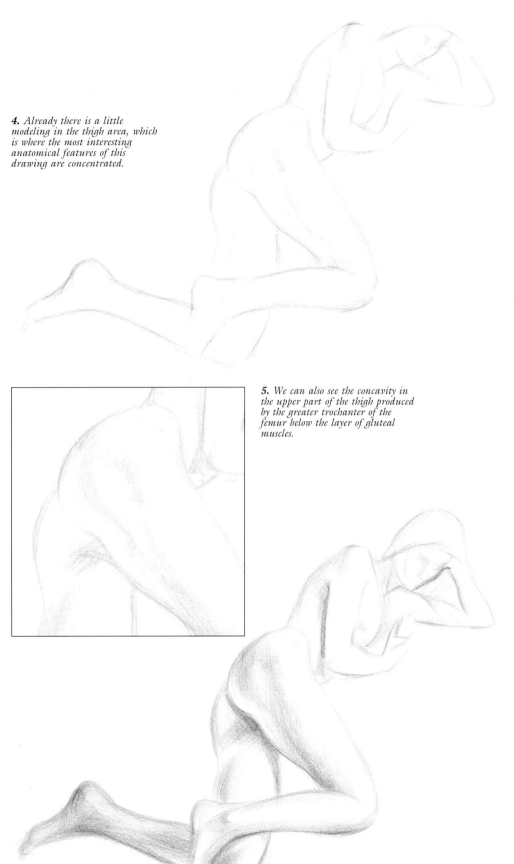

4. Already there is a little modeling in the thigh area, which is where the most interesting anatomical features of this drawing are concentrated.

5. We can also see the concavity in the upper part of the thigh produced by the greater trochanter of the femur below the layer of gluteal muscles.

6. The entire anatomical drawing should advance as a unit, without devoting more attention to one part than another. That is the only way to be sure that the work is done correctly at each stage.

7. Here are some new anatomical features of interest, such as the lateral malleolus in the ankle and the olecranon in the elbow. These are small but significant details that make the drawing true to life.

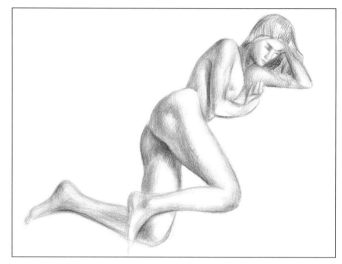

8. Although they are not expressly represented, the drawing clearly suggests that there are anatomical shapes in areas such as the shoulder and the knee—shapes that determine the form of the limbs and their movement.

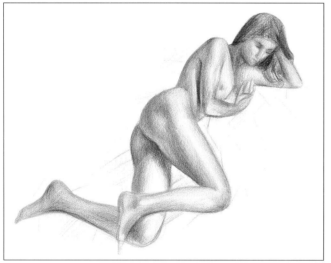

9. The modeling of the body is nearly complete. Note how every anatomical shape is part of a harmonious whole, without taking precedence over any other.

10. The figure's right arm shows the small depression where the deltoid inserts between the biceps and the brachialis. Details like this are the ones that demonstrate the knowledge of anatomy hidden beneath the artist's craft.

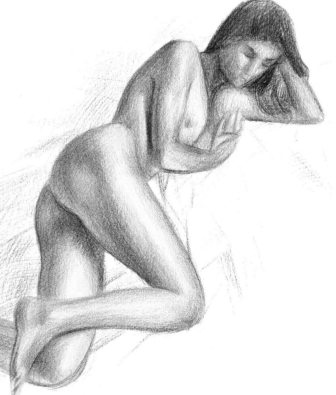

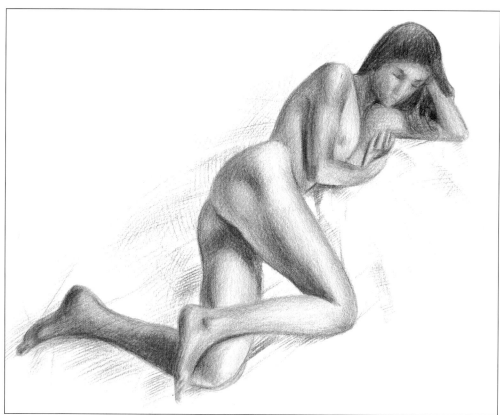

11. *The gray lines that suggest the folds of a sheet create a pleasing contrast with the overall warm tones and introduce a suggestion of space that is so necessary in a drawing of this type.*

12. *At last the drawing can be considered done. This is an attractive synthesis of anatomy, a drawing dominated by a balance between rigorous anatomy and the figure's chromatic and linear grace.*

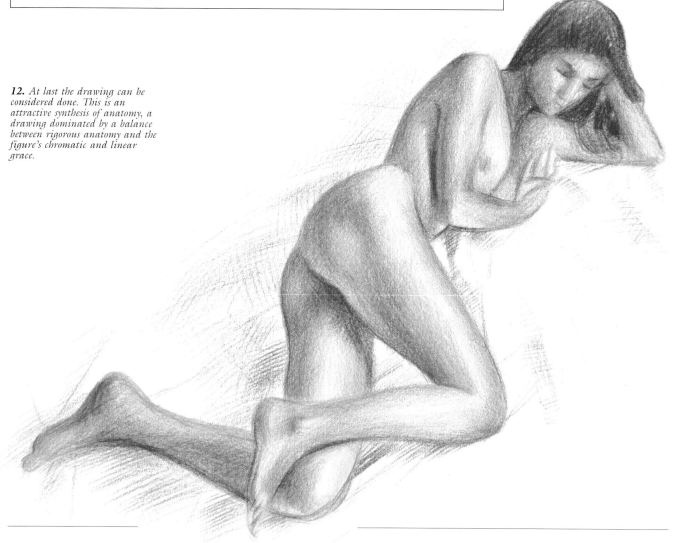

A Standing Male Figure

This exercise involves drawing the whole body of a male figure, which encompasses a great many technical and anatomical features. This type of study is common in art academies: a standing figure whose pose recalls classical sculpture to the extent that it suggests an attitude partway between repose and movement. This pose offers the opportunity to develop the anatomical features of the arms, the torso, and the legs.

THE DRAWING PROCESS

A total of three pieces of chalk will be used for this drawing; the colors are sanguine, sepia, and white. We will also use a graphite pencil for the initial framing of the skeleton. As usual with this type of work, the initial lines done in chalk will be blended to create shapes that have the right look.

ANATOMICAL FEATURES

As we will see in the early stages, the drawing requires a complete interpretation of the movement of the skeleton and the distribution of the muscles. This is, of course, a prerequisite for the correct formulation of the limbs in harmony with the canonical proportions. The pose clearly shows nearly all the anatomical features seen from different angles. One knee is seen from the front and the other in profile; the movement in the hips means that the leg bones are located at different heights; and a similar situation exists with the arms. Then there is the head, which is held up by the appropriate cervical vertebrae.

THE WORK PROCESS

The work process is much the same as we have already seen. The only important difference is in the intensity of the contrasts, that is, the chiaroscuro. In this exercise, we seek a strong counterbalance between light and shadow and the volumetric effect that this involves. It stands to reason that we have to be sure that the anatomical features are correct before proceeding to accentuate the shapes.

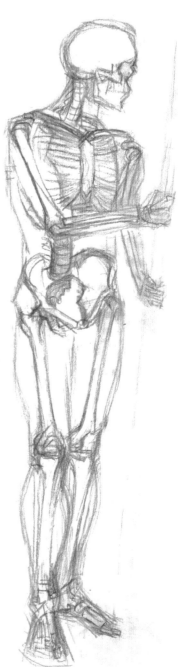

1. The bones of the skeleton are fairly well resolved in this drawing. Each bone has to appear consistent with the rest; otherwise, the errors will surely be reflected in the outline of the figure.

AN ACADEMIC POSE

The pose selected for this exercise is typical of academic instruction in anatomical drawing. The pole held by the figure suggests a lance or a javelin, as do figures of classical statuary. In fact, the teaching of anatomy for artists has always been linked to Greek and Roman canonical models. Even though those models do not apply universally in our time, they are still the ones that best embody harmony and balance among the parts of the body.

2. Lines in Conté crayon mark some parts of the skeleton to create an initial sense of three-dimensionality.

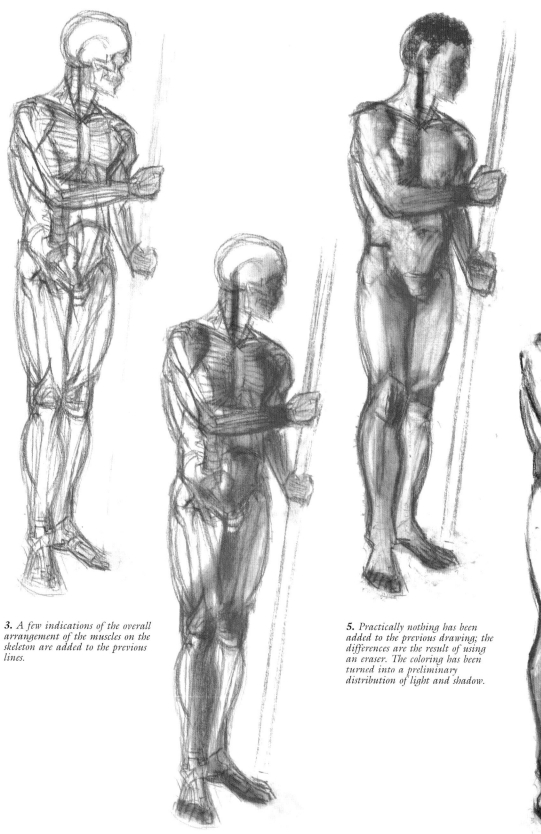

3. *A few indications of the overall arrangement of the muscles on the skeleton are added to the previous lines.*

5. *Practically nothing has been added to the previous drawing; the differences are the result of using an eraser. The coloring has been turned into a preliminary distribution of light and shadow.*

4. *An initial shading gives body and solidity to the entire anatomy. This shading has to be quite deft to highlight all the shapes.*

6. *The outlines are reinforced to accentuate the shape of the figure, particularly in the thighs and the back. In addition, the chiaroscuro is visible in the marked contrasts.*

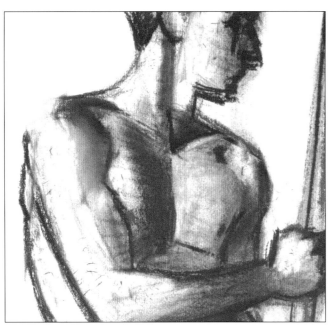

7. Here the neck and shoulder area has been elaborated to frame each of these anatomical pieces correctly and set up the attendant values of light and shadow.

8. The figure has taken on aplomb and stability. That is particularly important in a figure based on chiaroscuro, which tends to make the figures appear quite solid and heavy.

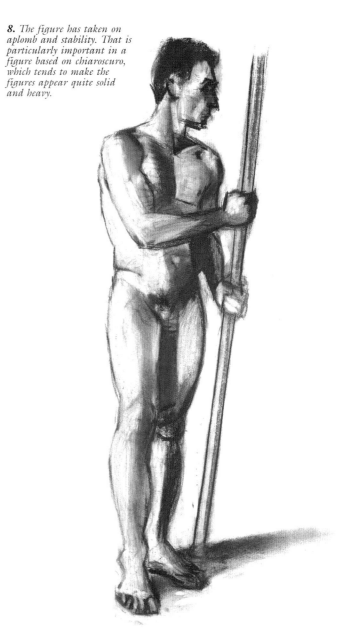

9. The shape of the stomach shows a set of shadows that involve the shading of the anatomy and the shadow projected by the arm.

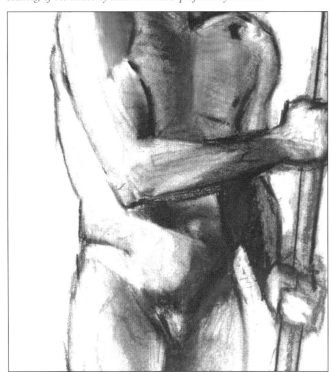

10. Now the work concentrates on the thighs in order to suggest volume by means of contrasts—in other words, through the contrast of the lighter outlines with the darker backgrounds or vice versa.

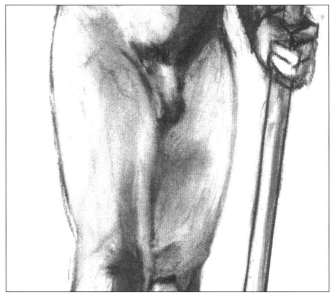

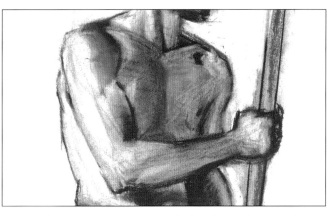

11. Now the arm appears with greater clarity, after erasing some of the shadows that were slightly interfering with its shape. The elbow joint is finally at the proper angle.

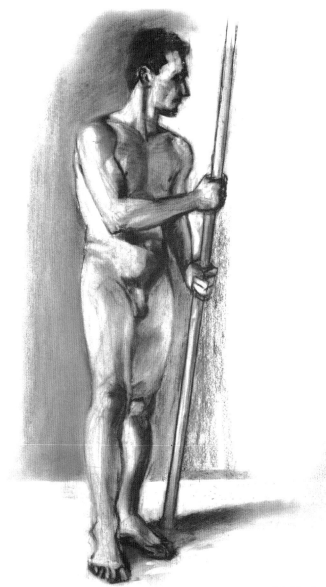

12. Now the background is darkened using a mixture of white chalk to create a contrast with all the tones of the figure and suggest the surrounding space.

13. The final product is very rich in different tonalities created by combining sanguine, sepia, and white. In this exercise, the vehicle for expressing the anatomical force of the figure is the chiaroscuro.

A Seated Female Figure

This last exercise of the series constitutes a review of all the procedures studied to date, especially the drawing technique used. All the aspects pertaining to shading, highlighting, and modeling the anatomy reappear here, treated in detail and with a high degree of finish. The questions of strict anatomy are implicit in all these features since the bones and the muscles are the physical substrate to which all the techniques for drawing figures are applied. This exercise involves drawing a female figure seated in a very collected and harmonious pose.

1. Rather than a complete representation of the skeleton, the preliminary sketch sets up the most important bony areas: the thoracic cage, the curvature of the spine, the pelvis, and some indications of the bones in the arms and legs.

2. A few strokes with charcoal are added to the initial framework in the areas that correspond to the most important contrasts.

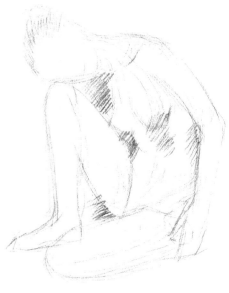

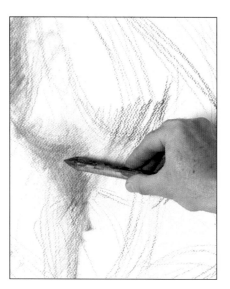

3. The outer lines are lengthened and blended together using a stump, thereby setting up some of the important contours.

4. The first areas of color have been blended together. Note that the outline is obtained not through lines but rather through the contrast between light and dark areas in the figure and the background shadows.

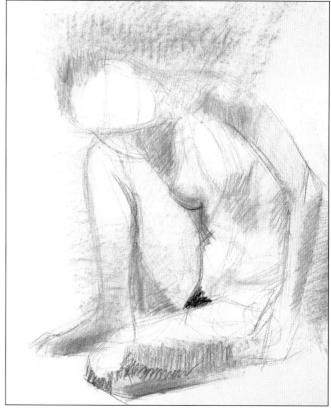

ANATOMICAL FEATURES

There is nothing new to add to this section that has not already been studied previously in the other exercises except the fact that the pose produces folds and shapes due to the pressure of the limbs on the body. The stomach is more prominent, the thigh resting on the floor broadens, and the curve of the back makes an angle at the top of the shoulder due to the inclination of the head.

THE DRAWING PROCESS

In this exercise, charcoal is once again used masterfully by Carlant. In this instance, a rag is used in addition to the fingers because of the large format. The rag makes spreading out the colored areas and blending them in large areas easier. The lightest areas are highlighted with white chalk to create effective modeling in the proper shades. Since this is a large drawing, the best choice is a stick of charcoal instead of a charcoal pencil. The point of the stick is used for drawing lines, and the stick is used flat for shading. A blending tool is also used for working on the smallest details.

THE WORK PROCESS

The following procedure does not emphasize a preliminary drawing of the skeleton as much as an initial framework that can be enriched little by little through shading and blending, without the need to effect changes or corrections. In contrast to the other exercises, the shading is applied to the entire paper to define the figure's space and the surroundings clearly. This treatment of the environment also serves to surround the light and dark areas of the body with contrasts.

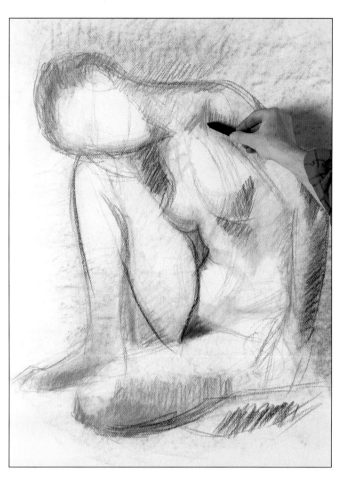

5. Little by little, each of the anatomical features takes shape. Here we see the shading of the shoulder, which highlights the deltoid.

6. The interior and exterior of the figure are worked simultaneously, highlighting certain details such as the shadow from the shape of the serratus muscles visible below the figure's left breast.

7. The rag softens the colored areas of the stomach and unifies the shades in this area. That way, the contrasts in tone alternate with smooth transitions.

8. *Shading the thigh directly in order to highlight its shape is not necessary. Darkening the areas outside it is enough. That way, the shape of the leg appears in all its integrity.*

9. *This entire area of the drawing is done "in negative"—in other words, by darkening the background to make the outline stand out clearly.*

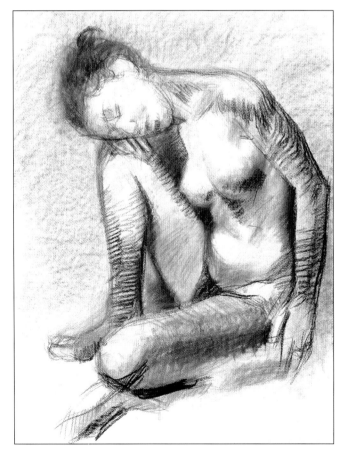

10. *The heavy parallel lines that now appear on the arms and legs will be blended using a rag and a blender. The softness of the charcoal makes it possible to do this without leaving any permanent lines.*

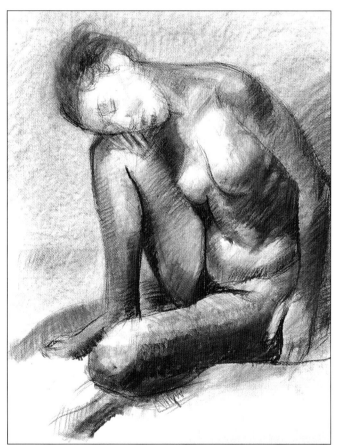

11. *The drawing is very rich in contrasts; as a result, the anatomical shapes stand out forcefully and clearly.*

12. *As the figure is darkened, a tonal balance is established between it and the background. The illustration shows the process of modeling with the stump.*

13. *The charcoal lines disappear little by little under the influence of the stump. The figure and the background evolve at the same pace.*

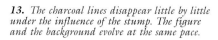

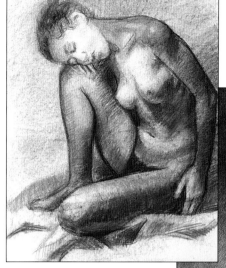

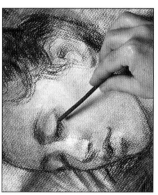

14. *The final stage of work focuses on the figure's face. Here we have to proceed with great delicacy since facial features cannot be created with very forceful strokes. The drawing of the features is at least as important as the contrast in shades.*

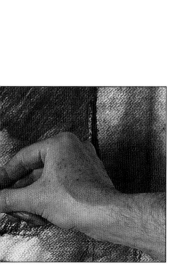

15. *The pronounced obscurity in the upper part of the composition creates an intense luminosity perfectly justified by the energetic contrast between light and shadow in the finished drawing.*

Topic Finder

Original title of the book in Spanish: *Todo sobre la anatomía artística*

© Copyright Parramón Ediciones, S.A., 2002—World Rights
Published by Parramón Ediciones, S.A., Barcelona, Spain
Author: Parramón's Editorial Team
Illustrators: Carlant, Héctor Fernández, and David Sanmiguel
Text and Coordination: David Sanmiguel
Exercises: Carlant, Héctor Fernández, Yvan Mas, Ferran Sostres,
and David Sanmiguel
Photographs: Nos & Soto

Translated by Eric A. Bye, M.A.

© Copyright 2003 of English language translation by
Barron's Educational Series, Inc.

All inquiries should be addressed to:
Barron's Educational Series, Inc.
250 Wireless Boulevard
Hauppauge, New York 11788
http://www.barronseduc.com

International Standard Book No.: 0-7641-5603-9
Library of Congress Catalog Card No.: 2002034525

Library of Congress Cataloging-in-Publication Data

Todo sobre la anatomia artistica. English.
 Anatomy for the artist / [author, Parramón's Editorial Team; translated by Eric A. Bye].
 p. cm.—(All about techniques)
 Includes index.
 ISBN 0-7641-5603-9
 1. Anatomy, Artistic. 2. Drawing—Technique. I. Parramón Ediciones. Editorial
Team. II. Barron's Educational Series, Inc. III. Title. IV. Series.

NC760.T6413 2003
743.4′9–dc21 2002034525

Printed in Spain
9 8 7 6 5 4 3 2 1